KU-001-309

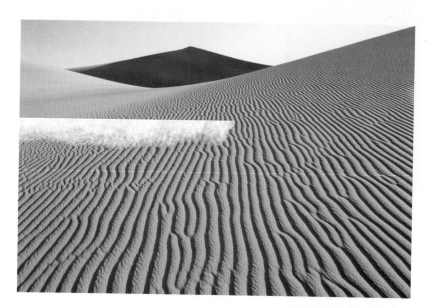

The New Art of Photographing Nature

WITHDRAWN

*125280
NESCol Library

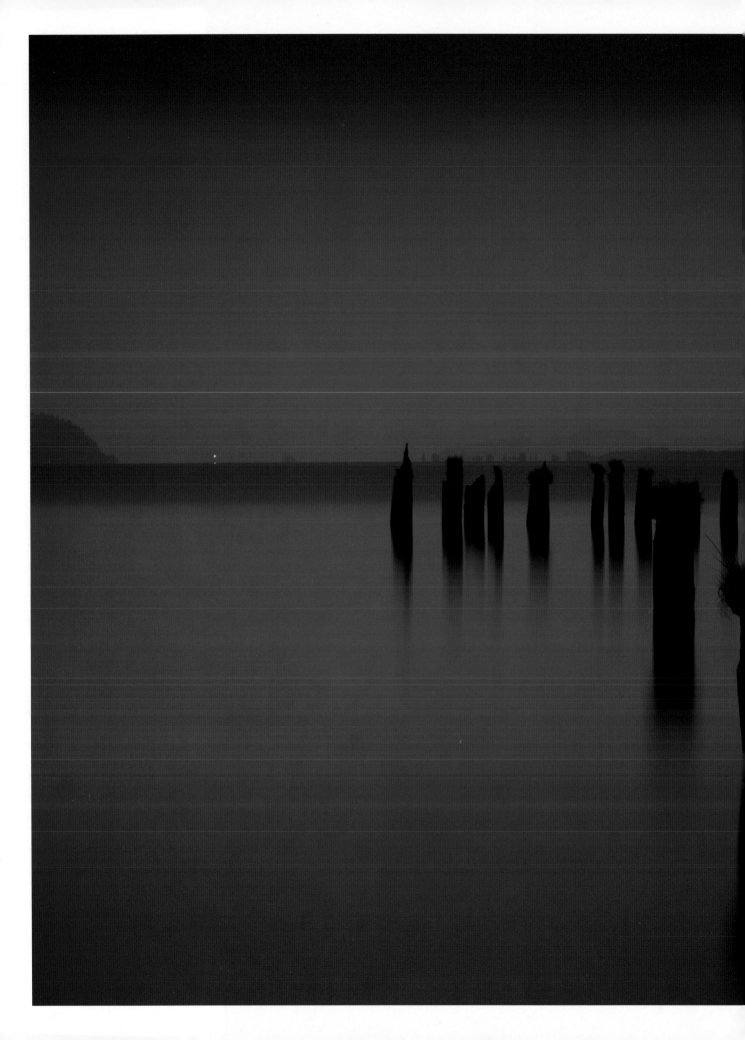

The New Art of Photographing Nature

Art Wolfe

and Martha Hill, with Tim Grey
Photographs by Art Wolfe

AMPHOTO BOOKS
an imprint of the Crown Publishing Group / New York

Text copyright © 2013 by Art Wolfe, Inc., Martha Hill,
and Tim Grey
Photographs copyright © 2013 by Art Wolfe, Inc.
Text copyright © 1993 Martha Hill
Photographs copyright © 1993 by Art Wolfe

All rights reserved.
Published in the United States by Amphoto Books,
an imprint of the Crown Publishing Group, a division
of Random House, Inc., New York.
www.crownpublishing.com
www.amphotobooks.com

AMPHOTO BOOKS and the Amphoto Books logo
are trademarks of Random House, Inc.

Originally published in different form by Three Rivers Press,
an imprint of the Crown Publishing Group, a division of
Random House, Inc., New York, in 1993.

Library of Congress Cataloging-in-Publication Data
Wolfe, Art.
The new art of photographing nature: an updated guide
to composing stunning images of animals, nature, and
landscapes / by Art Wolfe and Martha Hill; with Tim Grey.
Includes bibliographical references and index.
1. Nature photography. I. Hill, Martha, 1946- II. Grey, Tim.
III. Title.
TR721.W6565 2013
779'.3--dc23 2012016487

ISBN 978-0-7704-3315-4
eISBN 978-0-7704-3375-8
Printed in China

Design by Jenny Kraemer
Cover design by Jenny Kraemer
Cover photographs by Art Wolfe

10 9 8 7 6 5 4 3

Revised Edition

Acknowledgments

MH The idea for this book was conceived many years ago, while I was still picture editor at *Audubon* magazine.

To the many fine photographers I worked with over the years, I would like to express my gratitude. Theirs was a dedication born out of love and concern for their subjects, which, more often than not, meant sacrificing creature and material comforts in pursuit of their craft. Because of, or in spite of, these qualities, they came up with the outstanding images with which we could work.

In any project such as this book, certain key people play a more active role, albeit behind the scenes. To these colleagues and friends, I would like to give special thanks: to Guy Tudor, bird artist and naturalist, and to my late father, Oscar Mertz, an innovative art professor, for their careful vetting of the artistic concepts contained in the manuscript. Thanks also to Jo Gershman, Harriet Huber, and Jessica Cook, whose insights and support were much appreciated.

To my coauthor, Art Wolfe, I want to express my deep appreciation for his beautiful imagery. And to Deirdre Skillman, his right hand, my eternal gratitude for keeping us on track and on time with unflagging enthusiasm.

And finally, to my husband, Kevin Schafer, whose criticism and advice were invaluable. This book belongs, in part, to him.

—Martha Hill, 2012

AW I would like to thank my staff, without whom this book would be an impossibility: senior editor Deirdre Skillman for shepherding this project through with the help of photo assistant Amanda Harryman, workshop coordinator Libby Pfeiffer, web and tech expert Bruce Decker, personal assistant Christine Eckhoff, and field assistants past and present, John Greengo, Gavriel Jecan, and Jay Goodrich.

Special thanks go to Martha Hill for agreeing to go another round in the pursuit of superior nature photography education—her old-school work ethic and sensibilities are refreshing. My thanks also to Tim Grey for coming on board and enriching the project with his technical expertise, to editor Julie Mazur for taking on the project in the first place, and to agent Peter Beren for getting *The New Art of Photographing Nature* into the right hands.

—Art Wolfe, 2012

Contents

PREFACE 9
INTRODUCTION 10

1 Isolating the Subject 19

Using Lenses 20
Eliminating Clutter 24
Removing Distractions in Post-Processing 27

2 Composing the Picture 29

Format: Horizontal or Vertical? 30
Framing: Cropping 32
Framing: Where to Place the Subject 33
Symmetry vs. Asymmetry 35
Subject in Center 36
The Golden Mean 38
Using Live View 43

3 Defining Your Perspective 45

Scale: How Large Should the Subject Be? 48
Understanding Sensor Size and Focal Length 52
Getting Close with a Telephoto Lens 54
Getting Close with a Wide-angle Lens 57
Compressing Spatial Relationships:
 Telephoto Lenses 58
Expanding Spatial Relationships:
 Wide-angle Lenses 60
Changing Camera Angle to Improve Composition 61

4 The Power of Color 65

Choosing an In-Camera Color Space 67
Primary Colors 68
Portfolio of Complementary Colors 70
Portfolio of Related or Harmonious Colors 72
Portfolio of Pastel Colors 73
Uniformity of Color 76
The Power of No Color 78
Converting Color Images into Black and White 80

5 The Elements of Design 83

The Power of Line 84
Horizon Placement and How It Affects Depth 88
Placing the Horizon Off Center 92
No Horizon: Aerial Perspective 94
Receding Lines and Shapes 96
Using Line to Create Depth 98
Using Diagonals to Create Dynamic
 Visual Interest 100
A Portfolio of Lines 102
Patterns 104
Texture 108
Composite Panoramas 110
Making Composite Panoramas 114

6 Reading the Light 117

Quality of Light: Time of Day 118
Understanding Color Temperature 120
Direct Sun vs. Overcast Light 123
Overcast Light 125
Direction of Light 126
Frontlighting 128
Sidelighting 132
Backlighting 134
Reflected Light 136
Spotlighting 138
Low-Contrast vs. High-Contrast Lighting 140
Finding the 18 Percent Gray 140
Expose to the Right 144

7 Creative Options 147

Using Shutter Speed to Isolate the Subject 148
Shutter Speed: Still Camera with Moving Subject 150
Shutter Speed: Panning Camera with
 Moving Subject 152
Shutter Speed: Stopping the Action 154
Understanding ISO 156
Using Slow Shutter Speeds to Capture
 Unusual Events 157
Depth of Field: Stopping Down
 to Improve Composition 160
Depth of Field: Opening Up
 to Improve Composition 162
Avoiding Heat Buildup 163
Graduated Neutral Density (ND) Filters 164
High Dynamic Range (HDR) Imaging 166
Polarizing Filters 168
Using Filters in Digital Photography 171
Adding Controlled Lighting: Flash and Fill-Flash 172

8 In the Field with Art Wolfe 177

What's in My Camera Bag 178
Animals: Human Interest 179
Animals: Getting Close 182
Capturing the Decisive Moment 186
Making the Most of Atmospheric Conditions 188
Working the Image 192
Tripod or No Tripod? 196
Adding Location Information to Your Photos 197

9 An Editor's View 199

Telling a Story Visually 200
Photography's New World 206

10 Tim's Top Tips for Digital Photographers 209

Shoot RAW vs. JPEG 210
Expose to the Right 212
Use the Lowest ISO Possible 214
Work in 16-Bit Depth 216
Take Control of Your Black-and-White Images 218
Edit in a Nondestructive Way 220
Back Up, Back Up, Back Up 221

RESOURCES 222
INDEX 223

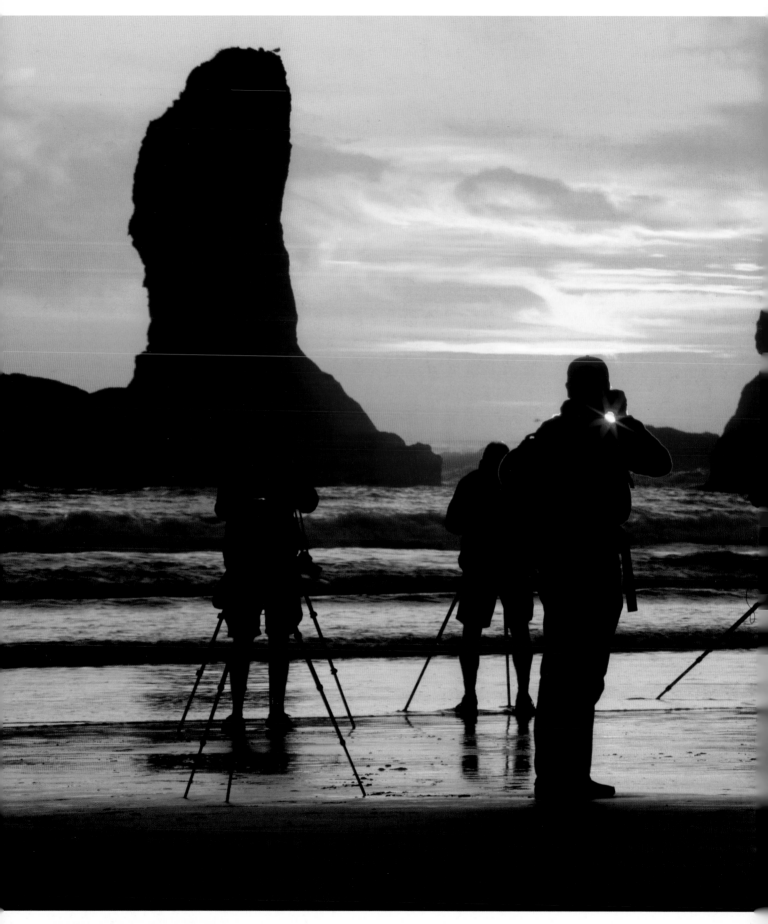

▲ SECOND BEACH, OLYMPIC NATIONAL
PARK, WASHINGTON

Preface

When we wrote the first edition of this book in 1993, digital photography was largely unknown, and yet today, some twenty years later, color film has become essentially obsolete. How quickly things can turn upside down.

The advent of digital photography has brought dramatic changes to the equipment and techniques of picture taking, including profound technical advantages that can markedly enhance creativity. Perhaps the most significant of these has been the addition of the LCD screen to digital cameras, allowing you to see the picture you've just taken. This immediate feedback allows us to see what works—and what doesn't—and to both correct mistakes and take greater risks. We can also now make enormous numbers of images without any real cost, freeing photographers to take chances, explore alternate views, and capture sequences without fear of running out of film—or breaking the bank.

In light of this industry shift, we invited a new voice to join us in this revised edition: Tim Grey, author, teacher, photographer, and expert in digital technology. Look for Tim's "Digital Workshop" sidebars throughout for a range of useful digital tips, such as enhancing your creative options and getting better control of tricky lighting conditions.

If there is a downside to the digital revolution, it may be the increased reliance on computers for processing, editing, and cataloging images. A quick trip to the photo-finishing lab has been replaced by time spent in front of the computer with a dizzying array of software options, both simple and sophisticated. This part of taking pictures now requires a new set of skills. We will not discuss these in depth, since there are many other fine books that cover these subjects in detail (see Resources, page 222).

What has remained unchanged in the last twenty years, however, is the craft of seeing itself; even with great leaps in technology, the visual process—selecting and composing an image—has remained essentially the same. Our aim for this revised edition is to embrace the new technologies simply as additional tools with which to expand every photographer's creative vision.

Introduction

If we had to summarize this book in one word, we would have to say it is about seeing. Seeing is something we all do unconsciously, like breathing. In one sense, we all see alike. We possess two eyes, retinas, rods, cones, and a visual cortex in the brain. We stand upright, within a foot or so of the same height, with our feet on the ground, looking out from this perspective at the rest of the world.

But in another sense, no two of us truly sees alike, even when we are standing side by side. We see not only through our eyes but with our minds. We interpret and select. Everything we look at is filtered through our experiences, emotional responses, our prejudices and preferences. So while we might look at the same scene, we see different pictures within that scene.

To visualize a photograph, that is, to isolate a piece of the landscape in your mind, you must focus your senses. Your mind must become the viewfinder, scanning and framing the scene, checking for elements that will make a strong composition.

Former *Life* photographer Andreas Feininger wrote, "No matter how violently photographers may disagree in regard to specific aspects of composition, they all agree on one point: A well-composed photograph is more effective and makes a stronger impression than a badly composed one . . . the purpose of composition is to heighten the effect of the picture."

Using Art's photographs, we have set up comparisons of similar photographs to show why one is a stronger composition than the other. Without being too technical, we will discuss them from two different points of view. Art, as the photographer, will explain the creative decisions he makes when taking a picture. As the former picture editor at *Audubon* magazine for thirteen years, as well as a judge, art critic, and teacher of photographic workshops, Martha will discuss the artistic merit of each picture and what it might communicate to a larger audience.

There is no "best way" to photograph a subject. We may have different opinions as to what works and why, and you may disagree with both of us. But we hope our discussions will help you evaluate your own and other people's work, then inspire you to look through your viewfinder in new ways.

The Compelling Image

In the 1980s and '90s, *Audubon* was the only publication to really showcase nature photography. Because of this, the magazine was swamped with submissions, and for thirteen years Martha looked at every one, never knowing when something new and wonderful would come along, one of the great delights of the job. Over the years, she must have scrutinized several million images, but less than one-quarter of 1 percent ever made it to publication. What do photo editors look for in a picture? Aside from the obvious technical considerations of sharpness, color saturation, and good composition, it is an additional quality of artistry—a unique point of view—that compels us to look at the image again.

The artist James McNeill Whistler once wrote: "We look at a painting to know the painter; it's his company we are after, not his skill." Photography is no different. When we look at a picture, we like to imagine ourselves in the photographer's shoes. We want to feel what he or she felt, see what he or she saw, and come away a little richer for the experience. Twenty people can look at the same landscape and create twenty different images. Some of those images will inevitably be more compelling than others. But while there is no best way to photograph a particular subject, there are definite ways to express it more artistically.

Audubon liked to run a compelling photo-story package in each issue, if there was room in the editorial well. These portfolios, along with the covers, were the most difficult items to find. We met in fall 1979, when Art brought a portfolio of his work in the Pacific Northwest and a recently published book of his photographs of Indian baskets to Martha at *Audubon.* It was the beginning of a long and fruitful working relationship.

The two of us share a background in the fine arts. Before getting into photography professionally, Art was an art teacher and painter. Martha was trained in printmaking and wrote and lectured about wildlife art. Both of us teach nature photography in workshops, and we feel that composition is the most overlooked essential in picture making.

▶ **ARCTIC TERN AND ICEBERGS, ICELAND**
500mm F4 lens, f/22
for 1/50 sec., ISO 320

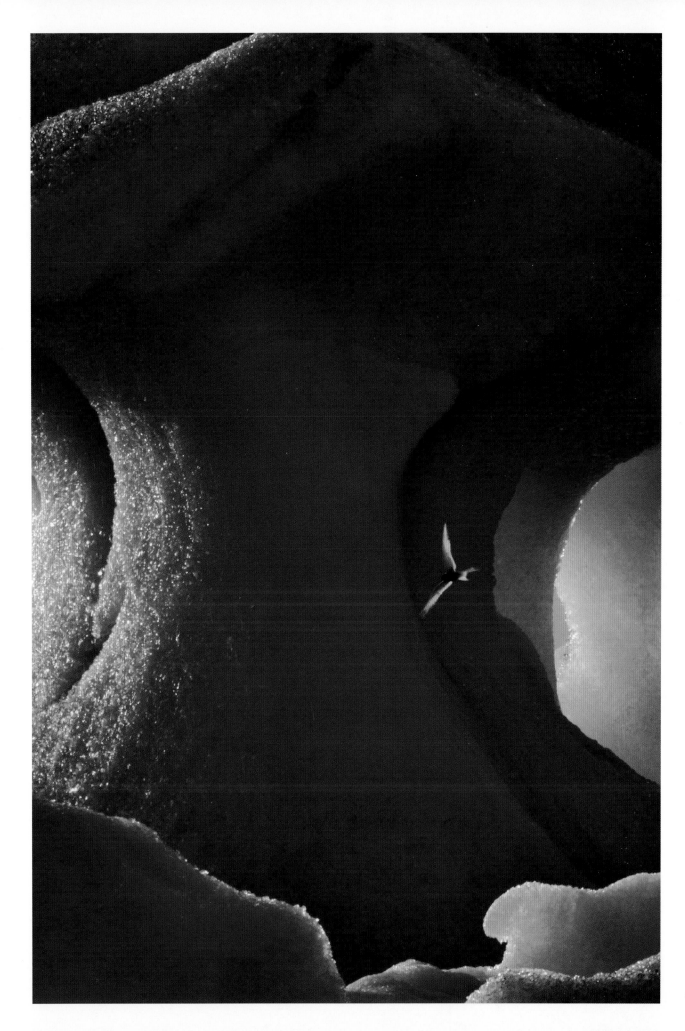

Making Order Out of Chaos

The elements that go into making a good image are basically the same for photography as for art, with one significant difference. An artist is faced with a blank piece of paper or canvas and has to construct a whole image by putting together the design elements—line, color, form, space, perspective—all of which the artist must create for him- or herself. As photographers, we are given all these same elements in our viewfinder and must subtract the material we find distracting and unessential to our vision.

Good photography is about decision-making; it is not a passive process. The eye must learn to detect what is essential and turn that into a meaningful arrangement. Initially, nature appears random and chaotic. Our mind needs to make order out of chaos, to create relationships between things in order to understand them. When we look at something, we subconsciously focus our attention on some aspects and ignore others; we filter everything through our experience and our emotions.

The camera makes no such distinctions or evaluations. It records everything it sees. It is, therefore, the photographer's responsibility to edit the camera's view and select those elements to be captured. Understanding what goes into making a strong composition can improve a photographer's personal statement. Freeman Patterson stated it beautifully when he wrote: "The camera always points both ways. In expressing the subject, you also express yourself."

In a good composition, one has the distinct impression that nothing could be added to or subtracted from the picture. This sense of completeness—of balance—is the key. Balance does not, however, imply symmetry. Asymmetrical compositions can be balanced. We will explore these concepts as we move from chapter to chapter, discussing where to place the subject, how to make it stand out, how it relates to the other elements within the frame, and what creative options you have to work with to make a stronger photographic statement. There are some guidelines that can be followed, but none of them are so absolute they should be adhered to constantly.

◀ **FROST CRYSTAL,
WASHINGTON**
55mm macro lens, f/16 for
1/4 sec., Kodachrome 64

**DEAD PINE TREE, YELLOWSTONE
NATIONAL PARK, WYOMING**

All images: 200–400mm lens (in 200mm
range), f/11 for 1/15 sec., Fujichrome 50

AW In the first image shown (top left), the
tree is silhouetted against a much lighter
pink sky. In the second (bottom left), it is
against a part of the cloud closer in value to that of
the tree, but the composition is still not quite there.
In the third (above), the cloud is now in complete
balance with the value of the dead tree, and I have
recomposed the tree to fill out all four corners of
the composition. To my eye, it is a more harmoni-
ous image.

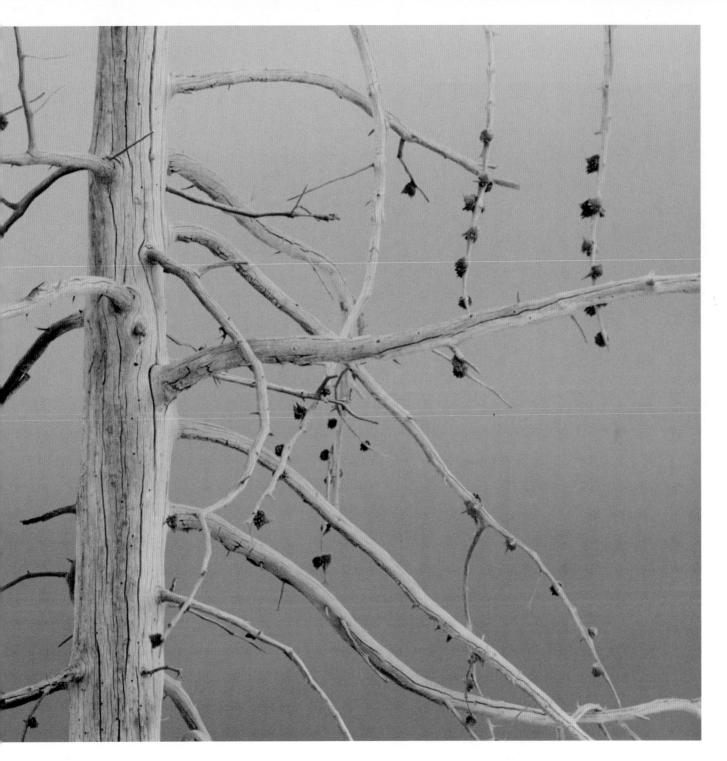

MH We are talking about very subtle distinctions here. Many people will like the first image over the third because of the luminous quality of the pink background. And it is clearly a matter of personal taste.

What makes the third photograph so appealing to me is the ethereal quality of the light. The background colors gradate very subtly from pink to lavender to blue in an even tonality, giving a sense of serene harmony and balance. The linear design of the tree branches is weighted slightly off-center, thus creating a delicate imbalance.

The spatial depth in the picture is also ethereal. As in an Asian painting, the sense of three-dimensional space is ever so subtly there, as the lighter tone of the tree brings it forward from the background. The branches reach to the edges of the frame, also bringing the tree to the frontal plane of the picture space. To me, this third version is *shibui*, which in Japanese describes something of an understated, highly refined elegance.

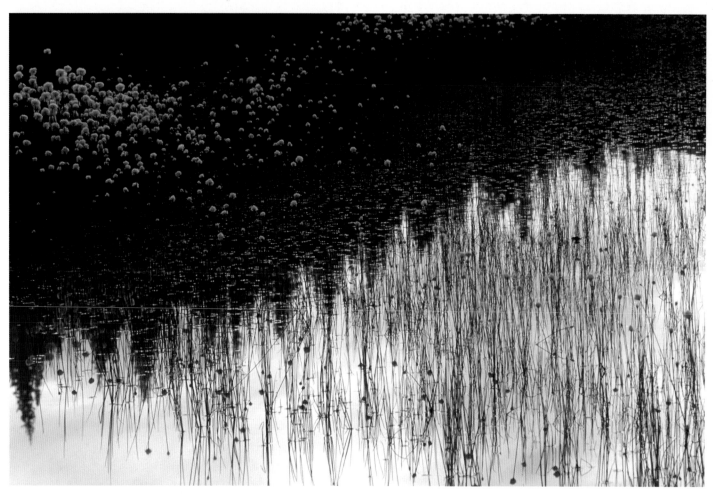

▲ **REFLECTION, COTTON GRASS AT LAKE EDGE, DENALI NATIONAL PARK, ALASKA**

80–200mm lens (in 80mm range), f/16 for 1/2 sec., Fujichrome Velvia 50

▶ **LEAPING ADÉLIE PENGUINS, ANTARCTIC PENINSULA**

300mm F2.8 lens, f/8 for 1/500 sec., Kodachrome 64

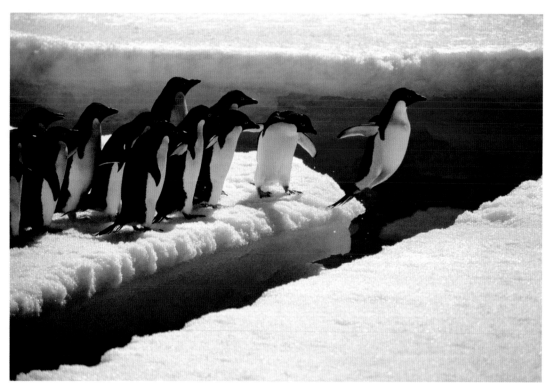

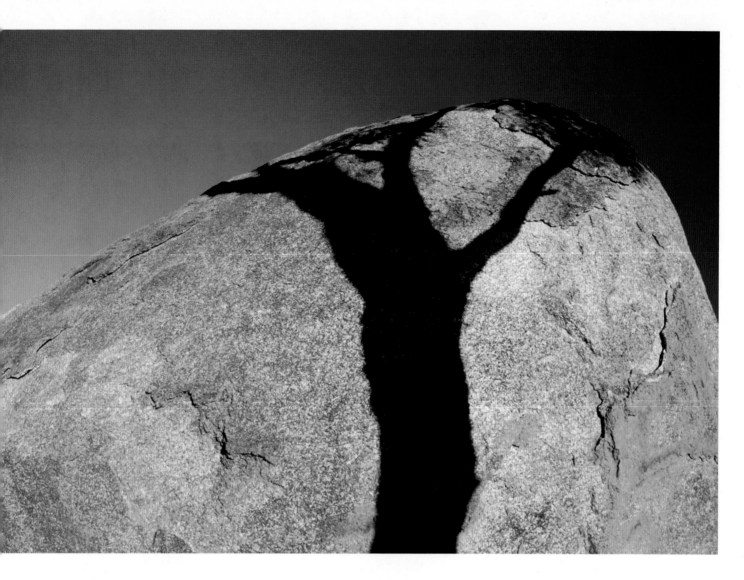

▲ SHADOW ON MONO-
LITH, DEVIL'S MARBLES,
NORTHERN TERRITORY,
AUSTRALIA
20mm lens, f/16 for 1/15
sec., Fujichrome 50

AW In this portfolio of three images, you see first the picture of cotton grass in Alaska (opposite, top). I wanted to make a complete composition that filled out the four corners of the frame. In the second image (opposite, bottom), the snow reflects lots of light, so I was able to shoot the Adélie penguins at 1/500 sec., which froze the action of the leaping bird. In the third image (above), your eye follows the tree shadow as it spreads out on the rock, again filling out the picture space within the frame.

MH What Art describes as filling out the four corners is working within the space dictated by the rectangle of the camera's viewfinder.

In the cotton grass image, the strong diagonal line of the shadow gives the picture its dynamism. Otherwise, it is quiet and subtle, a balance on the one side of soft, white puffs of grass, and on the other by the pastel cloud reflections. The interplay of light, line, texture, and color are reminiscent of an impressionist canvas. This is another image I would qualify as *shibui*.

The penguin shot is one of my favorites. It has humor, composition, a sense of place, and drama. The strong, dark diagonal takes us immediately to the most important penguin. Suspended in mid-leap, he provokes us to think not only about what he is doing but, more empathetically, about the hazards he has to face on a daily basis. The fact that he looks like a comical little man makes us chuckle, but we find ourselves hoping that he will safely reach the other side.

The last image, of the tree shadow on the boulder, is brilliant in its idea—we have the tree without having the tree. I like this visual ambiguity, where illusion and reality cross over. The shadow is a bold presence, more bold than the real tree, and looks almost like a deep crevice in the rock. Everything about this picture is bold, from its concept to its design and intense complementary colors of orange and blue.

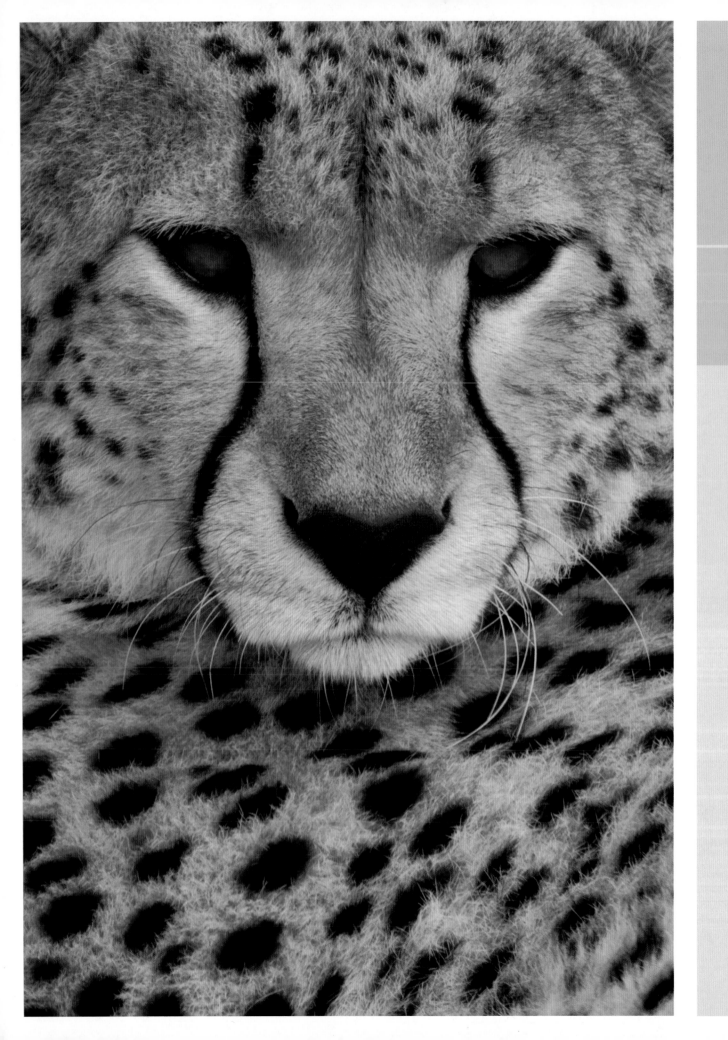

1 Isolating the Subject

◄ CHEETAH, SERENGETI
NATIONAL PARK,
TANZANIA

500mm F4 lens, f/22
for 1/50 sec., ISO 400

The first decision every photographer must make is simply what to photograph. The best place to start, of course, is finding what appeals to you. When Martha used to review portfolios, she could always tell which subjects the photographers really enjoyed shooting; it was invariably their best work.

If finding subject matter to photograph is easy, making it stand out is harder. Our first impulse, when something catches our eye, is to simply point the camera, center the subject, and shoot the picture. No surprise, then, that when we look at it later, we are all too often disappointed and wonder, "Why did I take that?"

The novelist and critic Henry James wrote, "In art, economy is always beauty." As a rule, simplicity is the clearest way to make a statement. At *Audubon* magazine, writers and photographers were told to assume that editors had the attention spans of five-year-olds. The message was to be bold and up-front with the communication. If they couldn't grab the editors' interest quickly, how could they expect to interest readers? Both visual and verbal communication had to be direct.

In his book *Principles of Composition in Photography,* Andreas Feininger describes the process of composing a picture as "isolating" the subject. The camera is completely objective and will record everything in the viewfinder. Most images that fail are disappointing because there is simply too much going on.

When Art is out in the field, looking for subjects to shoot, his eyes are like scanning radar. But once he locates something of interest, the creative questions take over: Where do I stand? How long

a focal length lens do I want? How large do I want the subject to be in the frame? Where is the light coming from? What is in the background? What is in the foreground?

In a landscape, there is often a glut of information. For that reason, artists who sketch in the field will often take a piece of cardboard with a rectangle cut from the middle. By holding it up to frame various sections in the scene, they can isolate what has potential to make a strong composition.

This can also be a valuable aid for photographers who have trouble visualizing the potential field of view of different focal length lenses. The closer you hold the hole in the board to your eye, the more it approximates the field of view of a wide-angle lens. The farther away you hold it, the more it resembles what a telephoto lens might see.

Isolating the subject is the first step in making a strong composition. This can be achieved in a number of ways—coming in close, backing up, looking down, looking up, changing the direction of the light on the subject, waiting for another time of day, blurring the action or stopping the action, using selective focus to blur unwanted elements, putting a light subject against a dark background— all of these are potential creative solutions that we will address throughout this book.

Isolating your emotional response to the subject may be more complicated and take time and practice, but it is an important step for an artist. If you can analyze why you feel drawn to make a picture, and work to express the feeling clearly, chances are someone looking at it will also respond with more than passing interest.

Using Lenses

AW One of the most important decisions that confronts a photographer in the field is how to record photographically what he or she deems an interesting subject. Often it is a matter of which lens to use or what angle will best capture the subject. As I was walking through a field of boulders high in the Canadian Rockies, I noticed the beautiful coral-like patterns of lichen on a slab of granite. I set up my 55mm macro on a tripod, several feet away, and began taking pictures. As you look at this first image (top left),

you can see how the lichen at the corner of the composition is overwhelmed by all the other lichens, as well as by the out-of-focus rock in the background. These details confuse the eye and weaken the picture.

What I liked were the strong patterns of lichen in the center, so for the second shot (below left), I moved in a little closer, to about 12 inches away. Now the lichen takes on the shape of coral and becomes more prominent in the composition. Still, I wanted to try it as a complete abstract, so in the last frame (below right), I moved in to within a couple of inches and reframed the shot to capture

LICHEN ON ROCK, JASPER NATIONAL PARK, ALBERTA, CANADA

All images: 55mm macro lens, f/16 for 1 second, Fujichrome Velvia 50

the strongest pattern. At this distance, the picture becomes not so much a literal "lichen on a rock" image as an abstract composition of rolling hills— or anything else you want it to be. The result is very two-dimensional and leaves little question as to my original intent.

MH Here, subject isolation is complete. Macro lenses open up whole new worlds and allow us to experience the familiar, and the ordinary, in an unfamiliar way. Edward Weston did this years ago in his close-up studies of vegetables in black and white. They were sensuous—reminiscent of the lines, curves, and forms of the nude human body. Likewise, Imogen Cunningham's close-up photographs of calla lilies seem extraordinarily sexual, much like Georgia O'Keeffe's flower paintings.

The macro lens involves us intimately with the subject, which has now become an abstract, freed from its former identity. Whether we see the coral shapes that Art did isn't necessary. We can free associate within our own experience.

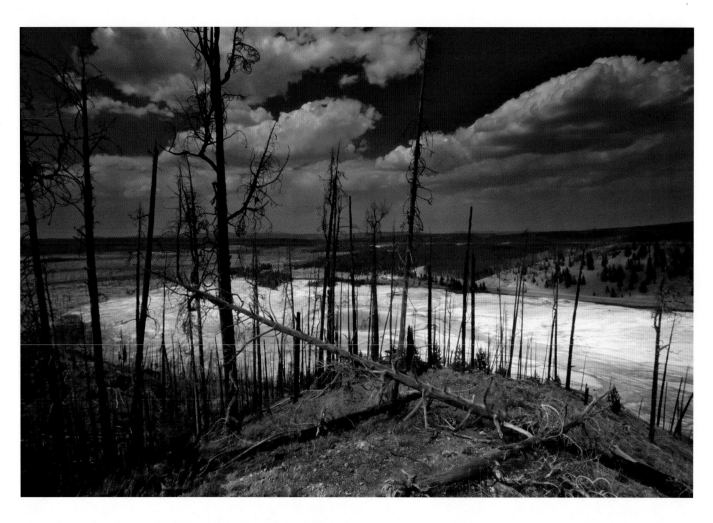

GRAND PRISMATIC SPRING, YELLOWSTONE NATIONAL PARK, WYOMING

▲ 16–35mm lens, f/16 for 1/10 sec., ISO 100

AW A common mistake many photographers make is finding a subject they really like, but then failing to spend time refining the image. Often, there is a shot within a shot within a shot—but rarely does the observer see the photographer's intent. What I have learned over the years is that if the subject is worthy of shooting, make it clear and unequivocal: *this* is the subject!

Here is a prime example. In this series of three photos, the first (above) was taken with a wide-angle and includes open sky, middle horizon, and the landscape of Yellowstone National Park, but it lacks a clear sense of what the subject is. In the second shot (opposite, top), I let go of the bright cumulus clouds, and started to zoom in. There is still a bit of clutter, including several cars, but I am on my way. This image may be fine as an editorial illustration in a guidebook, but it doesn't convey what I was trying to get out of the landscape. The last shot (opposite, bottom), however, creates a strong abstraction, combining the brilliant colors of the Grand Prismatic Spring with the weathered pines that died in the great fires of 1988.

MH This is a classic landscape dilemma most photographers face, and a perfect example of making order out of chaos. If you don't have the luxury of moving to a new vantage point from which to photograph, then you have to think of an alternate way to make the image say what you want.

In the second image, Art decided to shift to a vantage point that gave him a clearer view of the pool, the color of which dominates the otherwise monochromatic surroundings. In the final image, he has removed all distractions and emphasized the colorful spring, while still keeping a hint of the charred landscape, distilled to its most important elements. The result is a strong graphic combination of the pool in all its vibrancy, in the context of a landscape in eternal flux.

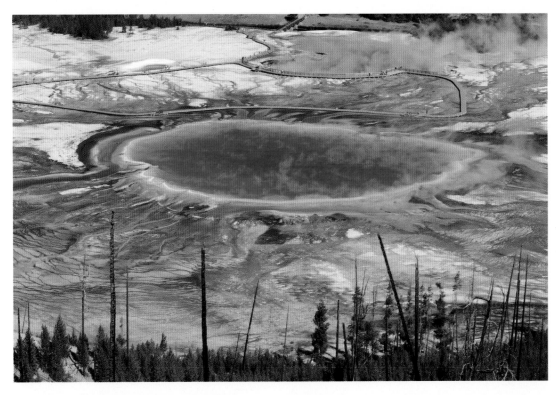

◄ 70–200mm F2.8 lens
with 1.4 teleconverter, f/13
for 1/50 sec., ISO 100

▼ 70–200mm F2.8 lens
with 1.4 teleconverter, f/22
for 1/25 sec., ISO 100

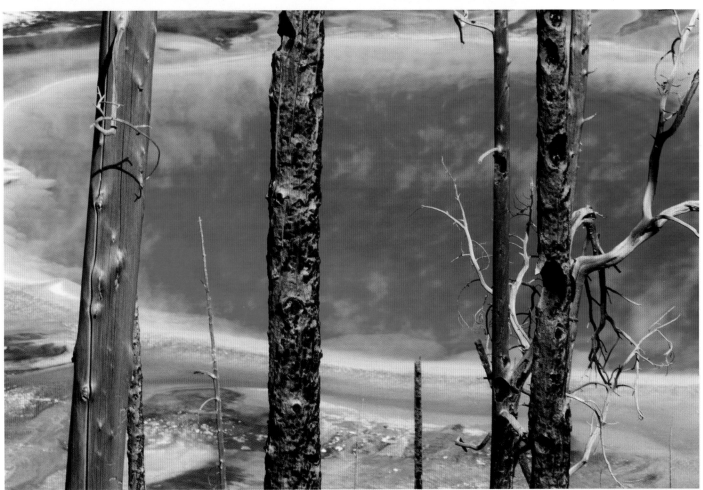

Eliminating Clutter

AW In this third set of images, I photographed maple leaves floating on a small pond on the Olympic Peninsula. In the first (below left), shot with a 50mm lens, there are a lot of elements that confuse the eye—the out-of-focus blades of grass in the foreground, the leaves below the surface, and the tangle of reeds at the top of the frame. You may look at this image and say, "What was Art trying to photograph?"

In the second frame (below right), I've changed to a 135mm lens, narrowing in on my subject matter. My interest is clearly the floating leaves, but there is still a lot of clutter here. Some leaves are out of focus, and my eye is still wandering around the picture, trying to make some kind of order.

In the final image (opposite), I've simplified it to a single leaf floating on the surface. To give it a sense of place, I've left a suggestion of the reeds in the reflection. This image has all of the same elements as the first, but the statement is clearer and stronger.

MH While I do like the composition of the second image, I would have to reject it for publication because of the shallow depth of field. If the front edge of the biggest leaf was sharp, it would be publishable. I'd also crop the light spots at the top edges.

The final version, however, is definitely the best of the three, partly because of its simplicity, but also because of the subtle play of elements within the composition. There is no question, visually, that the leaf is floating on the water. As the lightest subject in the frame, it pops against the darker background. Art has also placed it high in the picture, so it floats within the vertical space. But it is firmly held down by the strong dark space at the top. From the bottom, the soft curves of the reflected reeds seem to hold the leaf up in the frame.

The reflection of the grasses gives the image a wonderful swirling movement, without which the picture would seem static. In addition, the dark lines create a strong diagonal, which adds dynamism to the image and reinforces the illusion of motion.

MAPLE LEAVES IN POND, OLYMPIC NATIONAL FOREST, WASHINGTON
▶ 135mm F2.8 lens, f/5.6 for 1/30 sec., Kodachrome 64

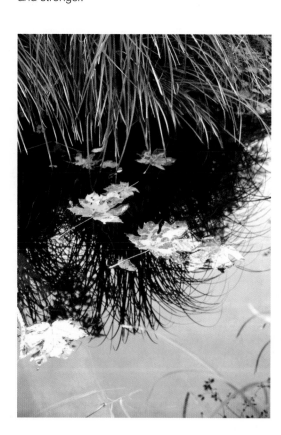

▲ 50mm lens, f/5.6 for 1/30 sec., Kodachrome 64

▲ 135mm F2.8 lens, f/5.6 for 1/30 sec., Kodachrome 64

INDIAN PAINTBRUSH,
BANFF NATIONAL PARK,
ALBERTA, CANADA
▶ 55mm macro lens, f/5.6
for 1/15 sec., Fujichrome
Velvia 50

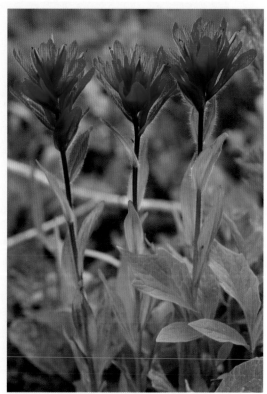

▲ 55mm macro lens, f/11 for 1/15 sec.,
Fujichrome Velvia 50

AW Often, when photographing, it is easy to be so intent on your subject that you don't even see distracting elements that weaken the composition and should be eliminated. With this comparison of two Indian paintbrush pictures from the Canadian Rockies, I was distracted from the soft greens of the plants by the hard, white line of a dead branch immediately behind them. By simply removing the dead branch and reshooting, the image was greatly improved.

MH This is a common problem many photographers have in composition: not seeing the little details in the picture that will suddenly jump out when the image changes from a three-dimensional experience to a two-dimensional frame. One little white line can divert the eye from the real subject. As we saw with the floating leaf, light elements tend to stand out, and dark elements recede. If any background element is lighter than the subject, it can fight with the eye and interfere with enjoyment of the picture.

Being aware of a picture's background is critical; I had to reject a lot of photographs at *Audubon* because of distracting elements in the foreground or background. In publishing, there are many times when a clean background is especially desirable, as when type needs to be superimposed on the image. Magazine covers almost always need some clean space of a solid tone (either pale or dark) in which to do just that.

Removing Distractions in Post-Processing

TG It is always ideal to create the best image possible at the time of capture, if only to minimize your work later. But the fact is, most of us add a small amount of refinement to even our best photos. Even when we are vigilant, there are often unwanted distractions or blemishes in the final image that we didn't notice at the time of capture.

Fortunately, there are a wide variety of tools available for cleaning up these kinds of blemishes. Among these is Adobe Photoshop, which has long been a popular program among photographers. One of the easiest tools in Photoshop is the Spot Healing Brush, which can seamlessly match any changes made to the surrounding area of an image. Even better, you can use the tool without altering your original image.

To use this tool, open your image in Photoshop. Click on the Background image layer on the Layers panel, and then click the Create New Layer button (the blank sheet of paper icon) at the bottom of the Layers panel. Give this layer a new name by double-clicking on the layer name, typing the new name, and pressing Enter/Return on the keyboard.

Choose the Spot Healing Brush tool from the toolbox, and check the settings for the tool on the Options bar below the menu. The Content-Aware option should be selected as the Type, and the Sample All Layers box should be checked so you can apply corrections based on the Background image layer onto the new layer you created. You then simply paint over any blemishes in the image and Photoshop will clean them up automatically.

Generally, the brush size for the Spot Healing Brush tool should be no larger than the blemish you're trying to remove. In some cases, you may need to use an even smaller brush, performing the cleanup in several stages. To adjust the size of the brush, use the left square bracket key ([) to reduce the size of the brush and the right square bracket key (]) to increase it.

For more complex cleanup tasks with a somewhat irregular shape, you can use the Content-Aware option in conjunction with the Fill command. This tool requires that you work on a copy of the Background image layer.

Start by dragging the thumbnail of the Background image layer to the Create New Layer button on the Layers panel. Then create a selection of the area you want to clean up using any of the selection tools. In many cases, the Lasso tool is a good choice since it allows you to create free-form selections of any shape simply by drawing directly on the image. Use the "Add to Selection" and "Subtract from Selection" buttons on the Options bar to refine your selection as needed.

Once you have a selection defined for the area you want to clean up, choose Edit > Fill from the menu to bring up the Fill dialog. In the Contents section, set the Use popup to Content-Aware, and click OK. The selected area as well as the rest of the image will be analyzed, and Photoshop will apply an intelligent cleanup of the selected area, taking into account the surrounding area and using textures from the image as needed.

These are just two examples of some of the techniques you can use to clean up blemishes and distractions in your images.

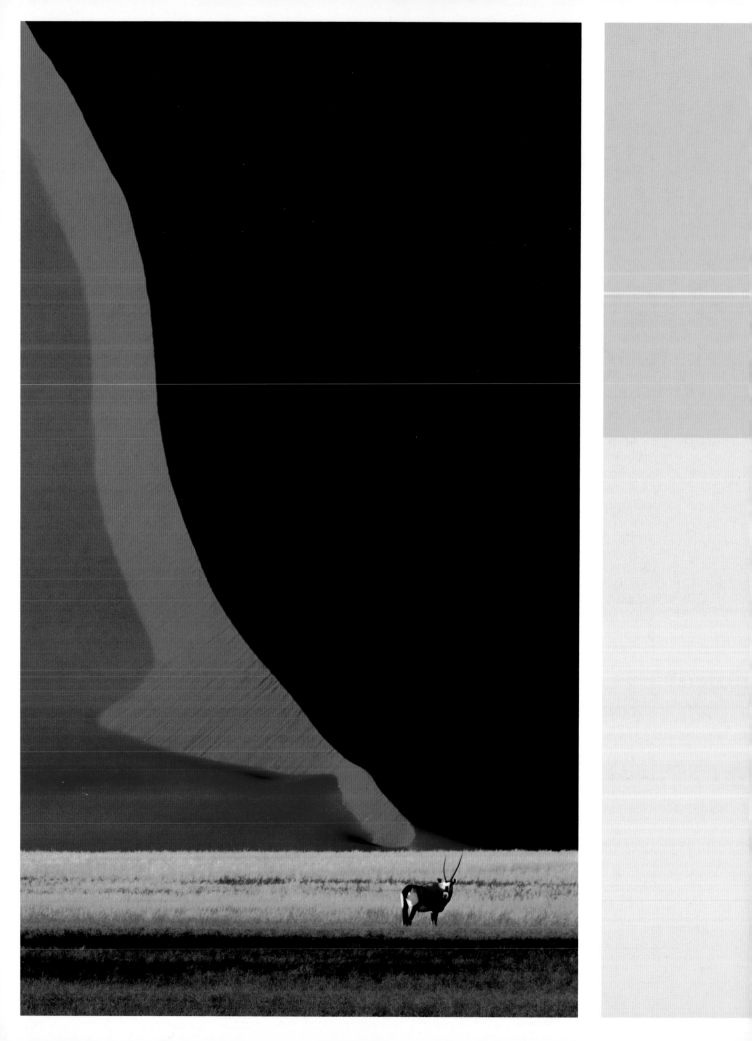

2 Composing the Picture

◄ GEMSBOK AND DUNE,
NAMIB-NAUKLUFT
NATIONAL PARK,
NAMIBIA

70–200mm F4 lens, f/14
for 1/13 sec., ISO 100

H. L. Mencken once wrote, "The true function of art is . . . to edit nature and so make it coherent and lovely. The artist is a sort of impassioned proofreader, blue-penciling the bad spelling of God." Composition is how we structure a picture to be coherent and lovely. Like the skeleton that is brought to life by the muscles and ligaments attached to it, composition is the unseen structure that gives strength to the photographic statement. If it is strong, lyrical, and clear, it has the power to move others.

What qualities distinguish a well-composed image from one that is not? First, there must be a center of interest. This doesn't mean, however, that the subject should necessarily be in the center of the photograph. A poorly composed image usually allows the eye to wander out of the picture space or seems out of balance in some way. Perhaps the subject is too small to make us feel its importance, or it may be too large in relation to other elements in the frame.

In his book on composition for painters, David Friend writes: "A good deal of the magic that transforms a painting into a work of art lies in successful unification. Pulling together the parts or elements of a painting is the crucial and most baffling problem to beginners. Perhaps the term 'integration' describes it better—integration of all the component parts of a picture into a series of rhythmic relationships to form an artistic whole." For photographers, the problem is a little different. You are searching for the right combination of elements in the viewfinder. But the integration of the separate pieces into a lyrical whole is the same goal.

Where to place the subject will be our first consideration. Then we will tackle the subject's relationship to other elements within the picture space. Bear in mind that subject placement has ramifications for the ultimate use of the picture, too.

If you are thinking about publishing, or submitting your images to a stock or microstock agency, chances are your pictures may end up with type superimposed on them or cropped to fit a square space. Generally, it is wise to have a little leeway in composing and not crop the picture too tightly. Art directors often need to crop images to fit their grid, so having both vertical and horizontal formats can be very helpful. *Audubon*'s cover format was unusual—a horizontal wraparound. Photographers always had to be reminded to place the subject off-center, so it would not be cut in half by the spine.

Format: Horizontal or Vertical?

AW There are situations in which horizontal and vertical formats are equally valuable. When I first started shooting, I shot only horizontals and effectively lost many sales as a result. Now I try to shoot both when possible. Each one is valid, but says different things. The first comparison is of poplar trees in the Hunza Valley of Pakistan. The second is a prairie falcon on a cliff.

MH In the first pair, the vertical image clearly emphasizes the tall, slender quality of the trees, whereas the horizontal gives more sense of place, of light and shadow, with the animal becoming more prominent, too. In the prairie falcon comparison, both are strong images. I prefer the vertical because it tells me something about how falcons live. One nearly always finds them perched atop high rocky cliffs where they command a good view, since height is crucial to their hunting strategy.

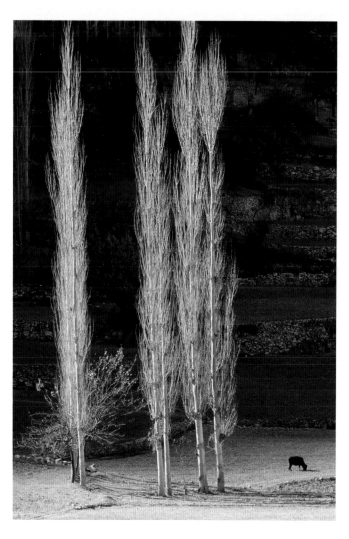
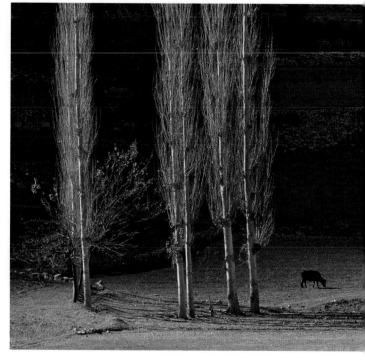

COW WITH POPLAR TREES, HUNZA VALLEY, PAKISTAN
Both images: 200–400mm lens (in 400mm range), f/11 for 1/15 sec., Fujichrome Velvia 50

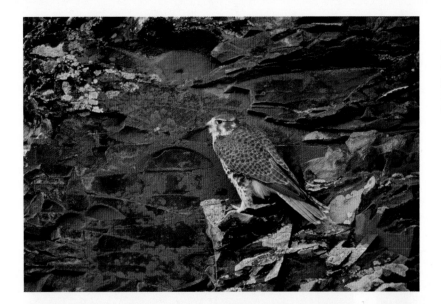

PRAIRIE FALCON,
COLUMBIA PLATEAU,
WASHINGTON

Both images: 800mm F5.6
lens, f/11 for 1/15 sec.,
Fujichrome Velvia 50

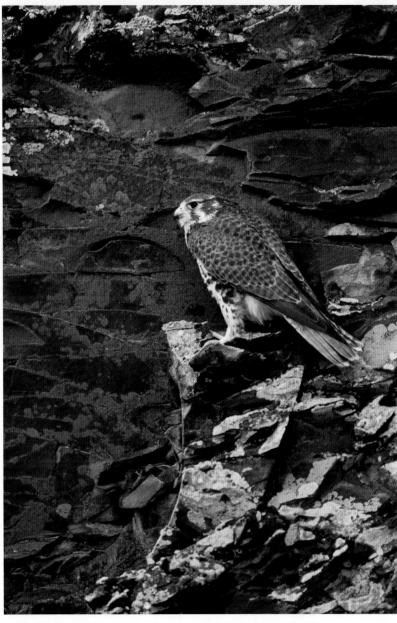

Framing: Cropping

AW Where you crop the image in the viewfinder can make a significant difference in how the subject looks. In the picture on the left, I have created an unpleasant effect with this tight crop because the head of the deer almost looks like a stuffed wall mount. Lowering the camera slightly, as I have with the image on the right, adds a little more depth to the body and solves the problem.

MH Looking through the viewfinder is like taking a rectangular slice out of life. By selecting certain subjects to lie within the frame, you make a statement about them and create a balance of elements. If those elements come in contact with the frame, or are intersected by it, you need to evaluate what this does to the overall balance. Sometimes, as in the small deer portrait, the cropping creates a strong sense of imbalance that is corrected, in the larger, by a slight change of proportions.

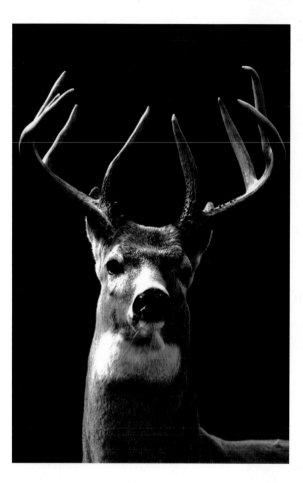

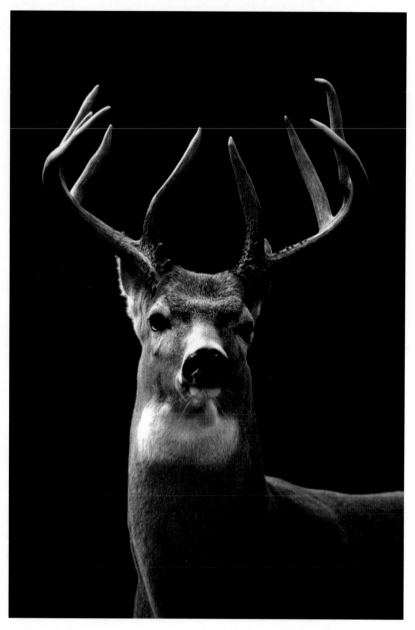

WHITETAIL BUCK, COLUMBIA RIVER VALLEY, WASHINGTON
Both images: 300mm F2.8 lens, f/8 for 1/60 sec., Kodachrome 64

Framing: Where to Place the Subject

AW A common mistake is photographing an animal looking out the side of the frame. What I liked in this scene was the heron against the mangroves. I took it at the J. N. "Ding" Darling National Wildlife Refuge in Florida. But I prefer the balance of the righthand image with the bird looking into the center of the picture. To my eye, in the first image, the bird feels crowded up against the left edge of the picture.

MH Nature photographers need to constantly think about not only how an animal relates to its habitat, but how the subject relates to the frame. Clearly, the bird in the first photo seems out of balance and its bill too close to the edge. The balance is much better in the second, and the vertical format gives a more balanced feeling of space and height, accentuating the fact that herons are tall birds.

Whenever a subject is looking out of the frame, there is an implied line of sight. Our eye naturally wants to look in the same direction. If this carries you out of the picture space too emphatically, then you are in danger of losing your viewer's interest.

Many people feel a subject should be looking directly at the viewer. But in the image here, we become more interested in what is going on precisely because the subject is looking away from us. We are curious about what has caught the heron's attention and thus more engaged in his world.

Subjects have a visual weight, which means they have a certain importance or position within the frame. When the subject seems out of balance within the frame—too high, too low, or too close to the edge—we find the effect unsettling.

GREAT BLUE HERON, "DING" DARLING NATIONAL WILDLIFE REFUGE, FLORIDA
Both images: 200–400mm lens (in 400mm range), f/11 for 1/8 sec., Fujichrome Velvia 50

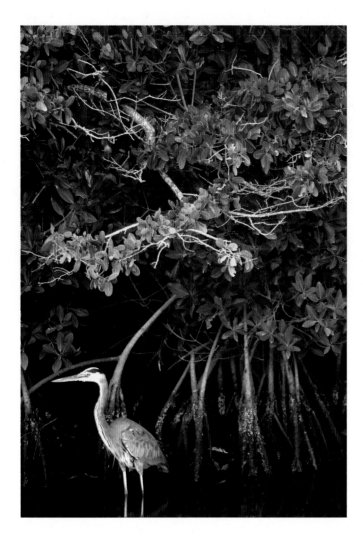

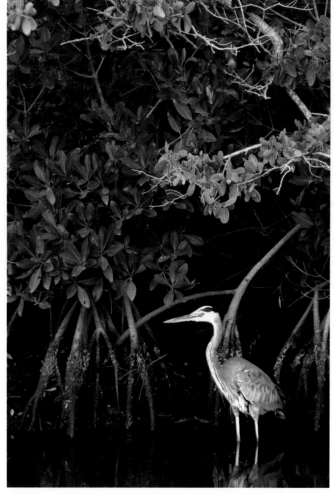

AW In the picture of the Dall ram, the white animal stands out dramatically against the dark fall colors, so your eye goes first to him, then follows the angle of his body into the rest of the compositional space.

MH Because it looks more like a painting than a photograph, I find the sheep picture very satisfying. The landscape is a rich tapestry of fall colors, and the sheep seems completely natural and unaware of the photographer's presence. He stands out against the darker mountainside, and the steep angle of the slope tells us a lot about his environment. With the sheep angled away from us, we find ourselves drawn into his world, and deeper into the picture space, into the valley beyond.

In fact, if Art had sent this to me when I was still at *Audubon* magazine, I would have pulled it for a fall cover. The off-center placement of the sheep would have been perfect for our horizontal wraparound format.

▼ DALL RAM, DENALI NATIONAL PARK, ALASKA

135mm F2.8 lens, f/11 for 1/30 sec., Fujichrome 100

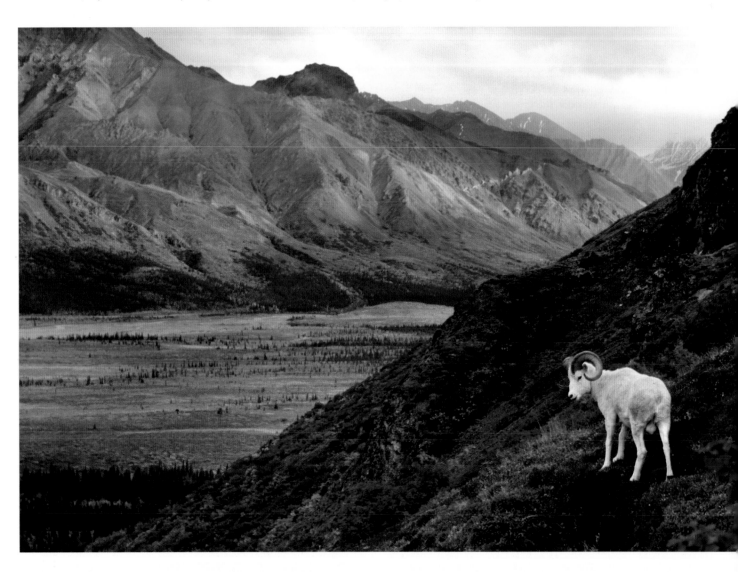

Symmetry vs. Asymmetry

In the tradition of Western art, composition was dominated by symmetry up until the Renaissance. The subject was generally in the center, as in paintings of Christ or the Virgin Mary. If there were other figures in the painting, the composition remained symmetrical as they extended outward, or downward, from a central figure. Today, painters predominantly use asymmetrical composition. This allows greater flexibility in giving a subject visual weight or emphasis.

Rudolf Arnheim, an expert on psychology in art, devoted a book to the subject of centers as the most powerful focal point in the composition. Circles, in particular, because of their perfectly round shape, have tremendous visual energy. Their power is contained within their circumference. Unless they are carefully balanced with the other design elements in the picture frame, the eye will always go first to the circle.

Symmetry is a form of centeredness, based on a central line. It implies a balance between the two spaces on either side of the line, an equilibrium called stasis, which gives us the word *static*. Symmetrical compositions emanate tranquility and stability. This may be the desired effect.

If, however, you desire a more dynamic statement, asymmetrical composition is the answer. It immediately shifts the emphasis, giving more visual weight to one area over the other. This off-balance positioning creates tensions confined within the picture frame. Tension—being visually tugged in a certain direction—can be disturbing, if it is not somehow counterbalanced to keep the eye and the mind focused on the action inside the picture space.

In this image of the sun and evergreen, the sun is the first thing to attract our eye. But it is balanced by the strong pyramid shape of the tree. Neither one overpowers the other. And yet the image is far from static. Our eye travels back and forth from the sun to the tree, enjoying the comparison of dark and light, of shapes and elegant simplicity.

Asymmetry requires that a balance be restored. We seem to have an innate desire for stability. Because of our experience of gravity, we look at the world with a subconscious assumption that everything falls to the ground. Things that are lower in the frame appear naturally weighted toward the earth. Large areas with solidity placed too high in the picture look out of balance, either

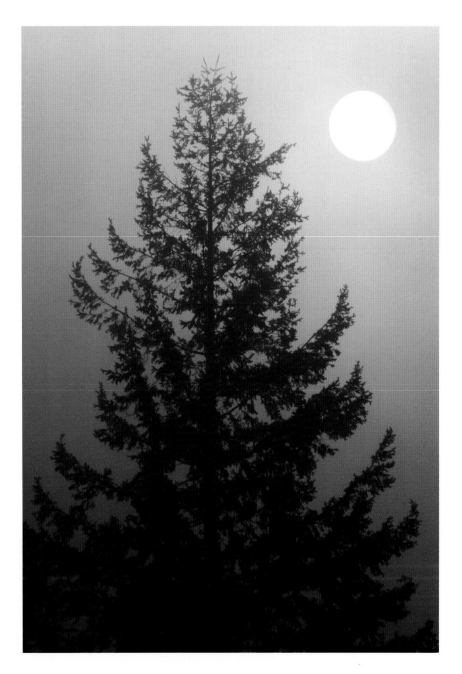

too heavy or as if they are taking off out of the top of the picture.

However, as we saw in the picture of the single leaf floating high in the frame (page 25), the balance was restored by two things—the grass shadows that curved upward in the lower portion and the large dark space at the top. These reweighted the visual elements so that they worked in a new harmony.

There are still times when putting the subject in the center makes a more powerful statement. Like the bull's-eye of a target, a subject in the middle of the frame keeps one's gaze on the center. As long as that is the most interesting part of the picture, it is entirely appropriate.

▲ DOUGLAS FIR
AND SUN IN MIST,
OLYMPIC PENINSULA,
WASHINGTON
300mm F2.8 lens, f/11 for
1/60 sec., Kodachrome 64

Subject in Center

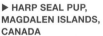

AW In this series of diverse subjects, I chose to put the subject in the middle to balance the photo. In the harp seal image, shown below, the mother looms protectively above and behind her pup. I thought there was a beautiful relationship between the two, and I therefore chose to photograph it in a very clean and balanced way.

I used the same central placement for the elephant's eye (opposite, top), with the textured folds of skin surrounding it. If I had shot this off-center, I would have gotten some background, perhaps, or more of the head and trunk of the elephant. My intention was to make the connection between this great animal and the viewer as immediate as possible.

The third image of a nest with hungry hatchlings (opposite, bottom), is a study of circles and lines. The round begging mouths, the round grass nest, and the straight lines of the dried grass at the edges of the frame dictated a centered composition.

MH The image of the harp seal is an example of central placement of a subject with dynamic tension to boot. Not only is the pup in the lower center of the picture, giving weight to the frame, but the mother is also centered and higher, though smaller, as she is at a distance. So we have central placement, but also a tension created by the mother's placement above, which makes the eye move around and take in the surroundings. So many of the harp seal pups are photographed alone, and usually very close up. This is possible to do, since the mothers go off to feed and leave the youngsters on the ice floes. It is a refreshing change to have both mom and pup in the same frame, with a sense of mother-pup bond as she looks over in a watchful way.

In the second image, there is really no other place to put the eye other than in the center. We are drawn into the elephant's eye as if by gravity. And since we can hardly unlock ourselves from its curious stare, we are reminded of the great intelligence behind it. The marvelous wrinkles provide not only an artistic surrounding of texture, but an immediate clue as to whose eye this is.

The nest image is a good example of how, when there is not another element to balance an off-center subject, placing it in the middle is logical. If the parent bird had been perched on the edge of the nest, then a different placement might have made sense. But here, the bull's-eye placement is perfect. This image is riveting and makes me feel as if I am the parent returning with food, so eagerly are these open mouths clamoring for nourishment. The message is about hunger and the demands of babies for constant feeding.

▶ **HARP SEAL PUP, MAGDALEN ISLANDS, CANADA**

17–40mm lens, f/16 for 1/30 sec., Fujichrome Velvia 50

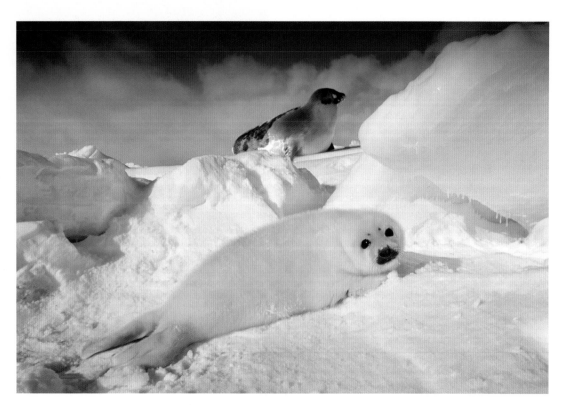

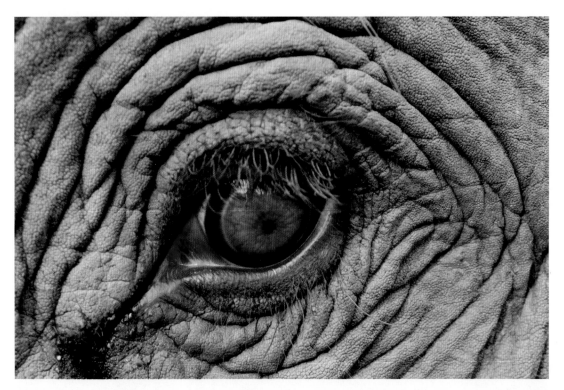

◄ ASIAN ELEPHANT, BANDHAVGARH NATIONAL PARK, INDIA
24–70mm lens, f/7.1 for 1/125 sec., ISO 400

▼ HATCHLINGS IN NEST, MONGOLIA
24–70mm F2.8 lens, f/4.5 for 1/100 sec., ISO 400

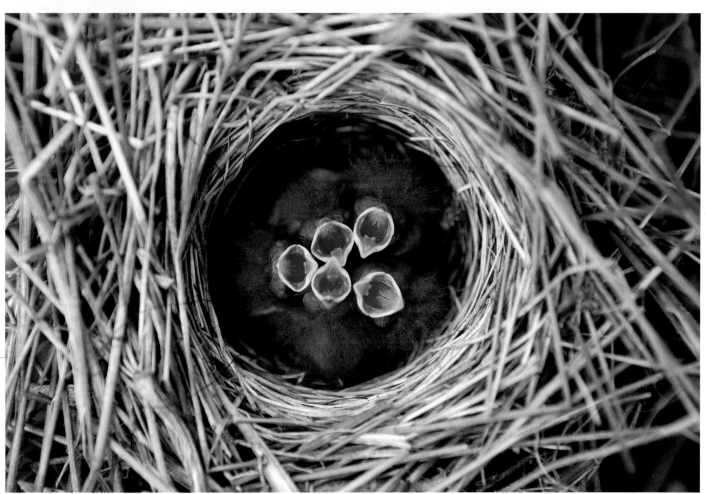

The Golden Mean

Art composes many of his images instinctively close to the ideal ratio the Greeks called *the golden mean.* It was considered the perfect spatial proportion for sculpture and architecture and works out mathematically close to a ratio of 8:5. For us, using 35mm format (24x36mm), it means a grid such as we have illustrated below. Accordingly, the focal point of the image should fall wherever these lines intersect.

Other books on photographic composition talk of the "rule of thirds." While the proportions here are not quite the same, the idea is similar. The intersections of the grid lines, in either case, represent powerful, alternative centers of interest.

Whether or not you subscribe to either of these formulas, they do create the possibility for an asymmetrical composition of appealing proportions and are fun to use in analyzing your own and other people's work. Try cropping your images and playing with the spatial relationship of subject to background and frame to get a sense of what proportions are most pleasing to your eye.

Rules, as we know, are made to be broken. Asymmetry, though, opens up more possibilities for composition than symmetry. Symmetry represents a formal, stable, static organization. Not having the visual weight in the middle opens the door for creating tensions and relationships between the pictorial elements, achieving a new balance and a more exciting dynamic composition.

▼ THE GOLDEN MEAN PROPORTIONS FOR 35MM FORMAT
Your center of interest should lie on one of the grid's intersections.

© Martha Hill

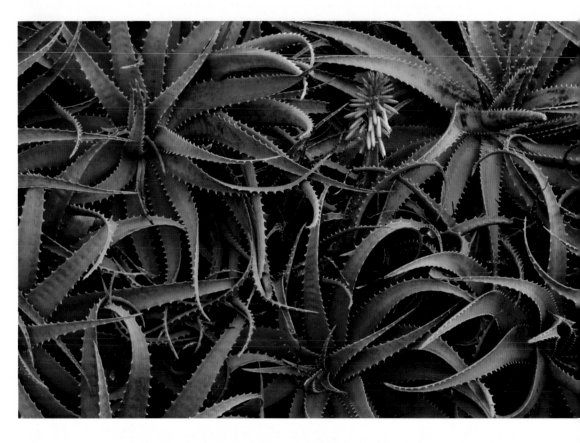

▶ ALOE PLANTS, HAWAII
55mm macro lens, f/16 for 1/8 sec., Fujichrome Velvia 50

AW In the first image of aloes (above), I was particularly struck by this pink flower spiking from the greenish-blue hues of leaves. A slightly off-center composition draws the eye through the image, allowing for more appreciation of the dense color and texture of the plants.

The second image (opposite) shows a great horned owl. Like other owls, it does not build its own nest but moves into the abandoned nests of other species. This one has taken up residence in a black hawk's nest; the visual weight of the owl and the nest provides a good balance to the thick arms of the saguaro branching off to the right.

In the third image (pages 40-41), an adult King penguin is wandering through a labyrinth of fuzzy chicks. If I had put the adult right in the middle, the viewer's eye would have been drawn straight to it and stopped, destroying any dynamism within the photograph. With the adult off to one side, your eye moves back and forth for context.

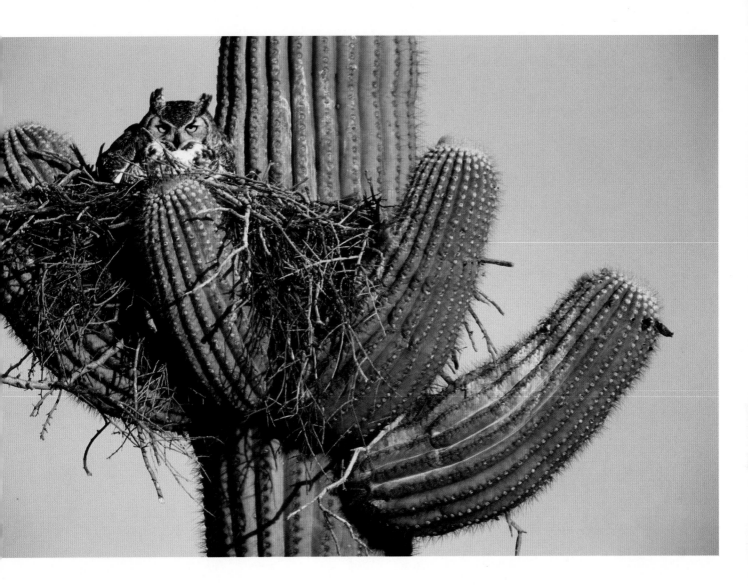

▲ GREAT HORNED OWL, SAGUARO NATIONAL PARK, ARIZONA
600mm lens, f/11 for 1/30 sec., Fujichrome Velvia 50

In the final image (page 42), I am again intentionally placing the subject, in this case a red-billed oxpecker, out of the center; the red eye of the bird is very eye-catching, as are the graphic white lines of the giraffe's reticulated coat.

MH The first image is not only satisfyingly off-center, but lovely in its soft color complements as well. The singularity of the flower spike draws attention to itself, and yet is not so strong as to take our focus away from the wonderful pattern of the curving spiky leaf forms surrounding it.

Off-center placement makes the second image an out-of-the-ordinary view, balancing the owl's nest on the left with the descending arms of the saguaro. There is just enough information here to give us the environment, without a lot of extraneous detail.

In the third image (pages 40–41), the off-center placement is paramount to its drama. One lone adult King penguin, amid the closely packed crèche of chicks, is asking us to think about what we are seeing. Is this adult having difficulty locating its chick amid the throng? What if the situation were the opposite—one chick among a field of adults? Would we be wondering the same thing? I doubt it. But it is a subtle reminder that these pudgy brown sacks of down will become adults just as elegant as the one lone representative. This would have been a perfect wraparound cover for the magazine.

For the fourth image (page 42), Art has used an off-center placement to bring attention to the subject, which might have otherwise been overpowered by the strong pattern of the giraffe's hide. The colorful bird draws our eye immediately. Had it been placed in the middle, we might have looked once and not twice. In this case, we are happy to look again, pulled in by the off-center tension.

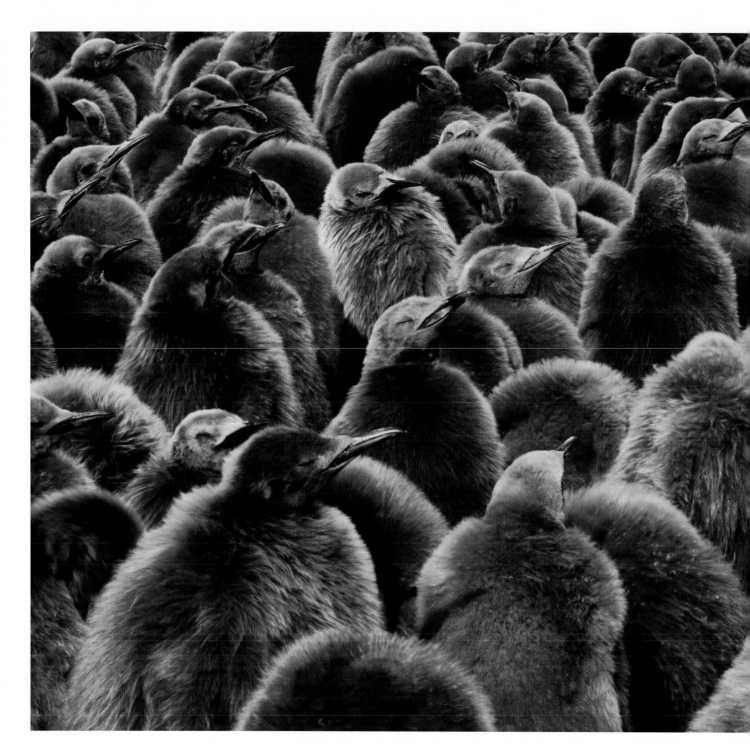

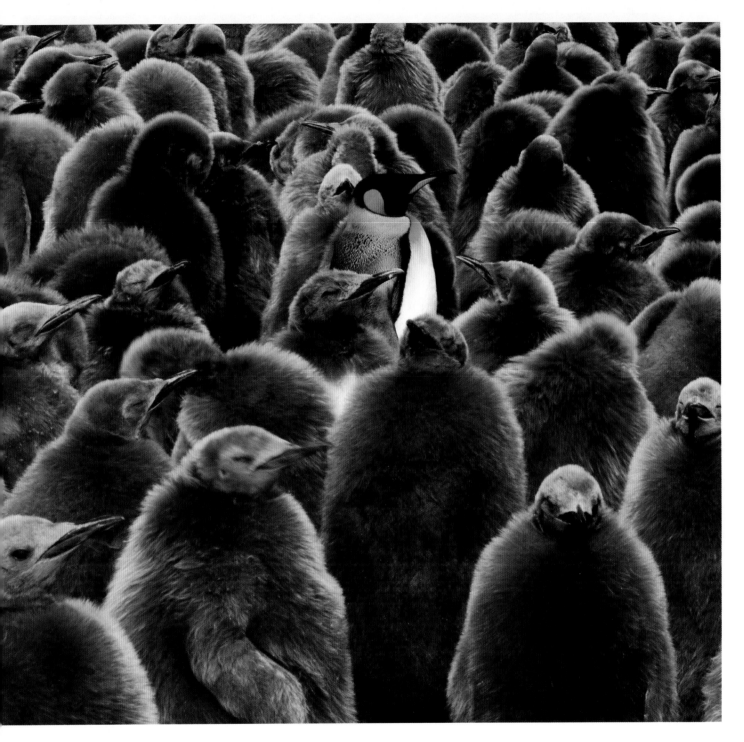

▲ **KING PENGUIN AND CHICKS,
SOUTH GEORGIA ISLAND**

70–200mm lens with 1.4 teleconverter,
f/32 for 1/15 sec., ISO 100

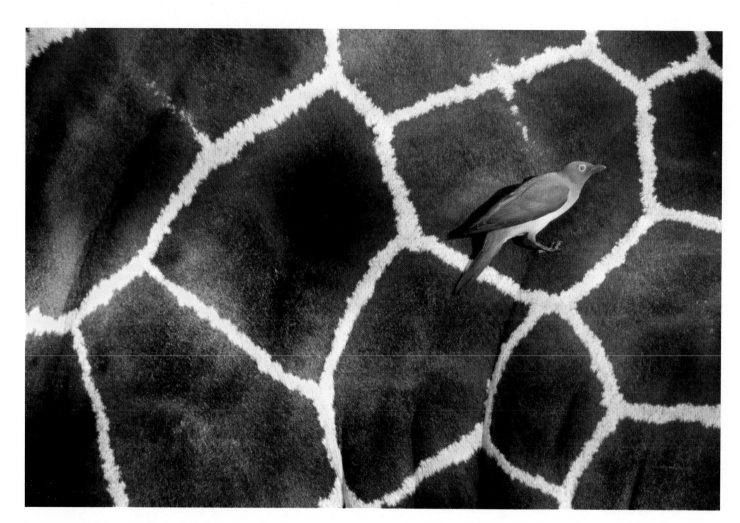

▲ OXPECKER ON GIRAFFE, SAMBURU
NATIONAL PARK, KENYA

600mm lens with 1.4 teleconverter, f/8 for
1/125 sec., Fujichrome Velvia 50

DIGITAL WORKSHOP
Using Live View

TG Photographers have long recognized the benefit of having an LCD display on the back of their camera. The display can be helpful for evaluating exposure, confirming focus, deciding what shutter speed will yield the best effect, and other purposes. Above all, it provides us with instant feedback.

Many recent DSLRs include the relatively new ability to see a live view on the back of the camera, effectively replacing the viewfinder. This feature was commonplace on point-and-shoot digital cameras, but is relatively new to DSLRs, since the mirror and shutter would normally obstruct this view.

A live view display can be very helpful when approaching a subject while simultaneously trying to consider overall framing and composition. Looking through the viewfinder is sometimes impractical, and even dangerous, since you are not able to maintain as much awareness of your surroundings. By using the live view display, however, you can easily keep an eye on the world around you as well as on your subject and the display on the LCD, hopefully leading to better (and safer) images.

Get acquainted with the live view display on your camera before you actually need it. Take time to review the manual and learn how to activate not only the live view display but the various options as well. For example, with many DSLRs you can display a histogram along with the live image, for a better sense of your exposure settings.

Keep in mind, however, that with a DSLR, you won't be able to see through the viewfinder when you are using the live view display because the mirror is locked up in order for the image circle to reach the sensor and be displayed on the LCD. The exception to this is a handful of DSLRs that feature a fixed pellicle mirror, enabling you to use both viewfinder and LCD display at the same time.

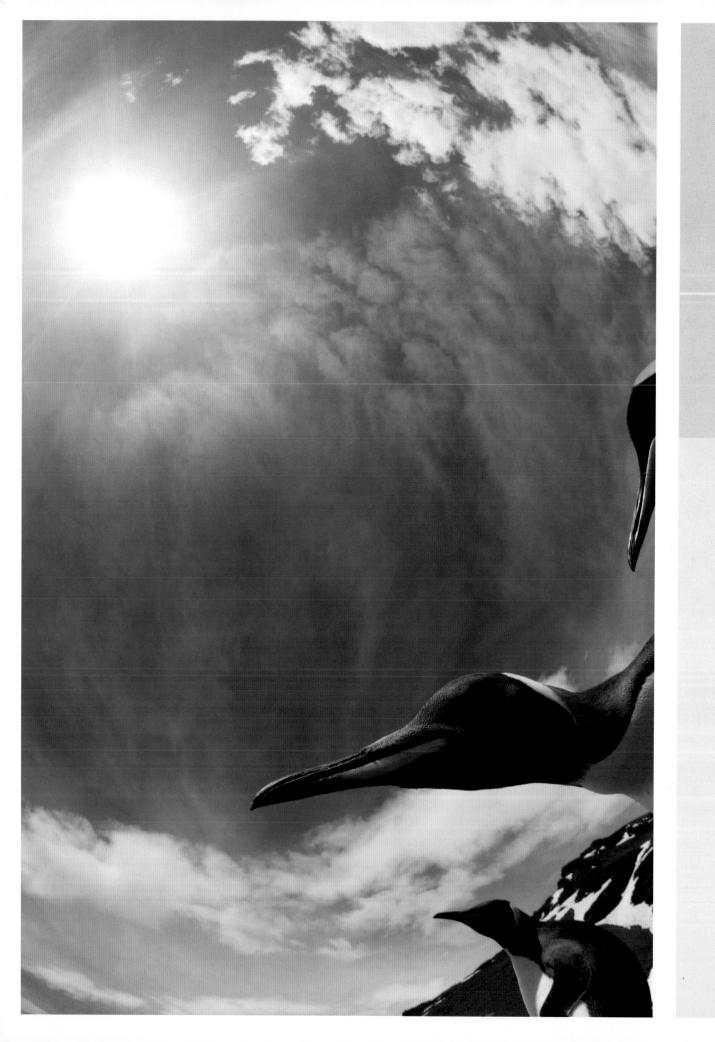

3 Defining Your Perspective

◀ **KING PENGUINS, SOUTH GEORGIA ISLAND**

15mm F2.8 fisheye lens, f/16 for 1/1000 sec., ISO 800

As a photographer, you have your own particular voice, your own statement that is unique to you. Developing this distinction involves your choice of lens, where you stand in relation to the subject, how different lenses alter spatial relationships within the frame, and your angle of view.

Defining your perspective as a photographer implies making an evaluation of the size of the subject in the frame, and its relation to the other pictorial elements. You have two choices for altering size: you can move closer or farther away to make the subject appear larger or smaller in the frame, or you can change lenses.

Now it becomes important to understand the relationship of your lens' focal length to the magnification of your image. Remember that we are talking about the standard 35mm format used in both film and digital SLR (DSLR) cameras; with this format, a 50mm lens comes closest to having a magnification power of one. This lens is often described as "normal," because it supposedly comes closest to the perspective we see with the naked eye.

Doubling that focal length to 100mm doubles the size of the subject in the frame. Taking this step further, a 500mm lens would render a subject ten times larger than the 50mm lens, equivalent to a ten-power binocular. (Note that with smaller digital sensors, the apparent focal length of your lenses may be magnified, transforming a normal lens into a mild telephoto.) The series of images shown on page 46 illustrates how much enlargement is needed for an almost frame-filling portrait of a small subject. Art remained thirty feet from the owl for each of these images, but increased his focal length from a 50mm lens to an 800mm, making the bird appear sixteen times larger in the final image.

Changing to a longer focal length is not the same as moving closer to the subject, as we will see in the second series of comparisons, shown on page 47. Each power of lens magnification cuts your distance to the subject in half. But the spatial relationships are not the same when you move closer. Shooting with a telephoto from a great distance, with a narrow field of view, gives you a much more intimate portrait than if you get up close to your subject with a wide-angle lens. It also tends to reduce distortion, capturing the subject's physical proportions more accurately.

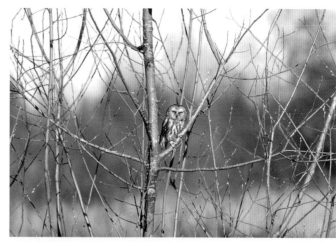

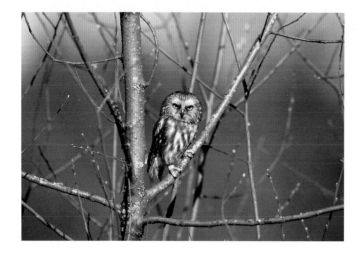

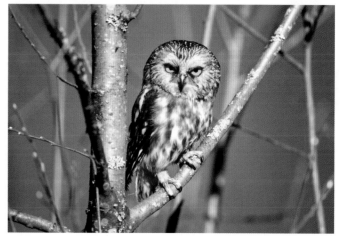

**SAW-WHET OWL,
WASHINGTON**

Top: 50mm lens, f/8 for
1/30 sec., Fujichrome
Velvia 50

Center left: 80–200mm
lens (in 80mm range), f/8
for 1/30 sec., Fujichrome
Velvia 50

Center right: 80–200mm
lens (in 200mm range), f/8
for 1/30 sec., Fujichrome
Velvia 50

Bottom left: 200–400mm
lens (in 400 mm range), f/8
for 1/30 sec., Fujichrome
Velvia 50

Bottom right: 800mm
F5.6 lens, f/8 for 1/30
sec., Fujichrome Velvia 50

Lenses have other features that alter normal seeing. This comparison of images of the same owl taken with lenses of different focal lengths shows how each has a different impact on the space around the bird. The owl stays approximately the same size in the frame. Art backed away as he changed lenses from the 20mm wide-angle to the 50mm, and then to the 200mm. While none of these images is a perfect composition, they are included to show how the relationship of subject to surroundings changes from the expanded space of the 20mm to the spatial compression of the 200mm.

Telephoto lenses not only bring the subject in close with magnification, they also create a false perspective of compressed distance between objects on different planes. A telephoto shot of trees would show them looking more compactly stacked together than they would be in reality.

Wide-angle lenses do just the opposite. They expand the distance between objects on different planes. This can be very helpful when photographing a subject in a tight place. A wide-angle, with its great depth of field (the zone of what will be in focus), allows you to come close to the subject and still keep everything distant in sharp focus. But it pushes those other elements farther away and makes them smaller in relation to the subject.

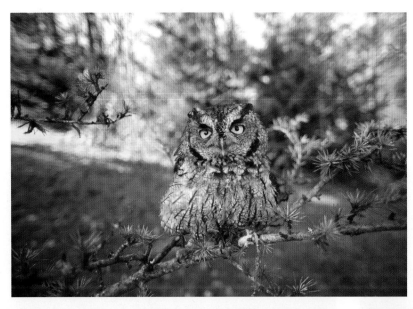

SCREECH OWL, WASHINGTON
◄ 20mm lens, f/4 for 1/60 sec., Fujichrome Velvia 50

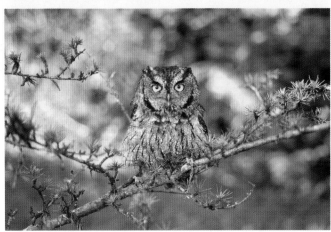

▲ 50mm lens, f/4 for 1/60 sec., Fujichrome Velvia 50

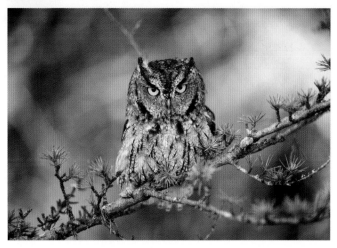

▲ 80–200mm lens (in 200mm range), f/4 for 1/60 sec., Fujichrome Velvia 50

Scale: How Large Should the Subject Be?

AW In these three shots of a spotted owl, we see how the owl changes in importance according to its relative size in the frame. In my opinion, no image is stronger than the other; they simply say different things. The first composition (below left) is a shot of old-growth forest that happens to include an owl as an element (80mm lens). In the second (below right), the owl is clearly more evident, and still enough forest shows to create a strong sense of place (200mm lens). But in the third (opposite), I've eliminated most of the forest and the owl is clearly the dominant element. It is a more rewarding view of the owl, and of the textures of the trees, which you can now fully appreciate. The sense of forest is definitely gone (400mm lens).

MH In each of these images, the owl relates to his surroundings in a different way. In the first, he is hardly visible, blending in beautifully with his surroundings. It is interesting that here, the light-colored branch, rather than being a detracting element, actually leads our eye right to the owl. The forest, with its strong vertical lines, is clearly the dominant element in the frame. If I had a story to illustrate that emphasized the need to save lots of habitat to provide for one owl, I would use this version.

In the second frame, there is much more of a balance between the bird and the forest. The owl stands on its own, without being overpowered by the trees. This would be a classic opening shot for a story on spotted owls and old-growth forests.

In the last image, you have a portrait of the bird. Now, too, the lighter limbs of the trees actually take over as the strong linear elements in the composition. The owl's soft shape stands out against the harder lines of the tree trunks, without losing the feeling of camouflage we had in the first version. Unless I had text I wanted to drop out of the space on the left, I'd crop this to a vertical to emphasize the owl even more.

SPOTTED OWL, CASCADE RANGE, WASHINGTON

▲ 80–200mm lens (in 80mm range), f/4 for 1/8 sec., Fujichrome Velvia 50

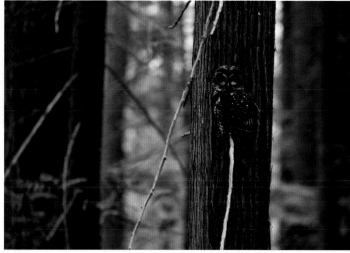

▲ 80–200mm lens (in 200mm range), f/4 for 1/8 sec., Fujichrome Velvia 50

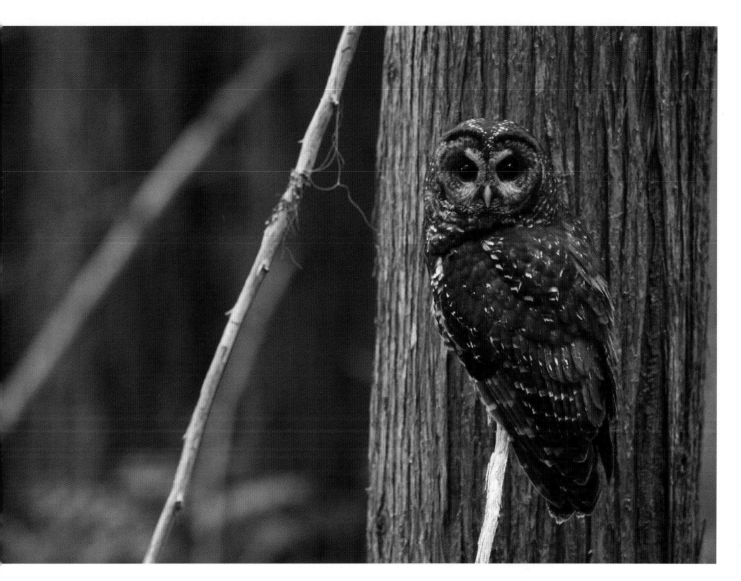

▲ 200–400mm lens (in 400mm range), f/4 for 1/8 sec., Fujichrome Velvia 50

AW To communicate the vastness of the Patagonian plain, I used an extreme wide-angle and a two-stop neutral density filter to darken the sky. This allows the texture of the clouds and the sweep of the open landscape to be the main objective. With a wide-angle, I was able to include these beautiful, curious New World camels to complete the story.

In the second shot (opposite), I framed a distant island off the Washington coast between bold columns of rock. The island communicates a sense of place and scale to the viewers so that they intuitively know what they are looking at.

MH We used to receive photos at the magazine with a dime or ruler or even the tip of a person's finger to give a sense of scale. This is an academic approach, used by scientists, but hardly aesthetic, especially where nature is concerned. The secret is to find something whose size most people will easily recognize.

In the shot of the guanacos, the animals provide the proper scale to the landscape. By choosing a wide-angle lens, Art included more of the environment in the frame, emphasizing its importance, while the choice of a low camera angle draws attention to the dramatic clouds and sky.

▶ **GUANACOS, PATAGONIA, CHILE**
17–40mm lens, f/10 for 1/125 sec., ISO 100

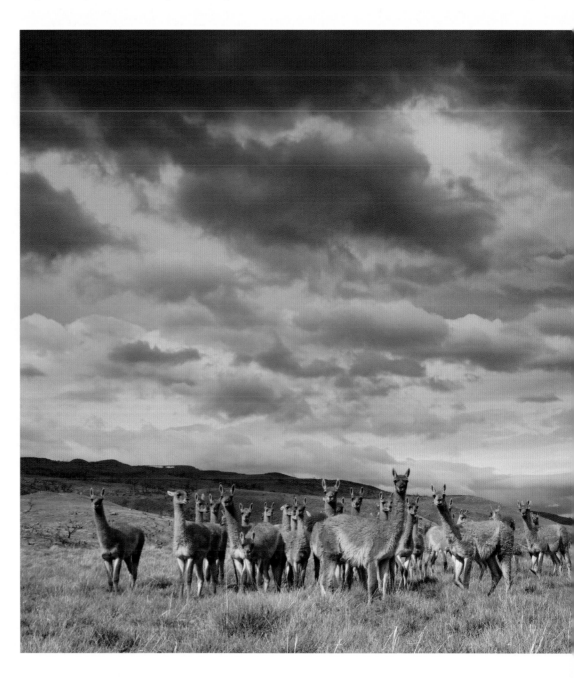

I love the bold, graphic composition of the sea stack image and the use of the framing to create emphasis. We don't need to know how large the rock columns are, nor the size of the island. It is their juxtaposition that gives us what we feel—a sense of drama and distance. What ends up being most important is the contrast of angular verticals with the delicate, graceful shape of the island.

▼ SEA STACK, CAPE FLATTERY, WASHINGTON
70–200mm lens, f/14 for 1/30 sec., Fujichrome Velvia 50

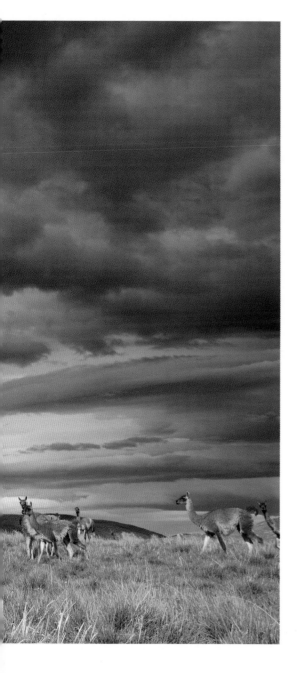

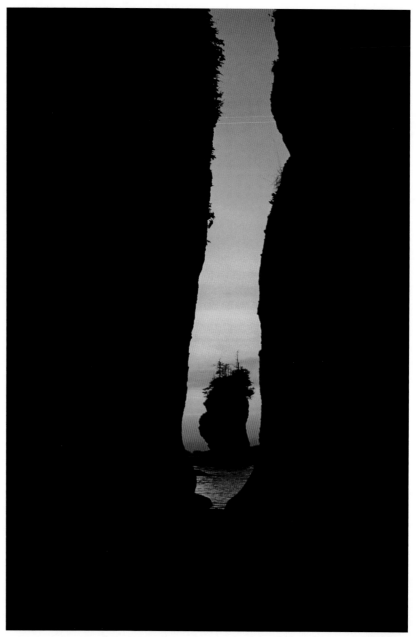

Understanding Sensor Size and Focal Length

TG Some higher end DSLRs feature what is called a "full-frame" image sensor, which roughly matches the dimensions of a single frame of 35mm film. This means that the lens behaves exactly as on a 35mm film camera.

There are also smaller sensor sizes available, where a smaller portion of the image projected by the lens is captured. The result is a narrower field of view, effectively cropping the image to achieve what would otherwise have required a longer lens. This cropping factor is sometimes described as a "focal length multiplier." This is a little misleading; it's not a true increase of the lens focal length, but rather a cropping of the image, resulting in an apparent magnification. For example, some sensors produce a field of view equivalent to a lens with a focal length 50 percent longer. This is often described as having a 1.5X cropping factor. So a photograph taken with a 100mm lens would produce an image with the same field of view as a full-frame sensor with a 150mm lens.

Many photographers view this cropping factor as an advantage because it makes their telephoto lenses "more powerful." However, there can be disadvantages as well, especially with shorter focal length lenses. With the same 1.5X cropping factor image sensor, a lens with a rather wide view at 17mm suddenly behaves as a not-so-wide 25.5mm focal length.

To address these limitations, new lenses are being offered that offer a wider field of view, but they generally also project a smaller image circle. Therefore, these specialty lenses can't be used with full-frame image sensors. For example, Canon offers a 10–22mm lens, which sounds like a remarkably wide-angle option. However, it is a lens designed for smaller-sensor DSLRs. Paired with the Canon EOS 7D, which has a cropping factor of 1.6X, this 10–22mm lens actually behaves like a 16–35mm lens would on a full-frame DSLR.

Compact digital cameras, meanwhile, often feature extremely small image sensors, where the cropping factor is quite extreme. Here, a camera may be described as having an "effective" 35–140mm focal length lens, even though the actual lens focal length is only 5.8–23.2mm.

The most important thing when it comes to lens focal length, of course, is to achieve the desired field of view in the final photograph. By understanding the relationship between lens focal length and image sensor size, you'll have a better sense of what to expect when you pair a given lens with a particular camera.

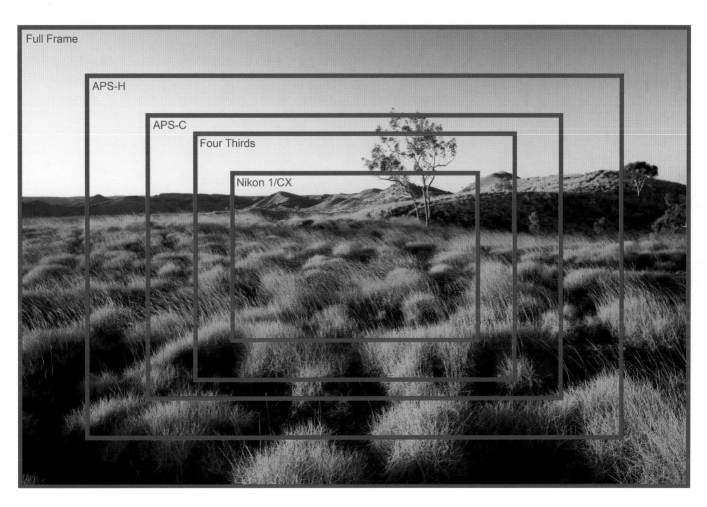

Full Frame

APS-H

APS-C

Four Thirds

Nikon 1/CX

▲ A comparison of various sensor sizes.

Getting Close with a Telephoto Lens

AW As we've said before, the cleaner and simpler the composition, the stronger the image. Telephoto lenses are good tools to achieve this, often reducing the number of distracting elements in the frame. With wildlife, this is especially important; this shot of the Rufous hummingbird is an example. While walking in one of the last old-growth stands in Seattle, I spotted this female incubating her eggs in a nest built in a sword fern. Using a telephoto, I was able to capture the detail and moment without disturbing her.

I also used a telephoto for the shot of an over-wintering swan on the shores of Lake Kussharo in Japan (opposite). The simple composition illustrates the grace of these powerful—and powerfully noisy—swans.

MH Long telephotos can bring the animal into close enough contact to see tiny details and feel a sense of intimacy. By adding working distance between the photographer and the subject, they make it easier to capture more natural behavior. When the animal's zone of comfort is not breached, it is not thrown into a flight or fight response.

This is a subtle but beautiful portrait of a female hummer on her delicately constructed nest. And it is something Art found nearby, without traveling to an exotic destination.

The photograph of the swan is an elegant portrait, isolating just a small part of a very large bird. The long lens allowed Art to capture the brilliant yellow on the swan's bill and reveal just a hint of its long, graceful neck. Here the telephoto allows us into this bird's private world, as it carefully preens its snow-white feathers, yet without any sense of disturbance.

▼ **RUFOUS HUM-MINGBIRD, SCHMITZ PARK PRESERVE, WASHINGTON**

70–200mm F4 lens with 1.4 teleconverter, f/10 for 1/6 sec., ISO 640

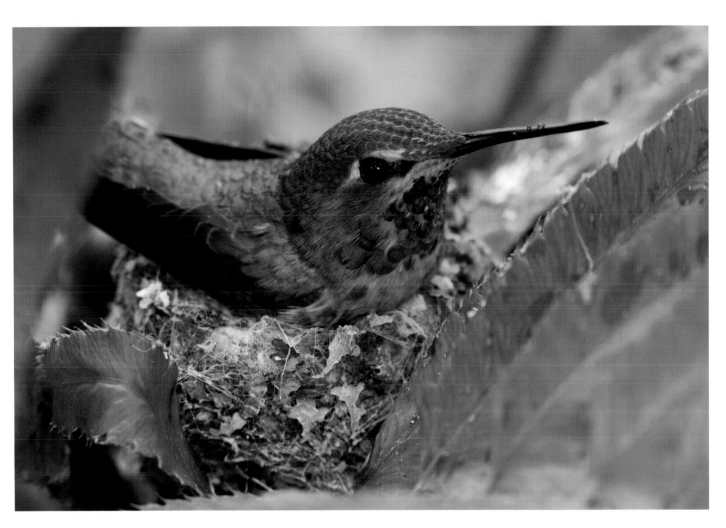

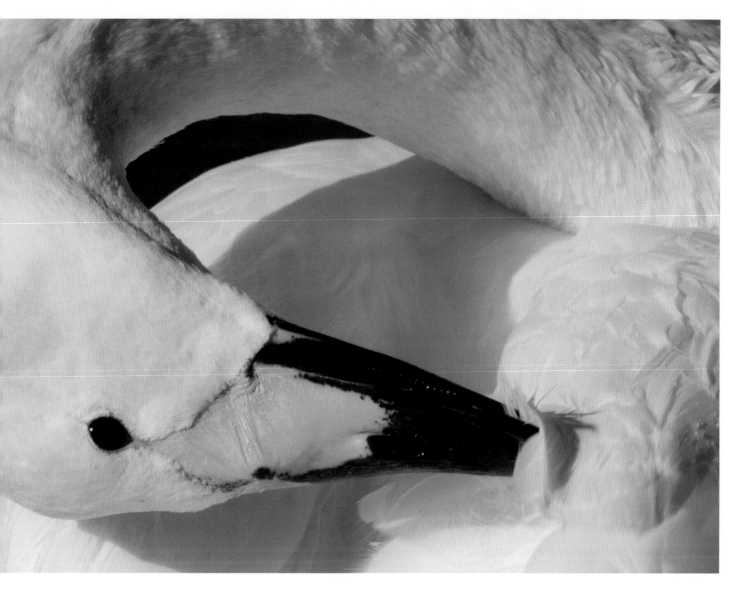

▲ WHOOPER SWAN, HOKKAIDO, JAPAN
400mm F4 lens, f/25 for 1/200 sec.,
ISO 400

▲ **ELEPHANT SEAL PUP, SOUTH GEORGIA ISLAND**

24–70mm lens, f/14 for 1/30 sec., ISO 400

Getting Close with a Wide-angle Lens

AW Often students in my classes will bring work that shows an interesting subject, but without enough information to tell a complete story. I find that one effective tool for storytelling is using a wide-angle lens close to my subject, so that some of the background is included, creating a valuable sense of place.

I find elephant seal weaners, fattened up and then abandoned by their mothers, to be wonderfully cooperative photographic subjects. With this weaner, I laid flat on the ground to photograph it on its level.

The hot-spring–addicted macaques in the Japanese Alps are another fun subject. When their own hot springs were invaded by the furry monkeys, the human residents built a monkeys-only spring. This youngster hung around the side of the pool, making a perfect subject for a wide-angle shot, which allows me to add important background and context.

MH Wide-angle lenses expand the space in a picture, exaggerating the distance between foreground elements and background. When you need to show both subject and environment within one frame, a wide-angle is often the solution.

Looking at us with its liquid black eyes, the seal pup seems to be hoping we are his mother coming to feed him. Weaned at three weeks, he seems a bit lost, even indignant, that the tap has suddenly been turned off. With the spectacular landscape of South Georgia in the background, this image creates a sense of loneliness, seeing this solitary pup by himself in this grand wilderness.

In the second image, the Japanese macaques are so human-like that it's a little freaky. The young monkey in the image seems curious, even mischievous, while his peers ignore his proximity to the camera and wallow in the thermal heat. I love seeing an animal in its environment, especially one as unique as this. It enlarges our understanding of how they live and sometimes gives us clues as to what motivates their behavior. Here, the slight distortion of the wide-angle lens enhances the drama of the scene.

◀ JAPANESE MACAQUE, HONSHU, JAPAN
16–35mm F2.8 lens, f/16 for 1/100 sec., ISO 400

Compressing Spatial Relationships: Telephoto Lenses

AW As I was driving down the Flathead Valley in the Montana Rockies, I noticed this homestead set against the distant mountains. The first shot (below left) was taken with a 50mm lens and most closely resembles what I saw from the car as I drove by. I recognized the possibilities, but this clearly was not it. It incorporated too much sky, too much foreground, and the dark furrow of earth leads your eye away from what was most important to me in the composition.

In the second shot (below right), I zoomed in with a 300mm lens, creating a telescopic effect, which brought the mountains closer in relation to the farm. I knew this was what I wanted—the farm with the looming backdrop of mountains. I placed the farm in the bottom and cropped so only mountains were above it, creating a sense of dramatic vertical rise. For the last shot (opposite), I used a 400mm with a 1.4 teleconverter resulting in 560mm focal length, bringing me even closer. By making the image a vertical I was able to emphasize the rise of the mountains, and using a polarizing filter allowed me to create a little more drama. For my money, this is the strongest image in the series.

MH Here again is a good example of what the camera can do that the eye cannot. The only way we could approximate this image would be to hike a long way to get very close to the farm. But even then you would not have the same perspective, with the farm and the mountains so strongly juxtaposed. This sense of drama is created by the compression of distance only achieved by using a powerful telephoto lens.

FLATHEAD VALLEY, MONTANA

▶ 200–400mm lens with 1.4 teleconverter (400 x 1.4 = 560mm actual focal length), f/16 for 1/15 sec., Fujichrome 100

▲ 50mm lens, f/16 for 1/15 sec., Fujichrome 100

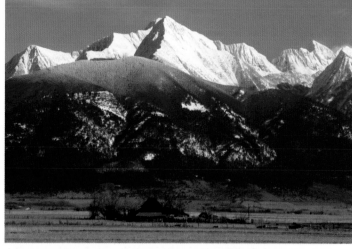

▲ 200–400mm lens (in 300mm range), f/16 for 1/15 sec., Fujichrome 100

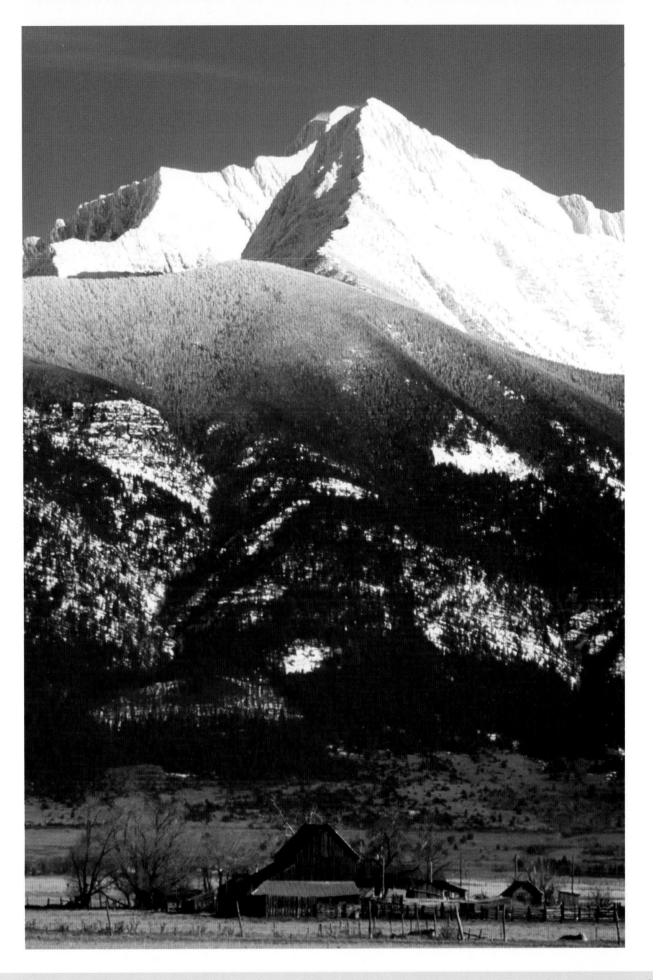

Expanding Spatial Relationships: Wide-angle Lenses

AW In the field, there are times when a standard lens is inadequate to capture a subject as you would like to portray it. Often I will use a wide-angle to create more interesting angles and more dynamic compositions. To photograph the beautifully carved stones that mark ancient graves in north-central Mongolia, I first used my workhorse 70–200mm lens at a 70mm focal length (right). While you get a sense of place with the stone in the foreground and the yurt and steppe in the background, the image lacked drama. In the second photo (below), I switched to a 16–35mm lens. Using the 16mm focal length I was able to show the fantastical deer carved onto the stone more fully.

MH These two pictures show how the wide-angle can improve the statement of a subject by changing the relationship of elements in the picture. The more normal perspective shows the stone with the yurt in the background, and I actually like the addition of the tent. It introduces a present-day human aspect to the ancient rock art. But in the second image, we have the stone up close, and the context of surroundings more subordinate, making the stone the most important focus, for reasons of its distinctly unusual design and antiquity. There is nothing to distract us from the carvings, and yet we have a sense of endless time since the background space seems more expanded than normal.

**DEER STONE,
MONGOLIA**

▼ 16–35mm lens F2.8 lens, f/14 for 1/60 sec., ISO 100

▶ 70–200mm F4 lens, f/32 for 1/15 sec., ISO 100

Changing Camera Angle to Improve Composition

AW In this comparison, you can see how simply moving the camera can enhance your composition. The first shot of a columbine (below left) was taken with a bright sky behind it. As we already noted, light areas attract your eye, while dark areas recede. With this pale flower virtually silhouetted against a much brighter sky, the subtleties of delicate yellow pastels are lost; the backdrop completely overwhelms the subject. By simply moving the camera up about eight inches, I've eliminated the bright background and allowed the soft colors to stand out and dominate the frame (below right).

MH I have seen many pictures over the years ruined by the presence of a light, featureless sky. Whether it is a solid blue expanse or pale gray, it can overwhelm whatever else is in the frame. Often, just a slight shift in position, as in the example shown here, is enough to solve the problem. The delicate pastel colors of the flower are lost against the light sky. Set off against a darker background, however, the colors, and the form, appear stronger. Wildflower photography requires great patience and care, and more often than not, simpler is better. Typically, the delicate colors and shapes of wildflowers are shown to best advantage against clean, dark backgrounds and under diffused, overcast lighting conditions.

▼ COLUMBINE, BANFF NATIONAL PARK, ALBERTA
Both images: 55mm macro lens, f/5.6 for 1/125 sec., Fujichrome Velvia 50

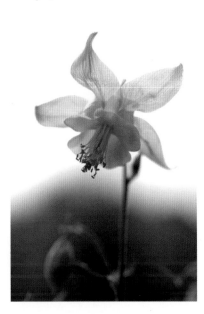

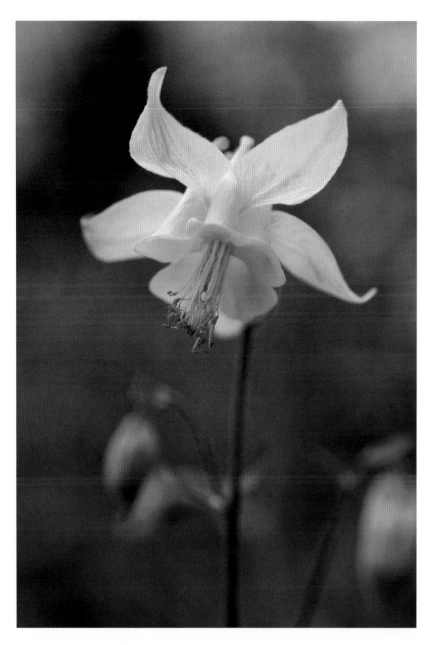

AW In the next two sets of pictures, I used a wide-angle lens throughout, but capturing the dynamism of the subject matter took some effort. With the granite boulders in Yosemite, I moved from my first location trying to find a stronger composition. In the first frame (top), the trees and rocks seem to sit there without creating much eye movement through the scene. In the second picture (bottom), however, I've moved in much closer, creating more tension between the rock and the tree for a more dynamic arrangement.

MH Here I disagree with Art, not about composition, but about content. The second image of the pine does have diagonal lines that lead the eye to the tree, and compositionally, it is beautifully balanced and organized. But it has a real feeling of solidity that the first image doesn't and which I happen to like.

In the first image, the horizon is low and right in front of us, giving us a sense of being near the edge of a precipice. Precipice is what this image is about. The boulders seem momentarily perched on the crest. The trees have been lucky to find a foothold. The second image has gained visual interest, but for me, it has lost some emotional impact.

JEFFREY PINE, OLMSTED POINT, YOSEMITE NATIONAL PARK, CALIFORNIA

Both images: 20mm lens, f/16 for 1/15 sec., Fujichrome 50

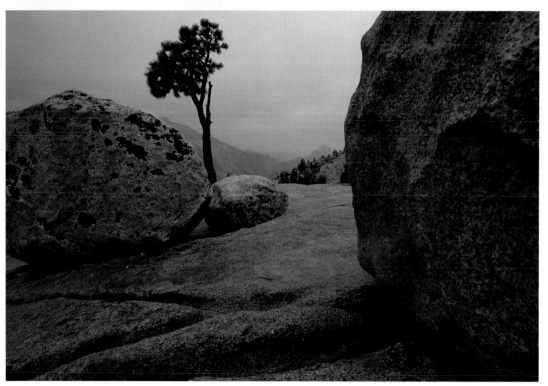

AW In the first shot of Portage Lake in Alaska (below left), I liked the composition, but thought the dark rocks in the foreground were a little out of balance, making the bottom too dark and the top too light. By getting lower and slightly changing the camera angle, I recomposed to incorporate the pink cloud's reflection in the bottom and to evenly distribute the light elements in the picture space (below right).

MH Both images are definitely publishable, but I also prefer the composition of the second one, partly for the reasons Art stated, but also because the sense of depth is enhanced with the higher horizon and by moving the dark rocks away from the bottom of the picture space. In the first version, they feel like a barrier to entering the picture. In the second, as if they were stepping stones, we can move with ease from stone to stone into the picture. Also, the mountain in the background is less dominated by the foreground in the second version.

PORTAGE LAKE, KENAI PENINSULA, ALASKA
Both images: 20mm lens, f/11 for 1 second, Fujichrome 50

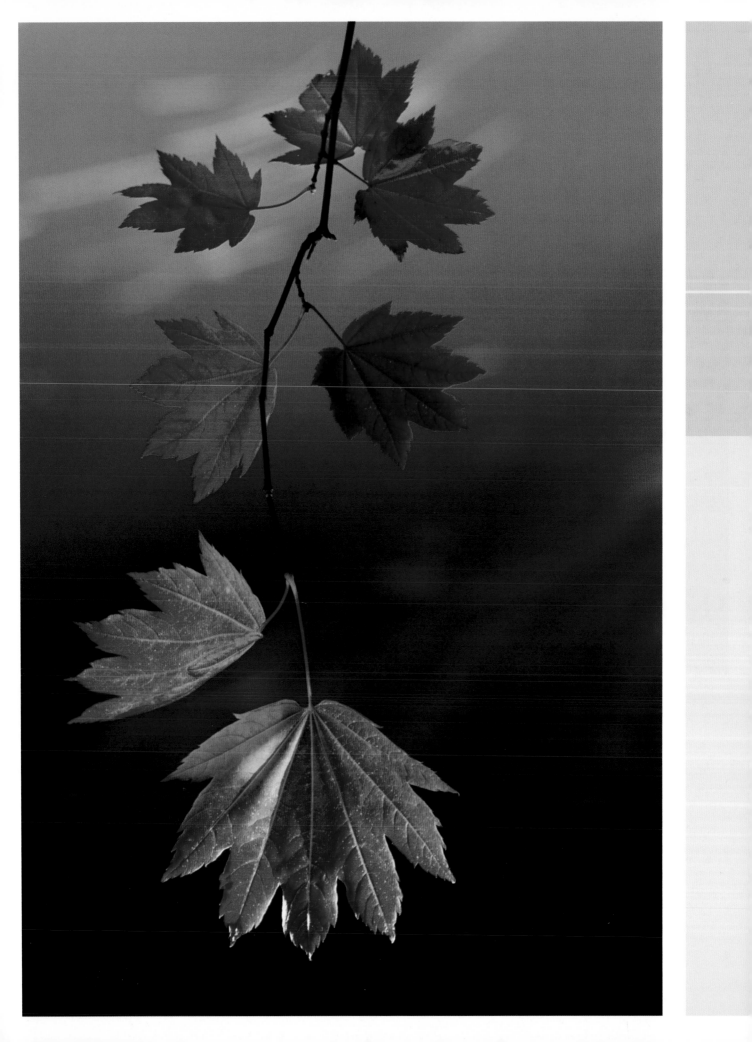

4 The Power of Color

◀ VINE MAPLE OVER
STREAM, MOUNT
RAINIER NATIONAL
PARK, WASHINGTON

70–200mm lens, f/11 for
1/60 sec., Fujichrome
Velvia 50

Color is perhaps the most powerful tool in visual communication. It has a direct link to our emotions and can affect our behavior. Experiments by psychologists have demonstrated the subconscious power of color; when violent children were put in rooms painted pink, they relaxed, stopped yelling, and some even fell asleep in ten minutes. Pink inhibits the secretion of adrenaline.

Even animals respond subliminally to color. Racehorses, after a thorough working out, were put in stalls painted either red or blue. Those in the blue stalls cooled down much faster than those in the red. Many restaurants use red in their décor because it supposedly stimulates the appetite and increases table turnover.

Color is a phenomenon of light, as Sir Isaac Newton discovered in 1676 when he refracted sunlight through a prism. White light is made up of seven basic colors of differing wavelengths, from violet (the shortest) to red (the longest). When we look at an object, what we actually see is light reflected back from its surface. For example, a red apple absorbs all the light wavelengths except those in the red part of the spectrum. The apple appears red because our eye is receiving the red light waves reflected back from the apple's surface.

All of us have color biases. Some of us prefer cooler shades of green, blue, and purple over the warmer colors of red, orange, and yellow, and someday scientists may prove that these preferences have a neurological basis. The field of photobiology is devoted to the study of the effects of different-colored wavelengths on the brain chemicals we produce. In Sweden, they have discovered that by using interior lighting with an ultraviolet component, they can counter the depression that afflicts many Swedes during the long, dark, light-starved winter months. No doubt this also accounts for the fact that so many Scandinavians love to decorate their interiors with bright, bold primary colors.

Colors are not just a visual phenomenon. Like words and symbols, they have connotations and associations and carry psychological implications that affect our emotions. Red, for example, symbolizes love, danger, fear, and heat, to name a few. It is the color of blood, of life and death. The heart symbol used to connote love is red. Stop signs are red to warn us and catch our attention. Bulls are thought to be angered by the red cape of the matador. Whether or not you love the color red, it is hard to deny that the sight of a bright red cardinal in a bleak winter landscape is cheering.

Yellow is warm, friendly, catches our attention, too, and so is used for high-visibility items, such as road signs and taxicabs. Children use yellow for the color of sunshine when they paint. Yellow evokes the warmth of the sun when we look at it, even though it is not the sun's true color.

A color also changes character when it is placed next to other colors. Red, when surrounded by a field of blue, looks hot. When placed in a field of bright yellow, however, the same shade of red looks cool by comparison.

Cool colors tend to recede, and warm colors tend to advance. Saturated colors appear closer than pastel versions of the same hue. Landscape painters learn to use warm colors to depict foreground subjects and cool colors for distant ones. Art schools teach artists to use color carefully and deliberately, always keeping in mind its effect on the viewer.

Photographers also need to be aware of the power of color. Have you noticed that magazines rarely publish black-and-white photographs anymore? This is because color is exciting, and editors know, in this age of computers, TV, and video, that readers must be enticed. Pages of text by themselves are intimidating. Designers use color images interspersed with text blocks to enliven a page and cajole us into reading.

▼ **BRIDALVEIL FALL, YOSEMITE NATIONAL PARK, CALIFORNIA**
200–400mm lens (in 400mm range), f/16 for 1/25 sec., Fujichrome 50

Choosing an In-Camera Color Space

TG If you've spent much time working to optimize your digital photos on the computer, you probably know that there are different color spaces available. These allow you to specify the range of colors available while working with your photos. What you might not realize, however, is that most digital cameras also include the option to choose a color space in their LCD menus. But before you decide which color space to select, let's take a quick look at how in-camera color space works.

If you're shooting in RAW, changes to the color space won't affect your final results. In fact, unless you're using the software that came with your camera to convert your RAW captures to a standard image file format, your color space setting will likely be ignored. What that setting *will* affect is the image preview and histogram on your LCD display, since it is used to translate the RAW capture into the embedded preview image that is included as part of that RAW file.

Most cameras let you choose between the sRGB and Adobe RGB color spaces. Adobe RGB is a larger color space, and thus tends to yield more accurate histograms and image previews. The sRGB color space is smaller, but tends to produce preview images that are a little more saturated and attractive. In other words, you're effectively choosing between a slightly more accurate preview and a slightly better looking preview.

If you're not shooting in RAW, the in-camera color space has a very real impact on the final image as it determines the range of colors in your final image. Generally speaking, opt for Adobe RGB if you want the greatest color range possible and sRGB if you are simply capturing quick JPEGs for online sharing.

▲ To select your color space, look in your LCD menu.

▲ CHILIES, MALI
70–200mm lens, f/9 for
1/20 sec., ISO 100

Primary Colors

Audubon once published a series of essays about color in nature that started with red because it is a favorite eye-catching color for editorial and advertising use. Thirty-six images were selected from several thousand submitted. The "red" essay proved so popular that it was followed by "blue," and then "yellow."

Some of the examples were the obvious—red maple trees in fall, a bluebird, a yellow daisy. But most were much less familiar—the red mouths of baby cuckoos, the yellow cere on the face of a Harris's hawk, the turquoise eyes of a baby cougar. When you think about it, life without color would be dull indeed. So much of the pleasure we experience in our surroundings is tied to the variety and abundance of color.

◄ **FALL COLOR, DENALI
NATIONAL PARK,
ALASKA**
24–70mm lens, f/11 for
1/4 sec., ISO 50

▼ **ICEBERG, ANTARCTICA**
70–200mm F2.8 lens, f/18
for 1/400 sec., ISO 400

Portfolio of Complementary Colors

▼ COCK-OF-THE-ROCK,
ANDES, PERU
400mm F4 lens with 2x
teleconverter, f/8 for 1/4
sec., ISO 500

Artists have long known to use colors based on their relationships to one another. On the color wheel of primary and secondary colors, those opposite each other are called *complementary*— red and green, orange and blue, yellow and purple—because they have an unusual optical effect on us. When used next to each other, each complement vibrates more intensely.

The nineteenth-century French impressionists were the first painters to exploit this phenomenon. It is no different for photographers: the bright red cock-of-the-rock, for example, will stand out much better against the backdrop of green foliage than that of a pale blue sky.

◀ ASTERS, YELLOWSTONE NATIONAL PARK, WYOMING
70–200mm, f/16 for 1/8 sec., Fujichrome Velvia 50

▼ PARSON'S CHAME-LEON, MADAGASCAR
70–200mm lens, f/5.6 for 1/50 sec., ISO 400

Portfolio of Related or Harmonious Colors

Harmonious colors are those that are related in hue or are next to each other on the color wheel—yellow, green, and blue, for example, or pink, orange, and yellow. Because of this, they tend to make a different kind of statement, less bold when placed side by side than complements, yet very appealing to look at. Certain seasons are characterized by harmonious colors, such as fall, with its reds, browns, oranges, and yellows.

Editors take color into consideration when selecting their magazine covers. *Audubon*'s bestselling cover was a fairly somber fall foliage shot of a gray-phase screech owl; what made the picture were the tiny orange berries left on a vine. As images to frame and hang on the wall, harmonious color schemes are soothing, like the subtle earth colors in the aerial of the Ord River. They wear better over time when they have to be looked at and lived with every day.

▶ **AERIAL, ORD RIVER DELTA, WESTERN AUSTRALIA**
70–200mm lens, f/4 for 1/640 sec., ISO 100

▶ **BAT STARS, HAIDA GWAII, BRITISH COLUMBIA**
50mm macro lens, f/11 for 1/8 sec., Fujichrome 100

Portfolio of Pastel Colors

Pastel colors can be thought of as simply muted versions of primary and secondary colors, with the same relationships still applying. They are often associated with spring, a season of pinks, lavenders, pale yellows, and greens—the colors of emergent vegetation. But they are also associated with winter, as in the image of the firs on Mount Rainier (below). The image of the Bolivian salt hills (following pages) with their soft pinks and blues also resembles a winter landscape.

The prismatic effect of abalone shell produces pastels in the whole color spectrum, satisfying and fascinating as they change according to the angle of the light. Like harmonious colors, pastels are emotionally pleasing and have a quieter impact, making them soothing, and therefore easy to live with.

▲ **ABALONE SHELL, CALIFORNIA**
24–70mm lens, f/22 for .4 sec., ISO 100

▲ **FOREST, MOUNT RAINIER NATIONAL PARK, WASHINGTON**
80–200mm lens, f/16 for 1/8 sec., Fujichrome Velvia 50

▶ SALAR DE UYUNI,
BOLIVIA
24–70mm lens, f/22 for
1.3 seconds, ISO 100

Uniformity of Color

The use of one tone, referred to as a *monochrome,* makes the subtlest statement of all. As in black-and-white photography, the eye is not seduced or distracted by competing colors. Instead, monochromatic images give other elements in the picture a chance to come forward, especially those you might not otherwise notice. The image of the dove, shown below, has an elegant simplicity. It is a study of form, with soft shadows lining the curves of the bird and the knobs on the door. The cheetah in the grass is a monochromatic study of texture. And the image of the fox among boulders is a subtle portrait of variations in texture, shape, and tone in the landscape. It would be hard to imagine any of these images with bold, bright color disrupting their delicate impressions.

▼ **RING-NECKED DOVE, MOROCCO**

70–200mm lens, f/7 for 1/160 sec., ISO 100

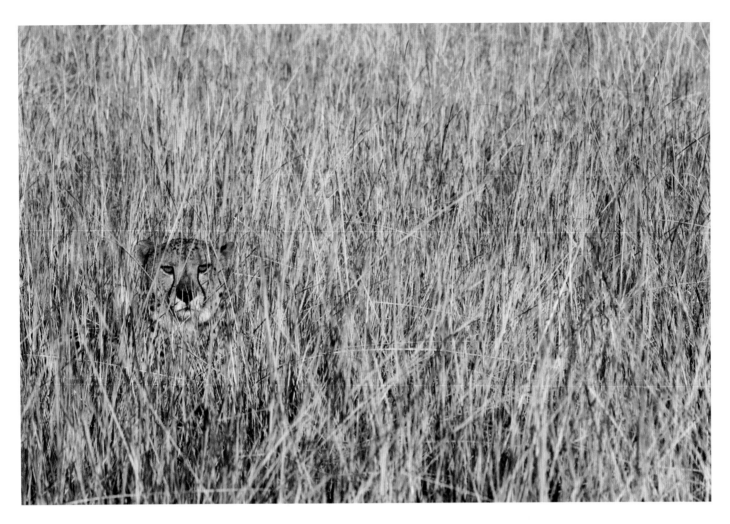

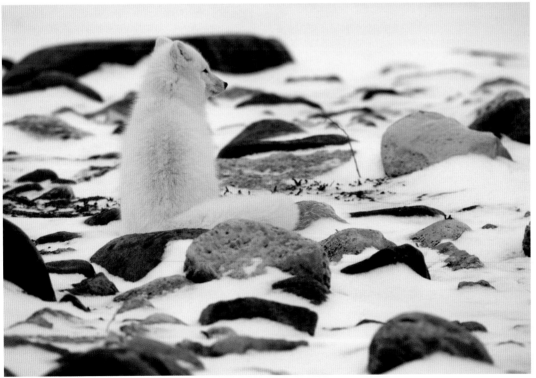

▲ CHEETAH IN GRASS,
PHINDA RESOURCE
RESERVE, SOUTH
AFRICA
70–200mm lens, f/22 for
1/15 sec., Fujichrome
Velvia 50

◄ ARCTIC FOX,
MANITOBA
600mm lens, f/4 for 1/250
sec., Fujichrome Astia 50

The Power of No Color

Sometimes a scene that does not work in color looks far better in black and white. Color may actually be a distracting element, weakening the impact of a composition. Black-and-white images have the ability to reduce the world around us to abstracts of shape, tone, and pattern. One of the great gifts of digital technology is the ability to easily choose between creating color or black-and-white images depending on the nature of the subject and the quality of the light.

HUANGSHAN, ANHUI PROVINCE, CHINA

▼ 70–200mm F2.8 lens with 1.4 teleconverter, f/13 for 1/32 sec., ISO 100

AW Never discount the ability to create effective photographs on a rainy, overcast day. During a workshop in Huangshan, China, we were hit with some pretty bad weather. Weather is rarely a reason to stop photographing and it is often changeable in mountains. I knew from experience that images taken on a day like this could yield dreamy photos with just a little dodging and burning, once converted from a color capture.

My workflow for these images was fairly simple. I created a virtual copy of the original image in Lightroom and desaturated it by dragging the Saturation Slider to 0. I then used the Brush tool to selectively dodge and burn areas of the sky to make the clouds pop. Next, Jay Goodrich, my co-leader on this trip, opened the image in Photoshop CS5 and added an Auto Curves adjustment layer that, to my surprise, made the image jump off the page. I don't usually have time to do this on location, but when I do have more time, I will further refine the black-and-white image by using Nik Software's Silver Efex Pro 2. This allows me to really fine-tune the image. I am always amazed at how many ways there are to process an image to get the results I am looking for.

MH I love both of these images, but feel the black-and-white version enables me to better savor the forms and textures of this ethereal landscape. I am reminded of the exquisite ink paintings the Chinese did on silk of these very same mountains, which are still an inspiration to modern-day artists.

▶ Black-and-white conversion done in Photoshop

DIGITAL WORKSHOP
Converting Color Images into Black and White

TG The digital photographer no longer needs to feel locked into a decision between black-and-white or color photography. Although with film you needed to make a choice (or carry more than one camera), with digital you can simply capture all images in color, then later convert those that seem to warrant a black-and-white interpretation.

Although it is possible to instruct your camera to capture in black and white, more than one photographer has been confused to discover that their RAW captures show up in full-color when downloaded to the computer. That is because a RAW capture is really a data file containing the information gathered by the image sensor, not a true image file. Therefore, most settings found on the camera related to the appearance of the image don't apply to RAW captures.

Generally speaking, only the exposure settings of aperture, shutter speed, and ISO will affect the data in the RAW capture (though there are some exceptions to this, such as the highlight priority mode found in some recent digital cameras). What that means is that black-and-white photography, for the photographer capturing in RAW, is largely a post-processing issue. You can set your camera to capture in black and white to get a sense of the scene with a basic black-and-white translation, but that is just a preview of one of your many options.

There are many software tools available to create black-and-white interpretations of your images. Both Photoshop and Lightroom provide tools for black-and-white conversions, and there is a wide variety of other tools, such as Silver Efex Pro from Nik Software (www.niksoftware.com).

◄ When converting an image from color to black and white in Lightroom, you can adjust the image's brightness values based on the colors in the original image, providing a great deal of control and flexibility.

▶ In Photoshop, the Black and White adjustment panel allows you to adjust brightness for the six primary colors, to fine-tune the tonal values of the final image.

▲ Silver Efex Pro from Nik Software allows you to select from a wide variety of presets to create an initial black-and-white version of a photo, and then optimize the final result.

5 The Elements of Design

◄ STREAM, YOSEMITE
NATIONAL PARK,
CALIFORNIA

75mm lens, f/22 for
6 seconds, ISO 400

Nature is not really chaos. It is replete with rhythms, patterns, functional designs, and structures. The more you observe and explore, the more you will discover them. The lovely spiral growth pattern of a chambered nautilus shell is the most famous example of nature's extraordinary engineering. Spiderwebs, hummingbird nests, honeycombs, peacock feathers, the baleen plates of whales, maple seeds, and an ear of wheat are just a few more examples of natural engineering, where form derives from function.

Along with color, the elements of design are the visual building blocks every artist or photographer has to work with in making his or her statement. Line, form, texture, and pattern all need to be taken into careful consideration when looking through the viewfinder.

In nature photography, except for the horizon, perfectly straight lines are rare. They appear manmade and architectural and call attention to themselves as being "unnatural." Lines and shapes, like colors, have psychological character. Bold shapes create bold images. Angular shapes are more dynamic and attention-getting than rounded, smooth shapes, probably because of our mental associations of sharpness and steepness.

Wavy, sinuous lines and shapes suggest sensuality and fluidity. Diagonals are more exciting to us than horizontal or vertical lines and can add energy to an otherwise static image. They also intersect the frame and seem to want to take us somewhere—away, up, down—sometimes even out of the picture space. They imply movement and need to be used carefully so as not to distract us from the subject.

Sometimes, lines are implied without actually being visible, as with the great blue heron on page 33, who is looking out of the frame. His line of sight carries us out of the picture, toward a point we cannot see.

The Power of Line

If colors have the power to move our emotions, lines have the power to move our eye within the picture's space. For example, look at these images of the weed in the pond in the Hunza Valley. In the first image (below), the shoreline fights with the weed for dominance. The hard line is a distraction, leading the eye away from the plant, which has much more to offer visually. When that shoreline is absent, as in the second image (opposite), we are free to contemplate the quiet illusions in this deceptively simple, Zen-like image. Here we can savor the texture of the weed against the smooth, cool surface of the water and enjoy the interplay of reality and reflection, of two-dimensional surface and three-dimensional space.

The sky's reflection in the surface of the water makes the plane of the surface disappear, giving it a fathomless feel.

The artistic tradition of our culture is rectilinear. We live in a world defined by verticals and horizontals: the pictures (and buildings) we create usually have a rectangular frame. We accept this as a normal view of the world, yet other cultures have different visual traditions. R. L. Gregory, in his clear and provocative book *Eye and Brain*, notes that the Zulu live in round huts, plow their fields in curved lines, and have few straight lines in any of their possessions. When confronted with optical-illusion figures based on angles and lines, they simply do not see them. Tribes that live in the dense forests of Central Africa have difficulty judging distant objects, since they never get to see

WEED IN POND, HUNZA VALLEY, PAKISTAN

▼ 80–200mm lens (in 80mm range), f/11 for 1/25 sec., Fujichrome 50

things far away. To them, such objects just appear to be miniature versions of what they know.

For those of us raised in the cultural tradition of Western art, however, lines are the most important way to indicate distance, or receding space, in a picture. Linear perspective, using the device of the vanishing point to re-create three-dimensional space, was discovered in the Renaissance. Leonardo da Vinci (1452–1519) described it as the "bridle and rudder of painting." Before then, spatial depth had been created by relationships of objects in size and scale to each other. A bigger figure was perceived as standing in front of a smaller figure.

In Asian art, however, which did not use vanishing point perspective, spatial depth is indicated in a different way. When you look at a Japanese or Chinese painting from before the twentieth century, it is as if you are a bird hovering just above the scene and looking down, more like what we see in the aerial shot of Uluru (pages 86–87). In Asian perspective, lines run parallel instead of converging. As in the photo of Uluru Rock, depth is indicated by an oblique positioning of the subject. Walls, figures, and objects often remain the same size relative to one another. There is usually no horizon line at all, although there may be an occasional reference to a distant shoreline or mountain.

Three-dimensional space is also suggested by emptiness. There may be a few objects in the foreground, and then only a hint of background. The unfilled areas of the picture space are used to create the illusion of intervening space, or a third dimension.

▼ 80–200mm lens (in 200mm range), f/11 for 1/25 sec., Fujichrome 50

Space, as we know and experience it in our everyday lives, is three-dimensional. Photographs and paintings are flat surfaces, and yet, in most cases, we can look at a photograph and imagine ourselves in the photographer's shoes. We immediately step into his vision as if it were our own—

such is the veracity of what the camera records.

The camera sees the same perspective illusions as we do. Vertical and horizontal lines that recede become shorter and appear to converge. Think of railroad ties or fence posts along a road. Likewise, forms that recede can also become paler, as the

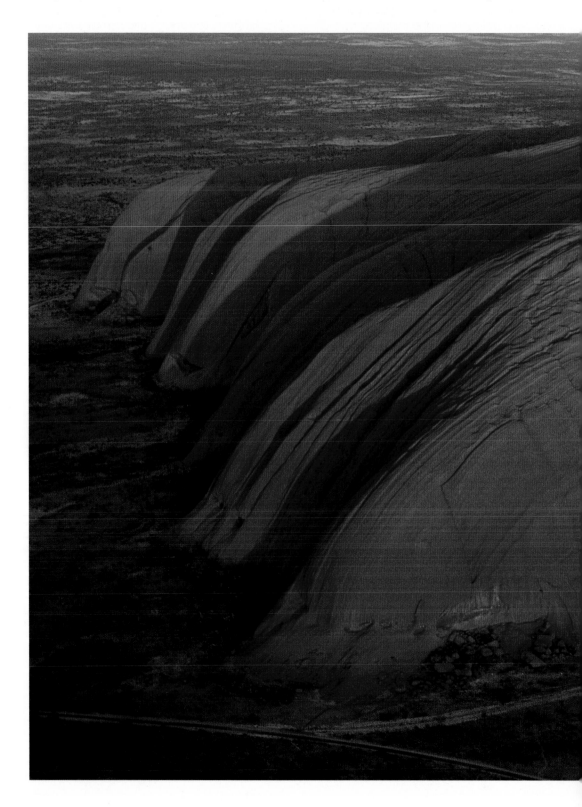

atmosphere in between interferes with our ability to see them clearly. Think of mountain ranges layered one behind the other. Our experience tells us to interpret these illusions as spatial depth.

The horizon is, of course, the strongest horizontal line we confront on a daily basis. How the photographer uses that line can make all the difference in creating a successful landscape image. And since we accept that we are rooted to the earth's surface by gravity and thus are perpendicular to the horizon, we tend to accept other upright beings and things as perpendicular, too.

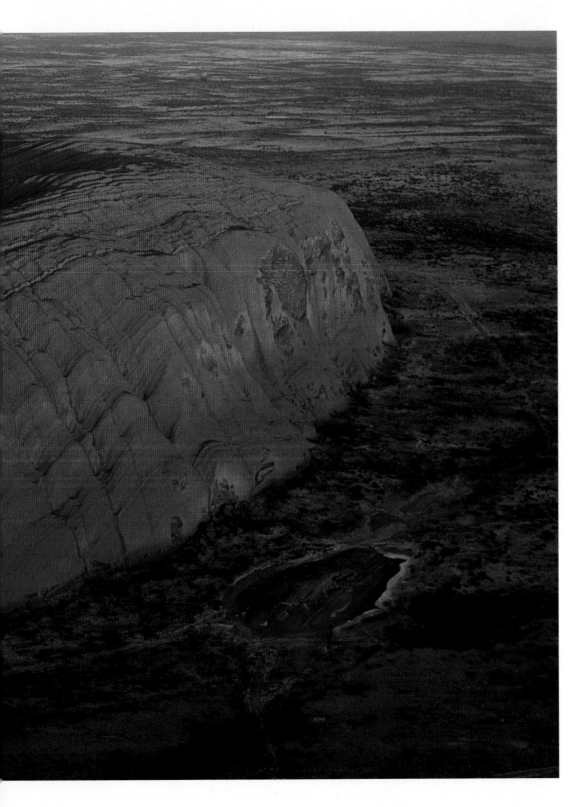

◄ ULURU, NORTHERN
TERRITORY, AUSTRALIA
55mm macro lens,
f/2.8 for 1/60 sec.,
Fujichrome 50

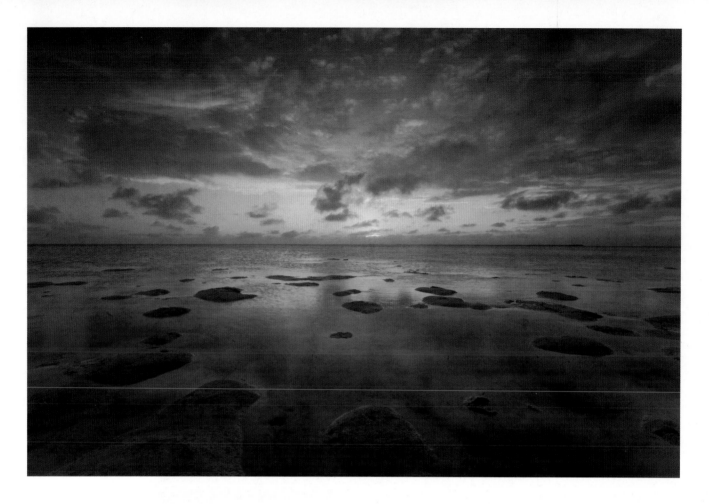

AMBERGRIS CAY, TURKS AND CAICOS

Top images: 17–40mm lens, f/14 for 1/8 sec., ISO 100

Horizon Placement and How It Affects Depth

AW One of the most common errors I see in portfolio reviews is the placement of the horizon in the middle of the photograph. In my opinion, this flattens out the image, creating less of a sense of depth. Placing the horizon high or low in the frame can create a dynamic that allows the eyes to wander through the image far more easily.

In the first image (above), with the horizon in the middle, the eye just stops. In the second (opposite, top), the high placement of the horizon allows me to add more foreground, showing the expanse of beach and tide. There is a nice play between the forms of sand and the drama of the setting sun. In the third shot (opposite, bottom), with the horizon low in the frame, the focus is on the sun and how it reflects on the water, giving greater emphasis to the clouds overhead. High and low horizons create less predictable images and, to my mind, a greater sense of depth and drama.

MH Because the horizon line is so straight, it cuts the picture space into definite sections and has to be factored into what you want to emphasize. In each of these images, we get a slightly different sense. Placing the horizon in the middle might be desirable if stability and tranquility are what you want to convey. However, it relies on a very dramatic sunset to make a powerful statement.

With a horizon placed high in the frame, the foreground becomes more important and requires either a texture or an interesting detail. However, if the drama of the sky is more powerful, then lowering the horizon is a better option.

▶ 17–40mm lens, f/14 for 1/6 sec., ISO 100

AW Despite what I said earlier about drama and depth, there are definitely instances when I will put the horizon right down the middle to create a sense of symmetry. If there are two elements in equal balance, placing the horizon in the middle works well, as does dividing the image in half using a strong vertical line.

In the image shown below, the graceful boughs of an alder tree reach down and touch the surface of Lake Crescent on Washington's Olympic Peninsula. I wanted to give greater play and emphasis to the way the lines meet at the water's surface. Rather than trying to create a sense of depth, I wanted to emphasize the reflection, and the abstraction it created, by drawing the viewer's eye to the precise spot where the lines converge.

In the image shown opposite, I was able to take advantage of the perfectly still waters in a canyon in western Australia. Not only is the darter sitting on the rock perfectly reflected, but the red canyon walls give the image a coppery glow.

▼ **LAKE CRESCENT, OLYMPIC NATIONAL PARK, WASHINGTON**
70–200 F4 lens, f/9 for 1/125 sec., ISO 250

MH The important centerline may not be the actual horizon line, or shoreline, but the line dividing the reflection. With the Lake Crescent image, Art made a symmetrical composition, like a Rorschach inkblot, by putting the mirror-image reflection in the middle on the horizontal axis. However, it is not symmetrical in the vertical, and that is what gives the picture its dynamism. The heavier branch on the left creates a strong sweeping line, complemented by the more delicate arc of the right side.

In the darter image, Art placed the bird and rock centrally on the vertical, but not the horizontal. The weight of this image is slightly lower in the frame, just far enough off the middle to make it interesting. In both of these images, this slightly off-balance tension enhances the visual interest.

Generally, the horizon line has the character of strength and stability; it dominates the composition and demands to be straight. Because our expectation is always for a level horizon, a tilted horizon is disconcerting to the eye. Images without enough room to correct this problem would not be publishable.

▼ **AUSTRALIAN DARTER, MORNINGTON SANCTUARY, WESTERN AUSTRALIA**
400mm lens with 2x teleconverter, f/8 for 1/60 sec., ISO 50

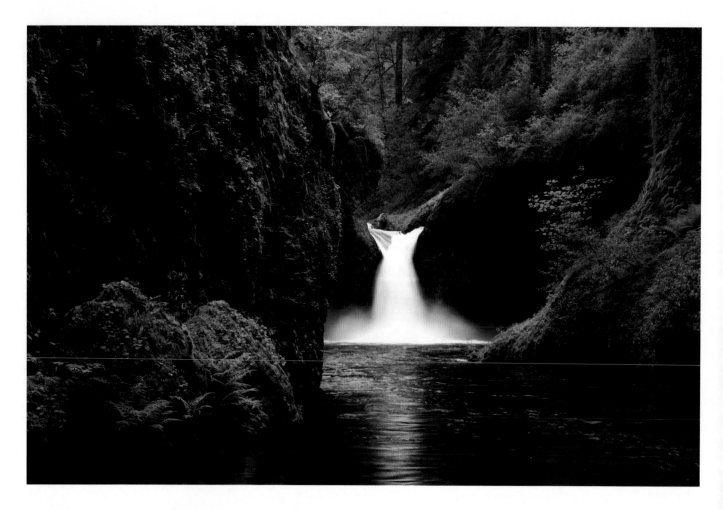

PUNCH BOWL FALLS, OREGON

▲ 24–105mm F4 lens, f/13 for 0.3 sec., ISO 50

Placing the Horizon Off Center

AW By placing the subject directly in the middle of your frame, you effectively flatten the image, making a more abstract statement. However, in many cases, this is not the desired effect. And once you remove the horizon from the middle, it is possible to create a much greater sense of depth and dynamics.

Punch Bowl Falls is a very famous feature in the Columbia River Gorge. In the first image (above), I placed the horizon in the middle of the frame; the eye goes directly to the waterfall and stops. In the second image (right), I selected a wider angle, placing the waterfall in the upper quadrant of the image. This allows me to incorporate the reflective water flowing toward me and, using a polarizing filter, show the submerged rocks. The interest created by the rocks and water balances the waterfall and creates a depth to the photograph that is absent in the first image.

For the image of Torres Del Paine (opposite, far right), I chose to lower the horizon to accentuate the dynamic, vertical sweep of a lenticular cloud.

MH In the second image, the placement of the waterfall higher in the frame creates a sense of depth by drawing the viewer into the picture space. Because the eye travels deep into the picture to the waterfall, it is as if we are re-creating the experience of finding this scene on our own. The version with the centered placement may be the more normal perspective, but it lacks the enhanced sense of discovery of the second composition.

The horizon is, by definition, horizontal. Enclosed by a horizontal frame, its energy seems to spread sideways. When a landscape with a

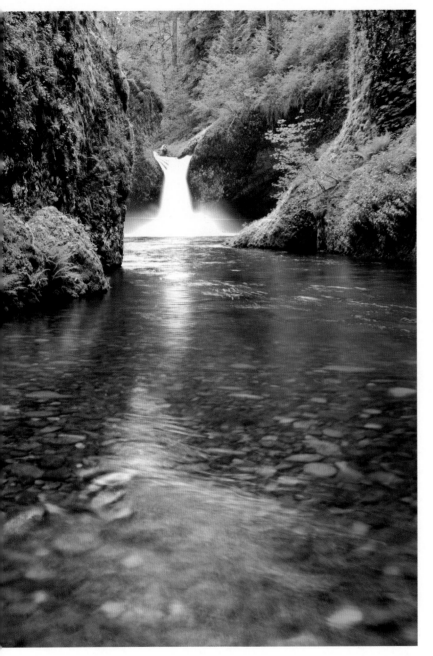

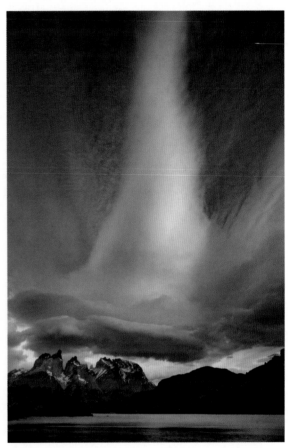

◀ 24–105mm F4 lens, f/13
for 1.6 seconds, ISO 100

▼ TORRES DEL PAINE
NATIONAL PARK, CHILE
17–40mm lens, f/7 for 0.3
sec., ISO 100

horizon is photographed vertically, interesting possibilities arise. The eye's attention is more easily drawn to the upper or lower portion, depending on where the horizon is placed. Certain tall vertical elements, such as trees, often demand to be photographed vertically to create the proper impression of height or majesty.

In the third image, the low placement of the horizon gives the cloud maximum emphasis and creates a wonderful energy. It actually feels as if the cloud is pushing down the rugged landscape beneath it, which, by its darkness and solidity, gives weight to the picture and anchors it. This is a landscape of high winds and rapidly changing climatic conditions, and this photo captures a sense of that power.

No Horizon: Aerial Perspective

AW Some of my most successful images have been taken from the air. We often take for granted the elements of nature that we see every day from ground level. When viewed from the air, however, they can take on an entirely new character, creating opportunities for dynamic compositions. Suddenly they reveal unexpected shapes, as in the elk herd picture (below), or strong forms, as in the Six-Shooter Peak image (opposite, top). Or you can discover completely abstract patterns, as in the aerial of Tanzania's

Lake Natron (opposite, bottom), where a flock of flamingos adds scale to an otherwise surreal and abstract landscape. Including the horizon from an aerial perspective is difficult, but in these images, it wasn't necessary. My goal was to challenge the viewer with a different viewpoint altogether.

MH With no horizon dividing the picture space and spreading energy sideways along its axis, aerial photographs become tapestries of light and form, texture and pattern. Space is not limited by the horizon and instead takes on an infinite quality. Without a horizon by which to judge distance, we look to other elements for depth cues.

▼ **ELK HERD, NATIONAL ELK RANGE, WYOMING**
135mm F2.8 lens, f/5.6 for 1/125 sec., Fujichrome 50

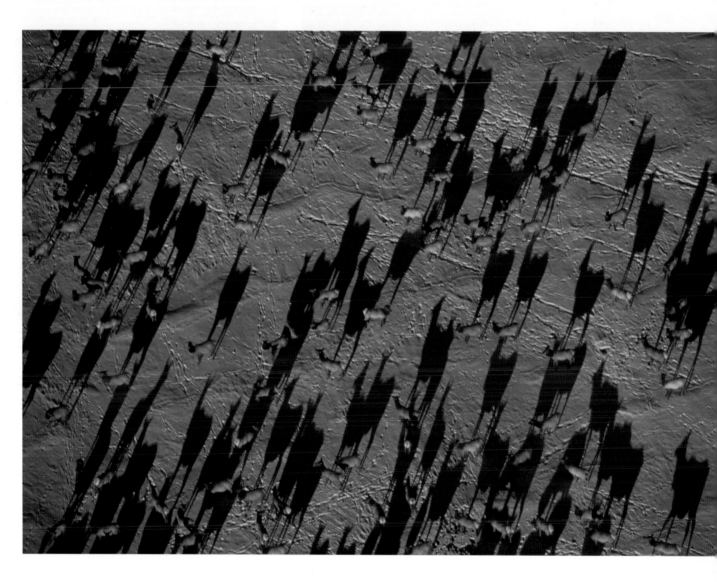

The elk image is one of my favorites. I love the way it jars our perceptions. From the ground, we perceive shadows as being less substantial than the object casting it. But look at what happens from the air; the unusual shapes of the shadows draw our attention first, rather than the animals. The shadows are large, dynamic, flat fields of color, and they form the dominant rhythmic element. Like shadow puppets, they loom larger than life, rising above the animals instead of lying beneath them.

With the aerial image of the peak in Canyonlands, the evening light showcases the peak's triangular form, set against the long, echoing shadow behind. The lighter, sunlit land-form comes forward in the picture space while the boldly shaped shadow recedes, carrying us into the depth of the picture. In the shot of Lake Natron, the perception of depth is created by the lake's tapering forms winding into the distance.

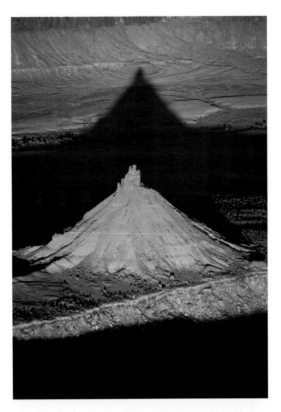

◀ SIX-SHOOTER
PEAK, CANYONLANDS
NATIONAL PARK, UTAH
135mm F2.8 lens,
f/5.6 for 1/125 sec.,
Kodachrome 64

▼ LAKE NATRON,
TANZANIA
70–200mm lens, f/3.2 for
1/1250 sec., ISO 400

Receding Lines and Shapes

AW In the shot of the karst mountains in Guilin, China, I wanted to emphasize their repeating pattern and unusual shapes: individual humps instead of long ridges. I used my 80–200mm lens to zero in on an area that I felt made the strongest statement.

The second shot (opposite) was taken a few minutes from my home in Seattle. I grew up in this neighborhood, and as a boy, I loved this path, with its graceful madrona trees. I went back to photograph it forty years later.

MH Spatially, light objects stand forward of dark in our normal experience of perception. When we have atmosphere such as fog, however, it is the reverse; dark objects are

▼ KARST MOUNTAINS, GUILIN, CHINA

80–200mm lens (in 200mm range), f/11 for 1/60 sec., Fujichrome 50

▶ MADRONA TREES IN MIST, WASHINGTON

45mm lens, f/22 for 4 seconds, Fujichrome Velvia 50

closer to us than light ones, as in the mountain scene. We understand this perceptually because atmospheric haze intervenes and makes the far mountains paler and less distinct. This is sometimes referred to as atmospheric perspective.

We also understand crisp outlines as close and fuzzy ones as distant, as with the trees in the fog, which is contrary to normal perception, where we can see distant objects in focus as well. The sense of space in both these images is definitely enhanced by the fog. Forms are more noticeable without competition from intricate detail. The tree trunks stand out more without the busy clutter of foliage. Because it shrouds things from view, fog, more than any other atmospheric condition, creates mood and a sense of mystery.

Using Line to Create Depth

AW Just as you can create depth with placement of the horizon, you can also do this quite effectively with line. In the first composition (below), we see a river cutting diagonally through snow. As it gets narrower toward the back, we know it is farther away. In the second (opposite, left), we have a backlit kelp frond, whose shadow leads the eye back into the picture.

In the third image (opposite, right), I photographed the extraordinary striated lines of mineral deposits embedded in rock. The higher horizon enabled me to incorporate a full sweep of the landscape. Where the leading lines of the rocks in the foreground intersect the frame, the eye is drawn up through the photo to the distant mountains beyond. I am using these lines as a pointer to where I ultimately want the viewer to look. The overall sense is of a vast and open landscape with emphasis given to the mountains.

MH In the river scene, as Art mentioned, our eye is naturally carried back by the oblique and tapering diagonal lines, giving what could have been a static scene a bold, sweeping sense of movement. In the kelp image, the brightest spot would normally jump forward. Instead, the shadow line draws us back into the picture space to the kelp, creating a sense of depth.

The third image is dramatically helped by its vertical format, which forces the energy of the rock patterns toward the distant mountains, leading back into the deep space.

▼ WINTER RIVER, YELLOWSTONE NATIONAL PARK, WYOMING

20mm lens, f/22 for 1 second, Kodachrome 64

▲ **KELP ON BEACH, WASHINGTON**
28mm lens, f/22 for 1/8 sec.,
Kodachrome 64

▲ **GLACIAL POLISH, LOS GLACIARES
NATIONAL PARK, ARGENTINA**
17–40mm lens, f/22 for 0.8 sec., ISO 100

▲ JAPANESE ALPS,
HONSHU, JAPAN

70–200mm F4 lens with
1.4 teleconverter, f/14 for
1/100 sec., ISO 100

Using Diagonals to Create Dynamic Visual Interest

AW Diagonal lines give a composition its dynamism. I love using a natural diagonal line to anchor an image; it's one of the first things I usually look for. For me, it is like a red light going off saying, "There's a photo nearby. Take a second glance."

MH Diagonals create tension and the excitement of the unexpected. In nature, some diagonals are very much expected, as in mountains and valleys, but because we are enclosing them inside a rectangular frame, their energy seems to want to escape confinement. The kinds of lines we are more apt to encounter in nature—wavy, zigzag, and radiating, among others—all suggest energy and motion, and can be cleverly harnessed to give drama to your image, as they are in this portfolio.

▼ SAND PATTERN, NAMIBIA
400mm lens, f/32 for 1/6 sec., ISO 50

◀ BLACK-LEGGED
KITTIWAKE ON ICEBERG,
SVALBARD, NORWAY

70–200mm lens, f/5.6 for
1/200 sec., ISO 100

▲ SNAIL TRAILS
THROUGH POLLEN,
HONSHU, JAPAN

17–40mm F4 lens, f/11
for 1/50 sec., ISO 400

A Portfolio of Lines

MH Lines are created by the contrast of dark against light, by the edges of forms and shapes differentiated by color or tone. Lines have character, too. They can be the main elements of pure graphic design, as in the zebra skin pattern or the snail trails. As abstractions, they invite us to forget the subject and simply enjoy their rhythms.

I find Art's shot of the snail trails in pollen delightful, because of the intriguing pattern and unusual subject. The image of snowy tree trunks is also a subtle beauty, focusing on the irregular dance of lines created by the light-dark contrast of snow on the trees.

▶ GREVY'S ZEBRA,
TANZANIA
600mm lens with 2x
teleconverter, f/5.6 for
1/125 sec., Fujichrome
Provia 100

Patterns

Patterns are repetitions of shapes that are organized in a rhythmic way. Textures are often patterns on a more minute scale, with the added dimension of a tactile quality. Texture alone gives images this tactile quality and allows us to experience what we are seeing with the added sense of touch. Both pattern and texture add visual variety and are abundant in nature, if only one takes the trouble to look for them.

The strongest patterns are geometric shapes, such as circles, squares, and triangles. However, these rarely occur naturally. The sun and moon are circles, and in Art's image of the sun and evergreen on page 35, we had an example of a circle balanced with the strong, triangular shape of the tree. Triangles, like diagonal lines, are dynamic, much more so than squares or rectangles. Odd numbers of things are also more dynamic in a composition. A picture of three boulders is more likely to form a dynamic arrangement than one made up of two or four. This is probably because evenness echoes the rectangular shape of the picture space. Odd-numbered objects shake up this equilibrium.

Patterns have the ability to become abstract designs. This is design for the sake of design itself, where the subject has lost its solo connotation and becomes an element of something larger. This is common in macro photography, where hard-to-see details can become an entire picture. Often these images have a flat, two-dimensional quality, since spatial depth is less important.

AW When you specifically look for patterns, and you have an area that is not completely balanced, the overall structure of the image is weakened. In the first shot of the gannets (opposite, top), the frame is not filled out to all four corners. It shows a rather loose grouping of the birds, but without a strong repetition of shapes. In the second (opposite, bottom), however, you have a strong pattern throughout. Every element is as important as the next, so it becomes an abstract design.

MH This is not abstract design in the sense that we no longer recognize the subject, but abstract because the pattern has become the subject. The ingredients of the pattern are often of secondary importance. The repetition and the rhythm created by them are what make the image dynamic.

**NORTHERN
GANNET COLONY,
NEWFOUNDLAND**
Both images: 200–400mm
lens (in 400mm range),
f/16 for 1/15 sec.,
Fujichrome 100

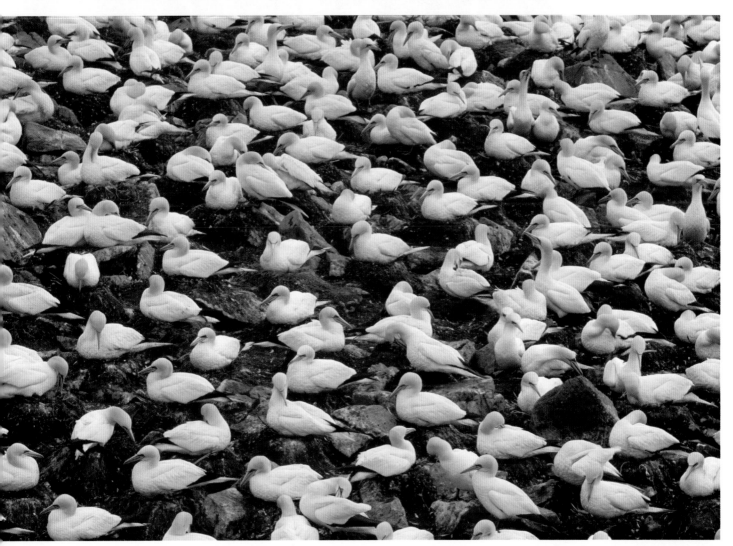

▲ SOCKEYE SALMON, WOOD RIVER LAKES, ALASKA

50mm macro lens, f/11 for 1/30 sec., Fujichrome 100

AW Patterns in nature can be quite diverse. However, the compositions I use are often very similar. By getting in close, I can emphasize the abstract beauty of the subject. The crimson spawning salmon, the hard spin of the nautilus fossils, and the sea-pocked surface of a sandstone cliff.

MH The nautilus image is perhaps a more literal example of pattern than the sockeye or sandstone, but they are all captivating designs. The nautilus shells are sublime examples of the beauty of natural architecture, arranged in a handsome, off-center design. The spawning sockeye shapes echo the fluid movement of water, looking down on the backs of the densely packed fish without the surface of the water obscuring the detail. And the sandstone pattern defies immediate recognition, being ambiguous enough that it could be the underside of a mushroom or lichen filaments. Instead, we find it has been created by the eroding forces of water on rock.

◄ NAUTILUS FOSSILS
24–70mm lens, f/20 for 6
seconds, ISO 100

◄ CHUCKANUT
SANDSTONE, SAN JUAN
ISLANDS, WASHINGTON
70–200mm lens, f/11 for
1/15 sec., ISO 50

Texture

AW Texture is an often-overlooked element of design, but one that can often be combined with line and pattern. Normally, you would not go out and say, "Today, I'm going to photograph examples of texture or shape or pattern," but it can be useful to be aware of them.

In the first image, I used the patterns of the moss on a cypress tree on the Monterey Peninsula to create a design. With a 400mm lens, the strands of moss fill out the four corners of the composition, and the soft lighting allows for subtle gradations of light and shade. Had this been a bright, sunny day, the textural character of the image would have been reduced.

Bringing texture to the flat photographic plane is a challenge I enjoy. The metallic sheen of a charred log and the sulfurous bubbling mud pots both offer distinctive tactile qualities.

MH As we will see in the next chapter, texture on an uneven surface is usually brought out best by sidelighting, which creates shadows in the depressions and highlights the uppermost surfaces. It is the contrast of highlight and shadow that enables us to see three-dimensional forms. Likewise, contrast throws even very fine textures into relief.

In the case of the moss image, some contrast is necessary to read the texture. In the other images, however, it is the *absence* of strong light that enhances the tactile qualities of what we see. Soft, overcast light gives a silvery sheen to the charred log, creating just enough relief to contrast with the smaller patterned cone. The shot of mud pots is a monochromatic study of texture and pattern without any other distractions such as color or bold darks or lights.

▼ **MOSS-DRAPED BRANCHES, MONTEREY PENINSULA, CALIFORNIA**
200–400mm lens (in 400mm range), f/16 for 1/15 sec., Fujichrome Velvia 50

◀ PINECONE ON
CHARRED LOG,
WASHINGTON

100mm macro lens, f/22
for 1/8 sec., Fujichrome
Velvia 50

▼ MUD POT, ALTIPLANO,
BOLIVIA

70–200mm lens with 1.4
teleconverter, f/22 for 1/32
sec., ISO 125

Composite Panoramas

AW I photographed this location several times in past years with film and was never entirely happy with the results until digital allowed me to create a panorama out of multiple images. Using the vertical format for capturing the height of the trees and the reflections in the water, I shot a series of overlapping scenes that I then assembled in Photoshop. The final image (pages 112–113) conveys the "closed in" feeling one gets from being surrounded by a dense stand of tall trees.

MH This digital feature of combining multiple images expands the potential to visually record our experiences in a new way. Instead of the more conventional wide sweeping landscape we normally associate with a panorama, Art has used it here to portray an interior forest scene with the unexpected result being a sense of intimacy, surrounded as we are within this tranquil landscape. It is a feeling of total immersion.

This series of frames, taken in sequence from a single vantage point, was stitched together to create the final panorama (pages 112–113).

GLACIAL KETTLE, GLACIER BAY NATIONAL PARK, ALASKA
All images: 70–200mm lens, f/18 for 1.6 seconds, ISO 50

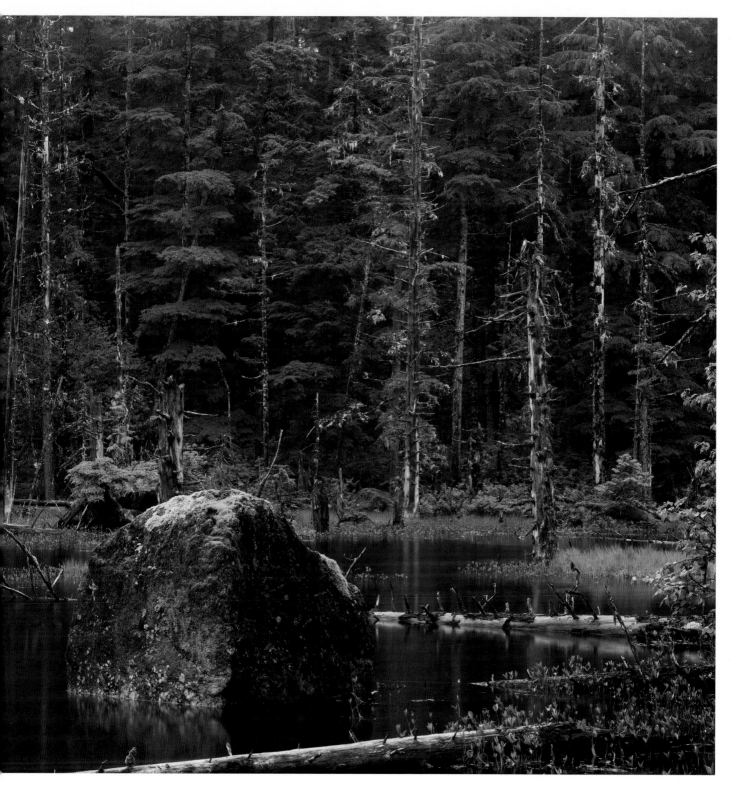

▲ GLACIAL KETTLE, GLACIER BAY
NATIONAL PARK, ALASKA

70–200mm lens, f/18 for 1.6 seconds,
ISO 50

Making Composite Panoramas

TG As photographers, we tend to look at the world through the perspective of our camera's viewfinder. But without the camera, we see much more, scanning across the landscape, following the horizon line. Because of this, it often makes sense to present an interpretation of the natural world in panoramic format.

While it is feasible to capture a relatively wide view and crop the resulting image into a panoramic format, doing so reduces the amount of information it contains. This, in turn, reduces the size we can print the photograph while still retaining adequate quality.

One way to achieve the best of both worlds is through a composite panorama. The first step is to capture a series of images that represents the full width of a scene, making sure to slightly overlap each frame. The most important consideration (besides using a tripod to ensure a stable platform and level horizon) is to use consistent exposure settings. That means working in a manual exposure mode, ensuring that aperture, shutter speed, and ISO remain the same through the full panoramic image. It can also be helpful to use a white balance preset rather than the "auto" white balance mode, just to ensure that the colors remain consistent throughout. Once the images are captured, the next step is to assemble the multiple shots into the final composite image; fortunately, this is quite easy in Photoshop.

If you are using Adobe Bridge to manage your images, get started by selecting the frames to be included in the composite and then choosing Tools > Photoshop > Photomerge from the menu. If you're using Lightroom, select the images and choose Photo > Edit In > Merge to Panorama in Photoshop.

In either case, Photoshop will then launch and the Photomerge dialog will be displayed. From the list of Layout options on the left of this dialog, choose Auto. Make sure the Blend Images Together checkbox is turned on. If you feel it is necessary, based on the equipment and techniques used for the original captures, you can also turn on the Vignette Removal and Geometric Distortion Correction checkboxes. Note that the images you had previously selected will automatically be listed in the Source Files section of the dialog.

To assemble the panoramic image from the source images, click OK. Photoshop will get to work processing the images, creating a composite image with multiple layers, and creating layer masks that identify where each layer is visible in the final composition. You can fine-tune the individual layer masks as needed, but in most cases that won't be necessary. You can also add adjustment layers at the top of the stack on the Layers panel to refine the appearance of the overall image.

By paying careful attention to how you're capturing the images in the first place, the actual assembly of the images can be quite simple, making it easy to present a wider view of any scene you choose to photograph.

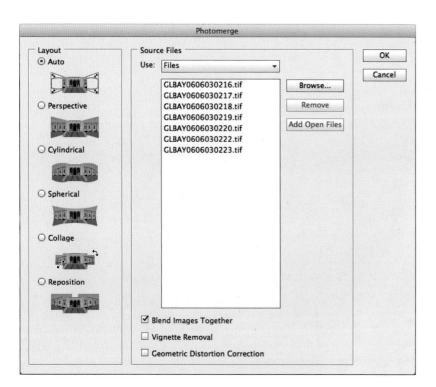

◄ With the Photomerge feature of Photoshop, you can identify the individual frames of a composite panorama so they can be assembled automatically into a seamless final image.

► Photomerge assembles the individual images as layers, with layer masks defining which areas of each photo will be visible in the final panorama.

6 Reading the Light

◄ SNOWY OWL, GEORGE
C. REIFEL MIGRATORY
BIRD SANCTUARY,
BRITISH COLUMBIA,
CANADA

500mm F4 lens, f/6.3 for
1/800 sec., ISO 1500

Without light we would have no color. And without light, there would be no photography. In fact, the word *photography* derives from Greek roots that mean "writing with light."

Primitive man did not have the benefit of science to explain natural phenomena such as the rainbow. Nor did we, until Sir Isaac Newton's use of the prism separated white light into its component colors. Light is a form of electromagnetic energy, which, in the whole spectrum of frequencies, is only visible as colors in a very narrow band. Other frequencies, such as infrared, ultraviolet, gamma, and X-ray radiation, are invisible to our eyes.

Yet, despite our basic understanding of light, it is something we are apt to take for granted, like the rising and setting of the sun. But in photography, we can never take light for granted, and must learn to perceive its many nuances. As we see on the following pages in the series of the four images of the Twelve Apostles taken at different times of the day, the quality of the light creates a variety of colors and moods. Light also models form, and the direction of light is crucial to how we perceive shape and depth in the landscape.

When talking about light, it is important to distinguish between quality and quantity. *Quality* of light can, for the outdoor photographer, mean the time of day, the angle of the light striking your subject, or whether it creates high-contrast or low-contrast conditions. It can also be measured as color temperature (in degrees Kelvin), with daylight on a sunny day being around 5500 degrees Kelvin. While color film required filtration to correct for changes in color temperature, digital cameras have a built-in white balance function that can adjust the camera to virtually any lighting condition, indoors or out.

Quantity of light simply refers to the amount of light reaching the camera's sensor and recording an image. It is by controlling this light, through changes in aperture and shutter speed, that we arrive at a proper exposure. Yet, as we shall see, there are situations where different choices produce very different results.

Quality of Light: Time of Day

Full midday sunlight is usually the worst for photography. Its direct overhead lighting produces flatness of form and washed-out colors. Most professional photographers choose to work in the mornings or afternoons, when daylight moves toward the warmer end of the spectrum and the tonal range is less extreme.

Although digital cameras can record more subtle gradations of tone than was possible with film, they are still limited in how much dynamic range they can capture in a single photo. Under conditions of extreme contrast, it is not always possible to record the full range of values. You could think of the image sensor as being like the human eye, but not nearly as sensitive to the full range of light. In bright light, the eye can see all the tonal values, from the brightest highlights to the darkest shadows, because the iris automatically adjusts to different light levels. Cameras, however, have a smaller parameter of sensitivity.

Our brains also tell us what to expect. For example, a scarlet tanager registers the same color red in our mind, whether we see it in sunlight or in shade, while the camera records it differently depending on the quality of the light.

AW I first photographed the Twelve Apostles, sea stacks off the southern coast of Australia, early in the morning, which resulted in the first, very pastel image. I came back later in the day and photographed the others: late afternoon (silhouettes), sunset (pinks and oranges), and just after sunset (very cool blues). By comparing all four images, you can see how the shifting position of the sun has profound ramifications for the emotional impact of the image. I like the warmth of the sunset shot with the pinks and oranges, but I also like the cool, subtle early-morning shot.

MH This series reminds me of the famous painting series of the Rouen Cathedral, by French impressionist Claude Monet. He painted the façade from the same vantage point, but under different light conditions at different times of the day and year. The resulting comparisons were a symphony of color tapestries with varying vibrations and moods. The cathedral was not the point. It was the effect light had on the cathedral's appearance.

Unlike the tourist who stands on the edge of the Grand Canyon, snaps a photo, and then says, "Okay, let's go. I've got it," we could stand in the same spot, every day, 365 days of the year, and have 365 different images. The subject will be the same, but it will not look the same because the lighting conditions will differ.

Color, as we saw in chapter 4, elicits an emotional response. Mood by itself can be the subject of a photo, as in these four images. But more important, mood is one emotional link the photographer shares with the viewer. Each of us can probably pick a favorite. It might be interesting to ask yourself why you like one more than another.

TWELVE APOSTLES, PORT CAMPBELL NATIONAL PARK, VICTORIA, AUSTRALIA

▼ **EARLY MORNING**
80–200mm lens (in 200mm range), f/16 for 1 second, Fujichrome 50

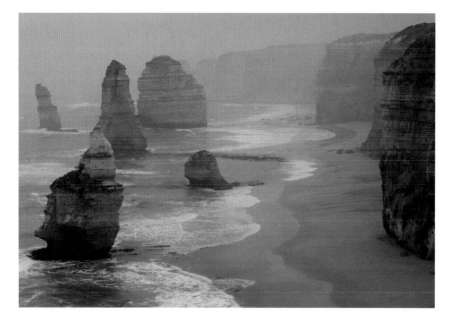

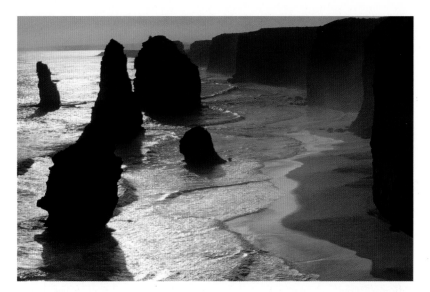

◄ **LATE AFTERNOON**
80–200mm lens (in 200mm range), f/16 for 1/15 sec., Fujichrome 50

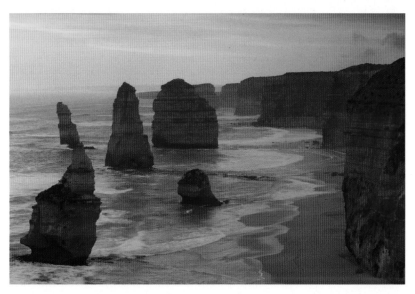

◄ **SUNSET**
80–200mm lens (in 200mm range), f/16 for 1/8 sec., Fujichrome 50

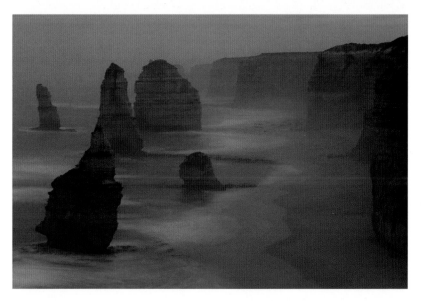

◄ **AFTER SUNSET**
80–200mm lens (in 200mm range), f/16 for 2 seconds, Fujichrome 50

DIGITAL WORKSHOP
Understanding Color Temperature

TG Digital cameras are not balanced to a specific color of light the way film was (such as a daylight-balanced film). This makes digital cameras more flexible, as we can fine-tune how the camera compensates for the color of light both during and after the capture. The term *color temperature* refers to the color of light illuminating a scene. As photographers, we are familiar with the relatively warm color of light (red, orange, yellow) that occurs when the sun's angle is low, and the relatively cool light (blue, cyan) found in shade. A color temperature adjustment (generally referred to as a *white balance adjustment*) allows us to compensate for the color of light in whatever scene we photograph. In theory, a white balance will ensure that a white object appears perfectly white, no matter what the color of the light source.

Of course, in actual practice, few scenes in nature are illuminated with pure white light. For that reason, it is crucial to understand the white balance settings in the camera to ensure you capture the colors accurately.

If you are shooting in RAW, you may choose to simply use the Automatic setting for White Balance. This is because the color temperature is not applied until the RAW conversion process. During conversion, you may choose from presets typically similar to that of your camera, or you can make fine adjustments for color temperature manually.

If you are using the JPEG capture mode, however, it is important to get the color as accurately as possible in the initial capture, since the white balance is fixed by the camera. Choose the white balance setting most appropriate to the current lighting conditions of your scene. These settings are often referred to as "presets," and their names reflect the light source they are designed for, such as Cloudy, Shade, Sunny, Fluorescent, Tungsten, and others. For example, since the light on an overcast day generally has a cooler colorcast (slightly blue), using the Cloudy preset will slightly warm the image and restore much of the natural color.

However, in some cases, you can get an improved result by intentionally using the wrong preset. Using the Cloudy setting on a sunny day will result in an image that is slightly warmer than the actual scene, which you may prefer.

And finally, after either converting the RAW capture or opening a JPEG capture, you can continue to adjust the overall color of the photograph until you're happy with it, usually without any loss of image quality.

▶ SECOND BEACH, OLYMPIC NATIONAL PARK, WASHINGTON
16–35mm F2.8 lens, f/13 for 1/30 sec., ISO 50

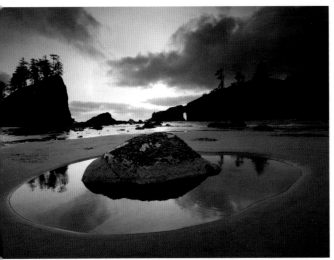

AWB AUTOMATIC WB

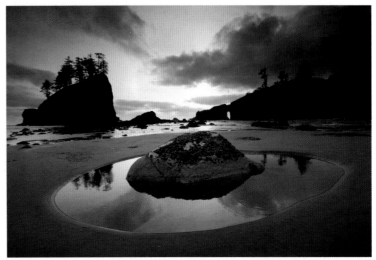

CLOUDY PRESET

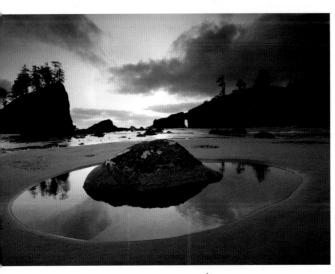

DAYLIGHT PRESET

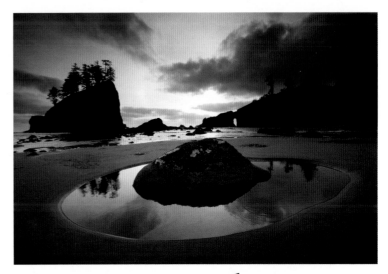

FLUORESCENT PRESET

**GRAND TETON
NATIONAL PARK,
WYOMING**

▼ **NOON**
20mm lens, f/22 for 1/60
sec., Fujichrome Velvia 50

AW Many people think that bright, sunny days are best for photographing landscapes. The sun can be an advantage, but as we saw with the Twelve Apostles (pages 118–119), time of day can make a world of difference.

Here I photographed the Grand Tetons from the east at noon, and then again at sunrise. Clearly, the low angle of a rising sun makes a more appealing shot. Snow makes for a tricky exposure, especially in bright sun. The light meter is weighted to read 18 percent gray and will actually try to make white snow appear 18 percent gray. With the low light and long shadows of the morning shot, my exposure is easier, and the sagebrush in the foreground more colorful.

MH Once you become sensitive to light, you rarely photograph a subject under midday lighting conditions, and this comparison clearly shows you why. Early morning and late afternoon provide more color in a landscape because the sun's rays pass through thicker layers of the atmosphere, which absorb the blue end of the spectrum, leaving us to see wavelengths at the warmer end.

While this phenomenon gives additional warmth here to an otherwise cool, snow-covered winter landscape, the low angle of light also creates shadows that give the foreground texture and interest and enhances the feeling of three-dimensional depth in the scene.

▼ **SUNRISE**
20mm lens, f/22 for 1/15
sec., Fujichrome Velvia 50

Direct Sun vs. Overcast Light

AW People are always amazed when I say that cloudy days yield richer color. Yet, with these cactus images, one shot in direct overhead sun and the other under a diffuser, it's clear that the second image renders the scene in more saturated, richer color because the overcast light of the diffuser has lessened the harsh contrast of bright sunlight. The effect is to make the image more readable because the shadows are not as dense.

MH A sunny day creates high contrast, ranging from bright highlights to dark, dense shadows, making it hard for the sensor to capture. In the sunlit version of the cactus image, strong shadows create contrast that is simply too extreme, and detail is lost in the dark shadows. Using a diffuser, however, mimics the effect of an overcast sky, evenly distributing the light and reducing contrast so detail is recorded in both highlight and shadow. This also allows for more color saturation, enabling a nice visual dance between the tapestry of thorns and the more brilliant red blossoms.

On a bright day, lots of the blue wavelengths of light are bouncing about, which causes shadow areas to reflect some of this blue light. Even though there might be momentary cloud cover, which acts as a giant white diffuser, there is still a strong blue component to the quality of the light. The sensor sees it even if we don't. The color difference between these two images is influenced by some reflected blue light reaching the sensor.

CLARET CUP CACTUS, WHITE SANDS NATIONAL MONUMENT, NEW MEXICO

▼ 50mm lens, f/22 for 1/15 sec., Fujichrome Velvia 50

◀ 50mm lens, f/22 for 1/4 sec., Fujichrome Velvia 50

AW These shots were taken a few minutes apart, as the sun moved in and out of clouds. In the first image (below left), taken in full sunlight, the angle of the animal's head casts a deep shadow, making it hard to see detail in the boldly marked face. The next image (below right), taken when a cloud covered the sun, shows what happens when the shadows disappear. Now the animal's face is easy to read and you can even see the subtle catchlight in the eye. Even though the position of the animal is not as strong as in the first image, the overall impact is more pleasing.

MH Reduced-contrast lighting helps with this image, but not without some loss. For one thing, the gemsbok's form is not as distinct. Without highlight and shadow to define his form, the animal is not as separate from the landscape background as in the first image. I agree that the second is a more appealing portrait because of the facial detail, but I still like the warm, sunlit feeling of the first image. There is no single "correct" way to portray something; photography is subjective.

GEMSBOK, SAMBURU NATIONAL PARK, KENYA
▼ 200–400mm lens (400mm range), f/5.6 for 1/125 sec., Fujichrome Velvia 50

▶ 200–400mm lens (400mm range), f/5.6 for 1/30 sec., Fujichrome Velvia 50

Overcast Light

AW The beige tones of these lions lying in sand would have been washed out under the midday sun, making the resulting shots unusable. Instead, simply waiting for a passing cloud rewarded me with the warm, soft light I wanted.

In the image of the bergy bits washing up on the southern coast of Iceland, I set my tripod low to enhance the crystalline quality of the ice. Behind it, more ice tumbles in the surf, the flat light revealing gradations of blues that contrast with the ocean's grayer tones. The monochromatic quality of the image makes it almost an abstract composition.

MH Capturing moments of animal behavior takes time and patience. In the image of a lion cub and sleeping lioness, the soft lighting enhances the serenity of an intimate moment. We feel the cub's sense of security, its paw draped casually over the mother's nose. The overcast lighting also brings out the appealing complementary colors of the lions' tawny fur against the pale blue gray of the ground.

In the image shown at right, the surreal view of ice and surf makes me shiver—I can feel the cold. It is not a picture that would have been possible under bright, sunlit conditions since the contrast between highlight and shadow would likely have been too much for the camera's sensor. Instead, the overcast light allows us to appreciate the whiteness of the bergs in the background and the subtle midtone colors of the translucent ice, and still have detail in the black, pebbly beach.

▼ AFRICAN LIONESS AND CUB, OKAVANGO DELTA, BOTSWANA
400mm F4 lens, f/5 for 1/400 sec., ISO 200

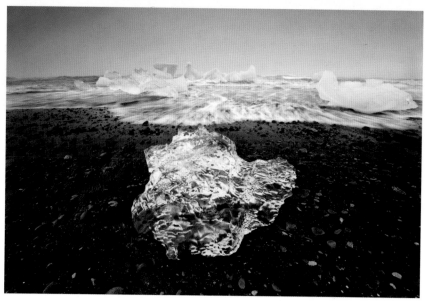

▲ BERGY BITS, ICELAND
16–35mm F2.8 lens, f/14 for 1/5 sec., ISO 100

SALT CARAVAN, SAHARA
DESERT, MALI

**SALT CARAVAN, SAHARA
DESERT, MALI**

▲ SIDELIGHTING
70–200mm F4 lens, f/11
for 1/125 sec., ISO 100

Direction of Light

AW This camel train in Mali perfectly illustrates how the direction of light affects our perception of a subject. With light from the side (above), the first image features an undulating s-curve and elongated shadows. In the second image, with lighting from an angle (opposite, top), the shadows are more clearly defined and precise. In the third image (opposite, middle), the lighting is from the front and the train itself is the focus, enhanced by the leading lines of the sand. In the last image (opposite, bottom), shooting directly into the sun creates a dramatic silhouette balanced by the dark negative space in the bottom of the frame.

MH I can't think of a better way to show how simply changing one's position to the angle of light can create a variety of unique images than with these photographs of a camel train. In the first two images, with the light from the side and at an angle, Art chose a higher vantage point to do away with the horizon. Here, the shadows become key elements of the composition, providing a dramatic counterpoint to the winding line of camels. In the third image, Art's perspective is nearly ground level, with the camels at the top of the frame and the light directly on his subject. The direct light allows him to use the fluted sand as a foreground, emphasizing the landscape more than the camels themselves. The last image, with its dramatic backlighting, makes a very different statement, with the camels reduced to graphic elements in an endless desert.

◄ **ANGLED SIDELIGHTING**
70–200mm F4 lens, f/11 for 1/160 sec.,
ISO 200

◄ **FRONTLIGHTING**
16–35mm F2.8 lens, f/11 for 1/50 sec.,
ISO 250

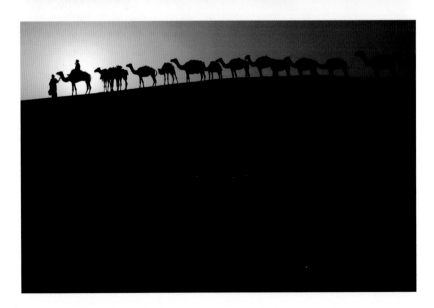

◄ **BACKLIGHTING**
70–200mm F4 lens, f/16 for 1/320 sec.,
ISO 200

Frontlighting

AW What happens to a lot of people in the field is that they get so excited as they get close to an animal, they forget to look which way the sun is coming from. They shoot from the direction of their initial approach, which may not necessarily provide the best lighting. I first analyze where the light is coming from, then approach the animal from the direction I think will give me the best exposure. In this case, the first image of the pronghorn (below left) was shot completely backlit, and there is a disconcerting amount of shadow on the face. In the second (below right), I've approached the animal so that direct light gave me better detail and color.

MH One of the first things photographers learn is to keep the sun over their shoulders. This provides strong frontlighting, which reduces shadows and contrast, and creates a more two-dimensional image. Direct light is particularly good for capturing strong eye contact in animal portraits or getting the most vivid color in your subject.

PRONGHORN, NATIONAL BISON RANGE, MONTANA

Both images: 300mm F2.8 lens, f/5.6 for 1/60 sec., Kodachrome 64

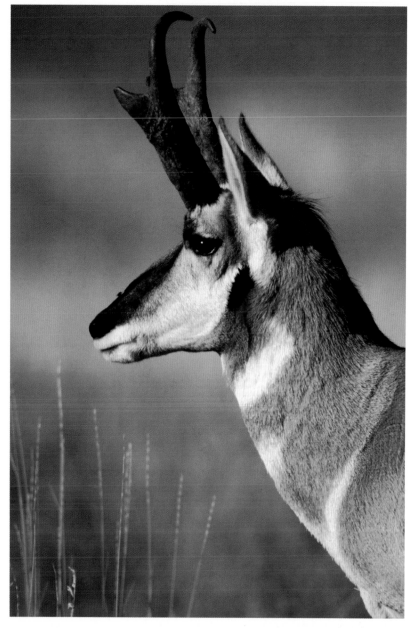

◀ HYACINTH MACAWS,
PANTANAL, BRAZIL
500mm F4 lens, f/8 for
1/320 sec., ISO 100

▼ POLAR BEAR CUB, MANITOBA
500mm F4 lens, f/11 for 1/250 sec.,
Fujichrome Provia 100

AW In the portrait of a lively hyacinth macaw pair, above, the even afternoon light emphasizes their outsize personalities as well as their cobalt blue plumage. These birds are highly endangered, but their population is on the increase in the Pantanal, the world's largest wetland.

MH This close-up shot of hyacinth macaws gives us the sense of being there. With the birds placed front and center in flattering direct light, we can absorb the full intimacy of this scene, the birds' expressions and colors, and even the texture of their roosting tree. Macaws, like all parrots, mate for life, and this pair will reinforce its bond daily, feeding and flying together, squawking and preening in mutual communication.

AW To capture this image of a polar bear cub, I set my camera on manual exposure and took a reading off the snow. Because light meters are calibrated to read any scene as neutral gray, I then set my aperture to overexpose by two stops from the reading to make sure the snow stayed white. Without this compensation, the bears would have been underexposed.

MH Warmth, safety, and a first look at a new world—this image magically conveys all of these elements. The cub has just emerged from the den, the only environment it has ever known and, still sheltered by the huge form of its mother, takes in the wonders of its icy home. The warm frontlighting gives everything in the picture equal emphasis, while the composition draws you directly to the cub's irresistible face. We don't have to look hard for anything—it is all there for us to enjoy.

AW This geyser basin in the Bolivian Altiplano, full of bubbling mud pots and hissing steam vents, comes alive visually when it is hit by the first sunlight of the morning. At over 15,000 feet, the air is icy cold and the super-heated sulfurous mist billows forth. With direct frontlighting, the depth and variety of textures are fully illuminated, emphasizing color, detail, and atmospheric quality. Strong sidelight, on the other hand, would have lost these elements in the shadows.

MH This is an ethereal picture, filled with won-derful pastel colors. Here, the soft light of dawn gives the image its warmth but allows for detail even in the areas the sun has not yet reached. Frontlighting on the steam also gives the image a sense of mystery, as it obscures some of the background detail.

▶ SOL DE MAÑANA
GEYSER BASIN,
ALTIPLANO, BOLIVIA
16–35mm F2.8 lens, f/22
for 1.3 seconds, ISO 125

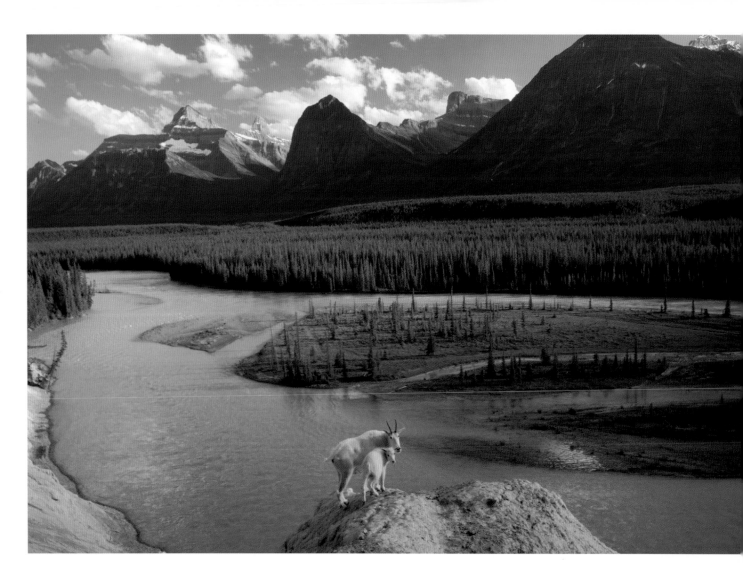

▲ MOUNTAIN GOAT AND
KID, JASPER NATIONAL
PARK, BRITISH
COLUMBIA

▲ MOUNTAIN GOAT AND
KID, JASPER NATIONAL
PARK, BRITISH
COLUMBIA

24–105 F4 lens, f/14 for
1/50 sec., ISO 400

Sidelighting

AW Two mountain goats stand on a small
promontory overlooking a river in the
Canadian Rockies. The sidelighting cre-
ates a sense of deeper space by contrasting the
background mountains in shadow with the lighted
goats in the foreground. With direct lighting from
the front, the overall scene would have appeared
flat, reducing its impact.

MH Sidelighting gives this scene its three-
dimensional quality, and gently models the
form of the animals in the foreground. The
high vantage point also creates drama, allowing Art
to use the receding wall of distant mountains as a
backdrop instead of a monochrome sky. The trees,
meanwhile, with their deeply shadowed edges,
add important texture and detail to the middle
ground. The overall effect captures the vastness
of the goat's terrain, and the steep, rugged slopes
they call home.

AW Here, a low angle of sidelight creates shadows that dramatically delineate the geometric patterns of the delicate crust on this high desert salt pan. If the sun had been high overhead, this image would be flat and uninteresting and the patterns largely unnoticeable. Only when the sun is at an oblique angle to the surface of the salt flat do these bold shapes appear.

MH This image has no obvious subject or scale, but I don't really care. What I love are the repetition of patterns and the white lines of the thin ridges receding in space. This shot demands sidelighting to make it work, since the low angle of light creates the shadows that define those thin ridges.

AW Sidelighting, or using a low angle of light, often enhances compositions, especially in open landscapes, like deserts or mountain scenes. Here, in Zion National Park, I was struggling with many visual elements and multiple layers. The strong sidelight added interest to the two rock columns and the single pine, linking them to the brightly lit cliffs in the background.

MH What I like here is that Art took advantage of the strong angle of the light to give this landscape some added drama. Contrast attracts the eye—we are visually drawn to darks and lights in any scene—and sidelighting, more than any other, adds contrast by creating strong shadows. It gives texture and form to the world we see, stressing that all-important third dimension: depth. Here, had the rock columns been dark dominant forms, we might have been less inclined to look deeper into the scene. Instead, our eyes travel from one lighted face to the next, as if wandering through the landscape ourselves.

▲ SALAR DE UYUNI, ALTIPLANO, BOLIVIA
70–200mm F2.8 lens, f/25 for 1/50 sec., ISO 400

◄ ZION NATIONAL PARK, UTAH
16–35mm F2.8 lens, f/14 for 1/10 sec., ISO 100

Backlighting

AW When in the field, lighting conditions are often constantly changing, and different situations present themselves. You might not set out to shoot subjects in backlight, but it helps to keep an eye out for it. In some cases, backlight can offer a dramatically different view of a subject you have been photographing with front-lighting—as we saw in the camel caravan images on pages 126–127.

Hiking in Arizona's spectacular Canyon de Chelly, I noticed these backlit leaves against the shaded sandstone. It was really just a matter of composing the image, putting the highlighted leaf shapes into a nice arrangement, and making sure there was no distracting clutter around the edges of the frame.

MH This picture is deceptively simple, but beautifully seen, using light from behind to separate the leaves from the dark back-ground. Art simplified his design by selecting only a few leaves, anchored by the strong shape at the bottom, creating a clean, graphic image that fills the frame with sunlight and character.

▶ **COTTONWOOD LEAVES, CANYON DE CHELLY NATIONAL MONUMENT, ARIZONA**
70–200mm F4 lens, f/11 for 1/125 sec., ISO 400

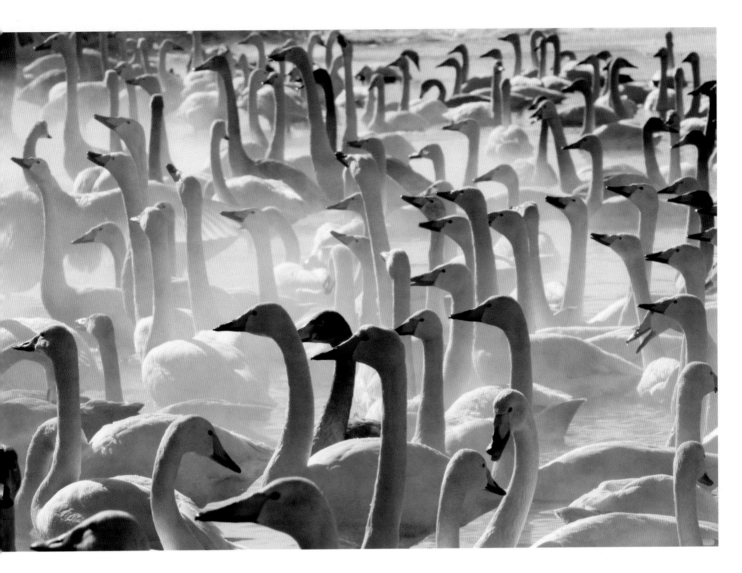

AW I often use backlighting to render complex scenes in a simple way, especially when working with groups of animals. In this case, I was photographing a large flock of swans and felt that the pattern of their similar shapes was enhanced by the backlight.

MH This is another situation where a change of simple shooting position can improve the resulting image. With direct light, the white swans might have had a tendency to blend together. By having the light come from behind, however, Art placed most of the swans in shadow. They become layers of receding gray shapes, with an occasional bright bird to accent the group. The eye travels around the scene, enjoying the repetition as well as the subtle variations of tone.

▲ **WHOOPER SWANS, HOKKAIDO, JAPAN**
400mm F4 lens, f/32 for 1/160 sec., ISO 400

▲ BUSH FIRE,
ARNHEMLAND,
NORTHERN TERRITORY,
AUSTRALIA

16–35mm F2.8 lens, f/5
for 4 seconds, ISO 400

Reflected Light

AW While some photographers still argue the merits of digital versus film, I find that digital technology provides many more opportunities with difficult subjects, such as these trees illuminated by a quickly advancing grass fire (above). Digital sensors are much more sensitive in low-light conditions and now offer better tonal range, and even better image resolution, than film.

MH I love this image, even though it portends destruction of the environment. There is a wonderful sense of drama and imminent danger with the fire illuminating the burning forest. It is a powerful image, beautifully seen, allowing us to feel the power of the fire and be mesmerized by its glow.

AW Photographing in penguin rookeries is noisy, smelly, and the light is challenging. This penguin chick (opposite, below) is protected from freezing by sitting on its parent's feet. I lay down on the ice and honed in on its face, which was softly illuminated by light reflecting off the snow.

MH In this picture, the snow is the reflector, opening up the shadowed underside of the Emperor penguin. Like the polar bear cub under its mother (page 129), the chick is the focus of the picture, with just enough of the parent's existence to give it a protective context.

AW Reflected light is not always immediately obvious when you are out in a landscape, but it is something to be on the lookout for, especially when the midday sun makes shooting difficult. It can often add rich, glowing color in a situation when direct light would be drab and uninteresting.

In this situation, I noticed that light was being reflected up from the sandy ground onto the wall of a rocky canyon. Because reflected light is softer than full sunlight, it can reduce the contrast between highlight and shadow, and here it made a perfect background for the palm tree.

Whenever I'm confronted with impossible lighting conditions, I always search for a source of this kind of indirect light—a light-colored rock, a patch of sand, or even a painted wall—that can save a situation.

MH This image intrigued me because the elements are not immediately recognizable, requiring a second look to see what is going on. Here, the bright, reflected light in the background gives this otherwise flat image its pizzazz; the shaded palm, by itself, might not be all that interesting. But the complementary colors and the vivid orange peeking through the fronds are what make this picture work.

◄ **PALM, KAKADU NATIONAL PARK, NORTHERN TERRITORY, AUSTRALIA**
70–200mm F4 lens, f/18 for 1/2 sec., ISO 400

▼ **EMPEROR PENGUIN CHICK, ANTARCTICA**
70–200mm F2.8 lens, f/8 for 1/60 sec., Fujichrome Velvia 50

Spotlighting

AW Spotlighting is an often unpredictable event that can create a dramatic and unexpected picture. With this image of a tiger in dense forest, it was essential that I spot-meter the tiger's illuminated face to ensure it was exposed correctly, since all of the deep shadows could have easily fooled the camera's meter.

MH I find this image intriguing. Tigers are among the most elusive of the big cats, and this image, by showing it lurking in the shadows, perfectly captures the animal's mystery. To me it is a more evocative rendering of the subject than the more commonplace, out-in-the-open view we often see.

▼ TIGER, KANHA NATIONAL PARK, MADHAYA PRADESH, INDIA

600mm lens, f/4 for 1/60 sec., Fujichrome Velvia 50

AW Getting up in the morning is sometimes the most difficult thing about photography! You have to be there when the sun breaks the horizon, if not before. It is a very narrow moment of time and easy to miss. Here, I waited for the moment when only the distant mountain was illuminated. Using both polarizing and gradu-ated neutral density filters, I took a reading off the snow in the foreground and, knowing that the light on the peak would be brighter, left the snow as a midtone.

MH Spotlighting is dramatic and immediately draws the eye to the subject, just as a spotlight would on an actor in a theater production. It creates intimacy, too, by drawing our attention into the picture space.

The Japanese consider Mount Fuji to be sacred. Here, Art has captured it in the *goraiko*—the "honorable arrival of light" in Japanese, and the favorite moment for Japanese climbers. With the rest of the snowy landscape in cool winter shadow, the viewer's eye goes directly to the light on Fuji's graceful slopes.

AW Spotlighting appears in a variety of ways; it could be the first shaft of light striking the landscape at dawn, as in the shot of Mount Fuji, or a beam of light bursting through an opening in a heavy cloudbank, as with this image of Bridalveil Fall. In the hours prior to this shot, the valley had been covered in flat light under solid cloud cover. Late in the afternoon, however, the clouds began to break, sending shafts of light onto the faces of El Capitan and Half Dome, and, in this case, the waterfalls that rush over the cliffs in early spring.

Getting the proper exposure in a shot like this can be challenging. Using my camera's spot meter, I took a reading off of the brightest area and opened up to keep the whole image from going too dark.

MH This image has drama and mood. Bridalveil Fall is one of Yosemite's most photographed icons, but the unusual lighting conditions captured here set this image apart. The momentary beam of light illuminates the distant waterfall, directing the eye immediately to it. Under different conditions, such as even lighting, we might overlook the waterfall altogether in this already dramatic landscape. The success of this image depends on timing—waiting for the exact moment when light will highlight an interesting visual element.

◀ **MOUNT FUJI,
HONSHU, JAPAN**
16–35mm F2.8 lens, f/14
for 0.8 sec., ISO 100

◀ **BRIDALVEIL FALL,
YOSEMITE NATIONAL
PARK, CALIFORNIA**
500mm F4 lens, f/11 for
1/250 sec., ISO 100

Low-Contrast vs. High-Contrast Lighting

AW When photographing people or portraits of animals, I often try to find a dark background with which to frame the subject. This reduces visual distractions and allows the subject to come forward in the frame, drawing the attention of the viewer. These puffins, set against the shadowy cliff, are a perfect example of this. To avoid overexposing the pure white on their chests, I metered off of the neutral rock below them to find the correct exposure.

Whenever possible, however, I try to shoot a variety of perspectives of the same subject. In the second shot of the puffins, I moved just a few feet, placing the birds against a beautiful lichen-covered cliff. Now the birds are less prominent and appear more as part of the landscape. This is a very different, but still striking, image.

MH Puffins, like penguins, can be challenging subjects in high-contrast light because of their bright, reflective feathers. In placing them against a dark background, as in the first image, it would be especially easy for all the dark space to fool the meter, burning out the highlights.

In the second image, the puffins are placed against a more neutral background, lighter than the first, and an averaging or matrix meter can more accurately read the scene. Because the lighting is now overcast, the problem of high contrast is reduced, and finding the correct exposure less difficult.

AW There was nothing complicated about the exposure for this shot of a misty forest in Canada (opposite, below). The even lighting presented an almost perfect 18 percent gray, so the camera's meter came very close to the correct exposure without much adjustment. The black-and-white penguins (page 142) were more challenging. Here, I had to make sure the brightest part of the penguin's breast was not accidentally overexposed. To do this, I metered off the darker ice behind the penguins.

MH Learning to make the most of different lighting situations is a critical element in successful photography. Even with the advances of digital technology, there is still no substitute for getting a correct exposure the first time out. In the first picture of fir trees in fog, we have a relatively low-contrast scene that is easy for the camera's meter to interpret: the picture contains just variations of gray. As a result, we have a multilayered effect, and a softness that makes this landscape more like a painting than a photograph.

In the image of the Adélie penguins (page 142), by comparison, we have brighter light conditions but a high-contrast subject, one of the most difficult to render properly. In the days of film, this was handled by bracketing exposures, just hoping that one frame would nail it. But the ability of digital to provide immediate results gives the photographer ample room to experiment at no additional cost. In other words, if your first exposure doesn't give you what you want, you can easily adjust the exposure accordingly.

Finding the 18 Percent Gray

No matter what the light conditions are, you need to know what your camera's built-in meter is telling you. Whatever metering mode you use—center-weighted, spot, or matrix—meters are designed to read the scene, compute light values, and select the exposure. In most cases, they will try to render the scene a neutral, or 18 percent, gray.

Some photographers carry a gray card that gives them a precise neutral gray to meter from. If you are confronted by a difficult lighting situation without a gray card, try to find an area in the scene that is close to 18 percent gray and take an exposure reading from that. Then, re-frame the shot and you should have a proper exposure for the entire picture.

Any subject, landscape or otherwise, can be reduced to its pure tonal values—white for the highlights, black for the shadows, and the rest in intermediate shades of gray. When trying to judge exposure, it helps to think in terms of black, white, and gray.

▲ HORNED PUFFINS,
LAKE CLARK NATIONAL
PARK, ALASKA

Top left: 500mm F4 lens,
f/14 for 1/25 sec., ISO 100

Top right: 500mm F4
lens, f/11 for 1/250 sec.,
ISO 100

◄ SUMMER STORM,
JASPER NATIONAL
PARK, BRITISH
COLUMBIA, CANADA

400mm F4 lens, f/6.3 for
1/1000 sec., ISO 400

▲ ADÉLIE PENGUINS, ANTARCTIC
PENINSULA
70–200mm F4 lens, f/11 for 1/25 sec.,
ISO 200

AW While photographing in Nepal's first national park, Royal Chitwan, I saw this tiny bird with its distinctive tail, surrounded by bare tree limbs, and placed the yellow ball of the sun behind it. I liked the composition, but my center-weighted meter reading made the overall image too dark, almost losing the silhouette of the branches against the sky. To correct this, I set the camera on manual mode and took a spot reading from a neutral part of the sky. This reduced the influence of the sun on the meter and gave me a more balanced exposure. Then I simply reframed the shot.

MH Shooting directly into the sunset (or sunrise) can give you the chance to make a dramatic graphic statement using a form silhouetted against the bright circular sun. The challenge is that the light from the sun tends to overpower your camera's meter, underexposing everything else. This can make your image too dark and increase the likelihood of unwanted noise.

You may have noticed the appearance of a hard-edged color line in the sun's halo. This is a phenomenon of shooting directly into the sun with digital. The sensor reaches its maximum 255 (bright white) and interprets that as an edge. Film does not have this delineation.

BLACK DRONGO, ROYAL CHITWAN NATIONAL PARK, NEPAL
◀ 400mm F4 lens, f/4 for 1/5000 sec., ISO 1000

▼ 400mm F4 lens, f/4 for 1/3200 sec., ISO 1000

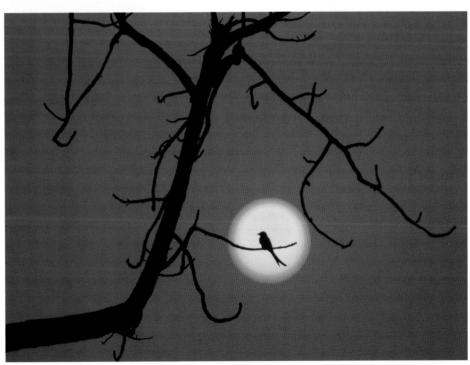

Expose to the Right

TG A common concern for photographers is how to keep detail in the highlights, especially under high-contrast lighting. If highlights are lost due to overexposure, they may be impossible to restore. At the same time, it is generally preferable to expose the image to make it as bright as possible without losing highlight detail.

This is referred to as "exposing to the right" because it results in a histogram whose data is shifted as far as possible to the right, where the majority of tonal values are captured. In some cases, this may result in an image on the LCD that is noticeably lighter than the scene itself, but it guarantees that the maximum amount of information will be recorded by the sensor.

An image that is underexposed (such as the darker version of the arctic fox image shown opposite), with the histogram shifted to the left, can suffer a loss of information, particularly in the shadow areas. If those areas are later brightened on the computer, the lack of information will be exaggerated in the form of noise (random variations of tonal and color values at the pixel level) and other problematic artifacts.

When setting your exposure and evaluating the results, you will need to weigh a variety of factors. If the subject is moving, or the scene is otherwise changing rapidly, you may not have time to change settings. And when the lighting is high-contrast, you may not have a lot of flexibility in terms of the exposure.

However, when the tonal range of the scene is relatively narrow, and you have time to make adjustments and evaluate your results, review the histogram as an additional tool for evaluating your exposure. If there is room to shift the histogram to the right without getting cut off at the right-hand edge, there is room for you to brighten your exposure. If you are using one of the semiautomatic shooting modes such as Aperture Priority (Aperture Value) or Shutter Priority (Time Value), you can apply a bit of exposure compensation to brighten the image. In manual mode, simply open up the lens aperture a little more, or use a slightly slower shutter speed. Just remember to change your settings back again!

Whenever you change your settings, remember that a more open aperture will reduce your depth of field, while a slower shutter speed may cause blurred motion.

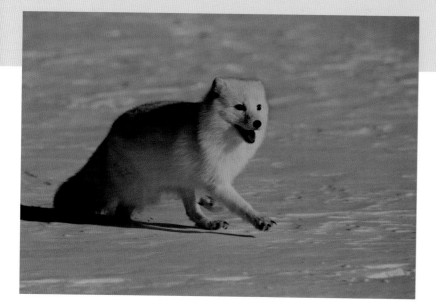

ARCTIC FOX, MANITOBA, CANADA

◄ If you rely on the camera's meter, you may end up with a less-than-ideal exposure. This image illustrates the camera's tendency to expose for middle gray values. The result can be reduced information and an increase in noise.

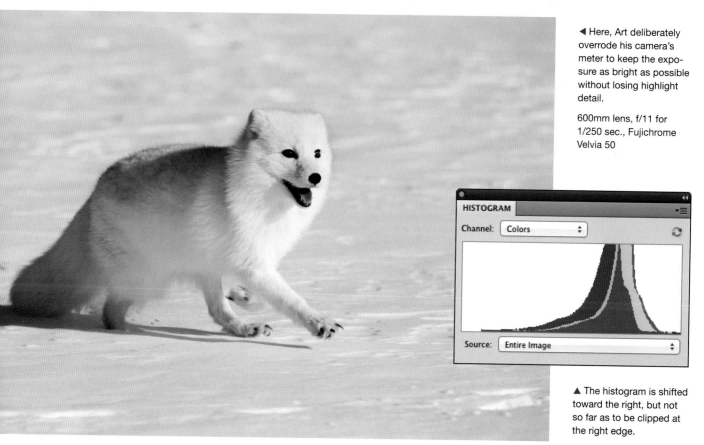

◄ Here, Art deliberately overrode his camera's meter to keep the exposure as bright as possible without losing highlight detail.

600mm lens, f/11 for 1/250 sec., Fujichrome Velvia 50

▲ The histogram is shifted toward the right, but not so far as to be clipped at the right edge.

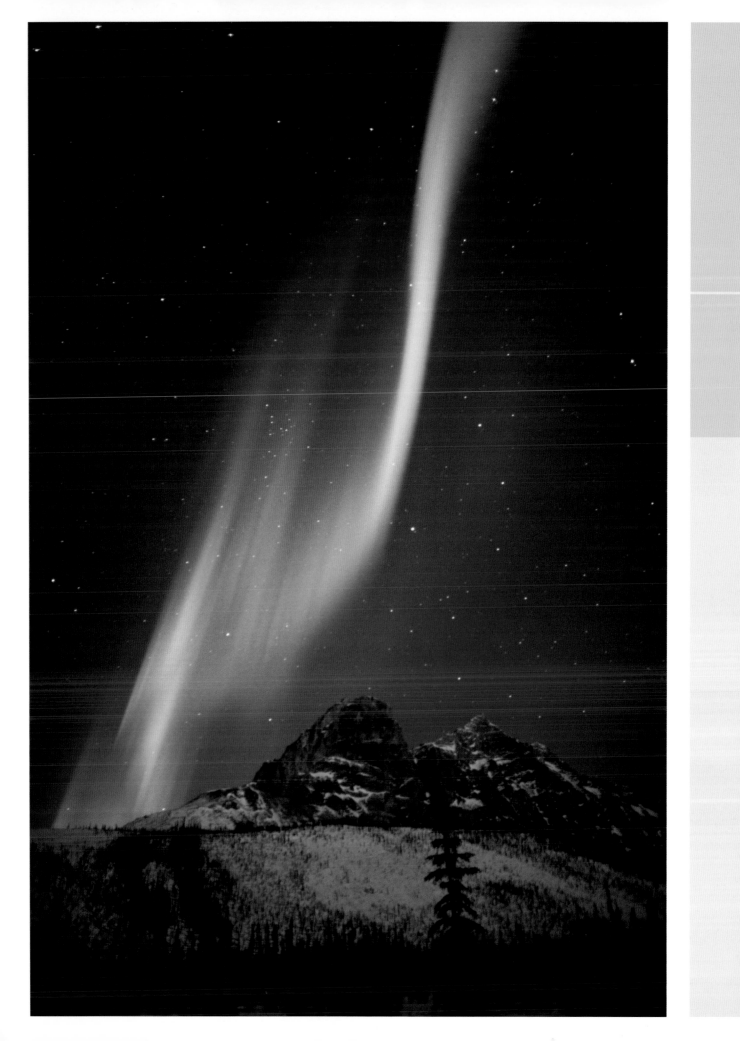

7 Creative Options

◄ AURORA BOREALIS,
BROOKS RANGE,
ALASKA

17–35mm lens, f/2.8 for
30 seconds, Fujichrome
Provia 400 film

The camera enables us to see and do things creatively that are beyond the capability of the human eye. It expands our range of seeing and gives us new options. Fast shutter speeds can freeze a moment in time that is too quick for the eye to see, and slow shutter speeds allow us to capture motion in a way we cannot experience. The simple choice of shutter speed, therefore, can have a dramatic effect on the final image.

At the same time, while our eyes can adjust focus to varying distances almost instantly, our depth of field is rather shallow. The camera lens, by contrast, is able to change the apparent depth of field, depending on whether its aperture is small or large. It is a property of lenses that the smaller the chosen aperture, the greater the depth of field. As photographers, we can take advantage of this, choosing to leave some things in focus while intentionally blurring others. This is *selective focus,* one of the many creative tools a photographer can use. (If you look again at the screech owl comparisons on page 47, you will see selective focus at work.) Other tools at the nature photographer's disposal include filters, flash, and High Dynamic Range (HDR) imaging. Together these allow us to move beyond a literal interpretation of the world we see.

Art generally uses only two filters for his photography: a graduated neutral-density filter to balance high-contrast lighting and a polarizing filter to reduce glare and reflections and intensify color. In the past, a photographer could be expected to carry an assortment of other filters to adjust for a variety of lighting situations, but one of the great advancements of digital has been the ability to make many of these adjustments in the camera itself.

And finally, the use of flash offers a means of expanding opportunities when light conditions aren't ideal. Although flash was once thought of as a tool just for shooting at night, it is increasingly useful in the daytime as well. Fill-flash can be used to fill in dark shadows in high-contrast situations, and to help restore the natural colors of your subject.

Using Shutter Speed to Isolate the Subject

AW In these photos of a brown bear at Brooks Falls, I shot the same animal in the same spot with two different exposures, the first at 1/125 sec. (below) and the second at 1/8 sec. (right). After about twenty minutes of observing this bear trying to catch salmon, I realized it wasn't going to be successful. I wanted to photograph it in an interesting way, so I tried to think of what else I could do. In the end, I decided to make the water a more important part of the composition. By shooting at 1/8 sec., the water's motion is blurred, in contrast with the stationary bear.

MH What makes the second image successful for me is that the water's motion is more apparent. Freezing motion at a fast shutter speed can make water look hard and brittle, more like liquid glass. Ironically, the slower shutter speed creates a stronger impression of water and its power, giving us a sense of the challenge this bear faces trying to catch fish under these conditions. The more literal first image does not make as strong an impression as the second image.

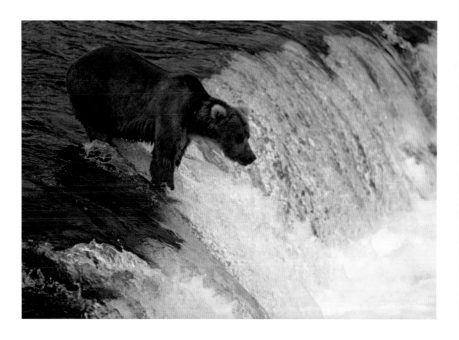

BROWN BEAR, BROOKS FALLS, KATMAI NATIONAL PARK, ALASKA

▲ 200–400mm lens (in 200mm range),
f/5.6 for 1/125 sec., Fujichrome 100

▲ 200–400mm lens (in 200mm range),
f/22 for 1/8 sec., Fujichrome 100

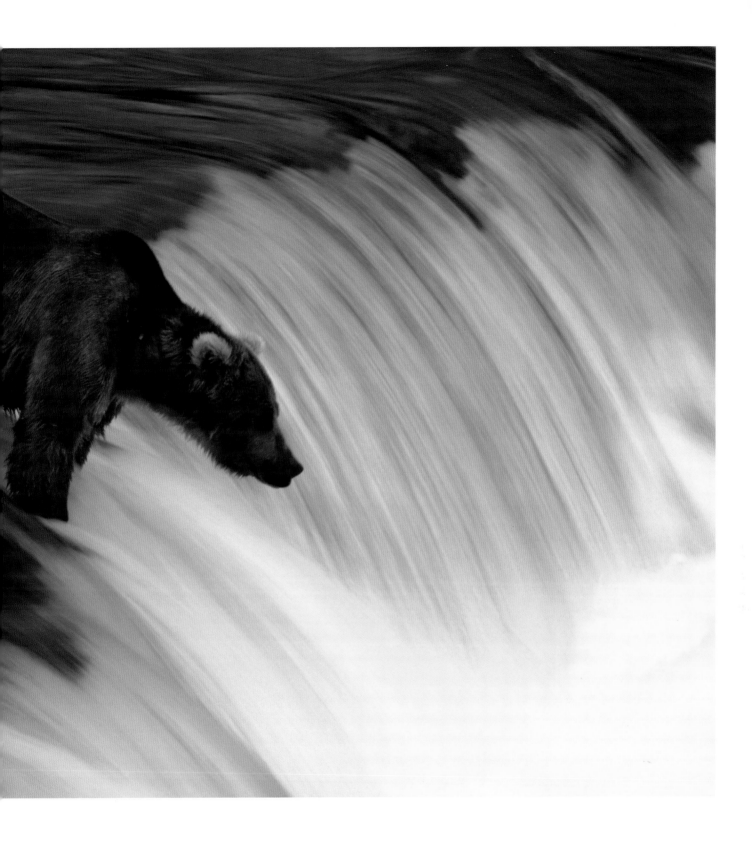

Shutter Speed: Still Camera with Moving Subject

AW In all of these images—a flock of snow geese taking off from a pond in New Mexico, a brown bear emerging from a river after fishing for salmon, and a scarlet macaw flying from a branch in the Peruvian rain forest—I left the camera stationary and allowed the motion of the animal to paint its image across the frame. This is one way to capture the sense of motion. The ideal shutter speed depends on the speed and direction of your subject. You may need to shoot a number of exposures and make adjustments in the field. In general, use as low an ISO as the conditions allow, a higher f-stop for a smaller aperture (more depth of field), and a slow shutter speed.

MH Animals, especially birds, are rarely stationary. Why not depict them as we experience them? In the snow geese image, you can almost hear the sound of all those birds in flight. What makes the picture strong, however, is that the sitting geese remain sharp, providing a nice contrast to the blurred birds in flight. In the bear image, choosing the correct shutter speed was crucial to making it work: too slow, and both water and animal would have been too blurred. Instead, Art found a balance of water motion and eye contact that lets us feel the power of the bear's action. What makes the scarlet macaw image work so well, meanwhile, is the counterpoint of crisp foliage and the slightly blurred wingtips of the bird in flight. With all three of these pictures, some part of the scene has remained in sharp focus to ground the overall image. If everything were blurred, the eye wouldn't know what was important.

The fact is, it is difficult to demonstrate a concept such as motion without showing blurred movement: even a Formula One racecar looks frozen in its tracks when shot at 1/1000 sec. Used sparingly, these kinds of images can have real impact and offer an artistic alternative to sharp, detailed compositions.

▶ **SNOW GEESE, BOSQUE DEL APACHE NATIONAL WILDLIFE REFUGE, NEW MEXICO**
500mm F4 lens, f/20 for 1/30 sec., ISO 800

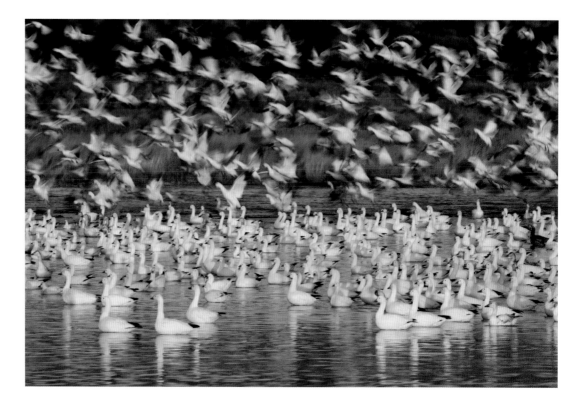

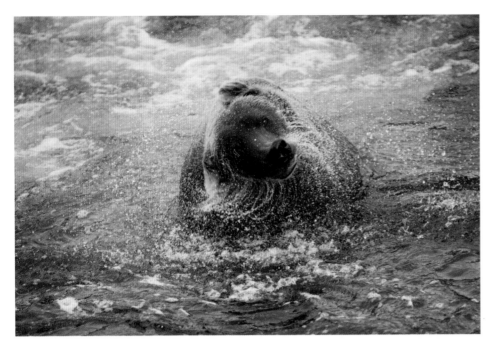

◄ BROWN BEAR, KATMAI
NATIONAL PARK,
ALASKA

70–200mm lens with 2x
teleconverter, f/5.6 for
1/800 sec., ISO 400

▼ SCARLET MACAW,
MANU NATIONAL PARK,
PERU

70–200mm F2.8 lens with
2x teleconverter, f/5.6 for
1/250 sec., ISO 500

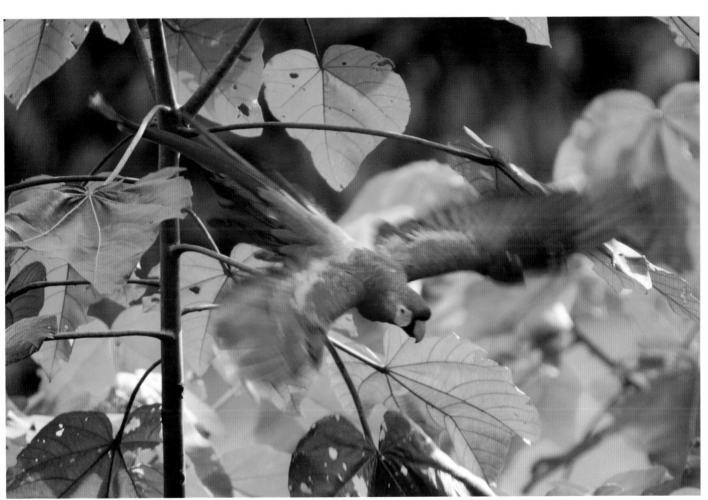

Shutter Speed: Panning Camera with Moving Subject

AW There are all sorts of ways to capture animals in motion. One of my favorite techniques, employed liberally in my book *Rhythms from the Wild,* is to pan the camera with the motion of the animals. This can transform a static image and give it more life.

In this next sequence of images—lions in South Africa, caribou in the Arctic, and an elephant in Kenya—I'm simply using a small aperture opening, therefore requiring a slower shutter speed. Then I lock the animals in focus, preferably on the eye, and pan with their motion. With this technique, it is critical that the camera pans at the same speed as the animals are moving. This allows a part of the moving animal to stay relatively sharp in comparison with the blurred background.

MH Blurriness has always been an issue in selecting images for publication; people tend to think that only sharply focused images can be published. At *Audubon,* we once ran a cover of daisies blowing in the wind that proved surprisingly controversial. But how better to illustrate the concept of wind than with something moving? Uniformly, though, photographers congratulated us for having dared to use it, and blurred images appear in print much more often today.

Speed, like wind, offers another conceptual challenge. Successfully capturing the perfect combination of blur and detail depends on how fast or slow a shutter speed you use, and experimentation is often necessary because of the unpredictability of the results. This kind of blurred motion may not be exactly what the human eye perceives, but it connotes the feeling of motion and life.

▼ LIONS, OKAVANGO DELTA, BOTSWANA
600mm lens, f/22 for 1 second, 50 Fujichrome Velvia

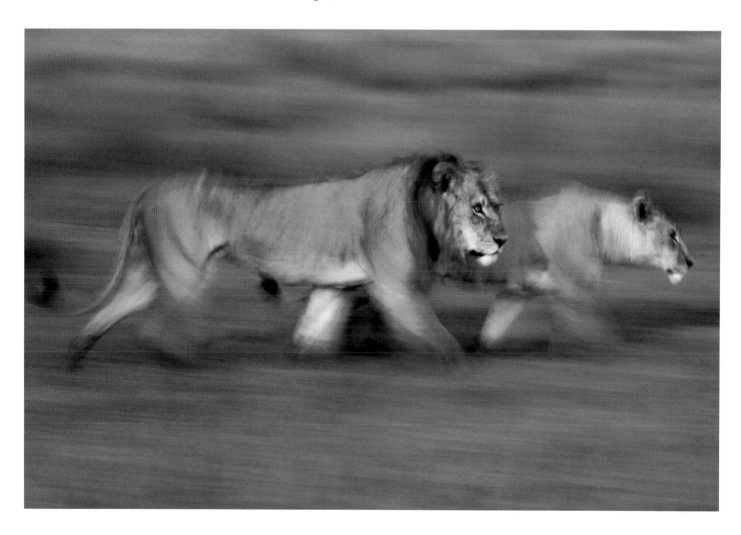

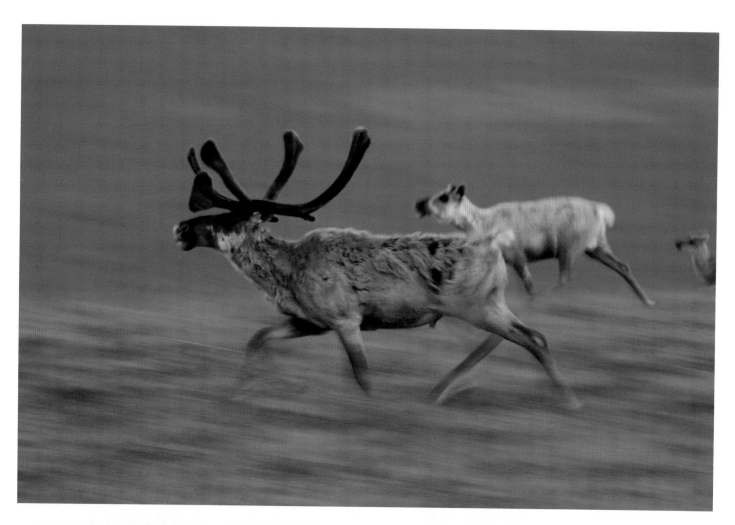

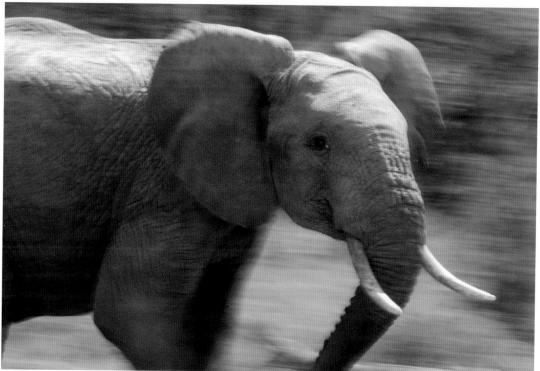

▲ CARIBOU, ARCTIC NATIONAL WILDLIFE REFUGE, ALASKA

500mm lens with 2x teleconverter, f/22 for 1/10 sec., ISO 200

◄ AFRICAN ELEPHANT, LAIKIPIA PLATEAU, KENYA

400mm lens, f/32 for 1/8 sec., ISO 100

Shutter Speed: Stopping the Action

AW In this set of images, I chose the fastest possible shutter speed to stop the action, capturing a frozen moment in time rather than a more impressionistic view. In the age of digital photogaphy, the ability to select higher ISOs and thus get faster shutter speeds allows me to capture moving subjects in sharp focus, although my preference is still for blurred motion.

MH The penguin shot is a wonderful example of allowing us to enjoy something unusual, in this case, a penguin "in flight." This is

▶ **GENTOO PENGUIN, ANTARCTICA**

70–200mm F2.8 lens, f/4.5 for 1/1600 sec., ISO 800

▼ **IMPALA, MASAI MARA NATIONAL RESERVE, KENYA**

600mm lens, f/8 for 1/500 sec., Fujichrome Velvia 50

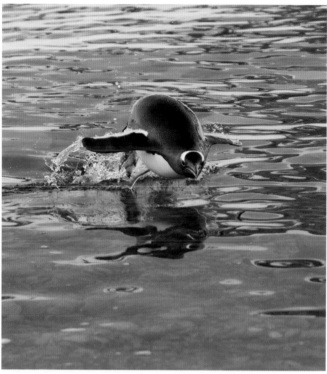

a split-second event and takes remarkable timing to capture with a camera. The result allows us to appreciate the penguin's torpedo-like shape, and understand a little better what makes them such speedy swimmers.

All of these images are examples of the camera being able to record something that is either too fast or too slow for the human eye to capture accurately. Fast shutter speeds enable us to savor moments of peak action at a later time and at our own pace. One of the greatest advantages of digital has been the ability to immediately see your results, allowing you to experiment and then make corrections on the spot. This can be especially valuable when testing different shutter speeds to gauge their effect.

▼ WHOOPER SWANS, HOKKAIDO, JAPAN
400mm F4 lens, f/6.3 for 1/1250 sec., ISO 400

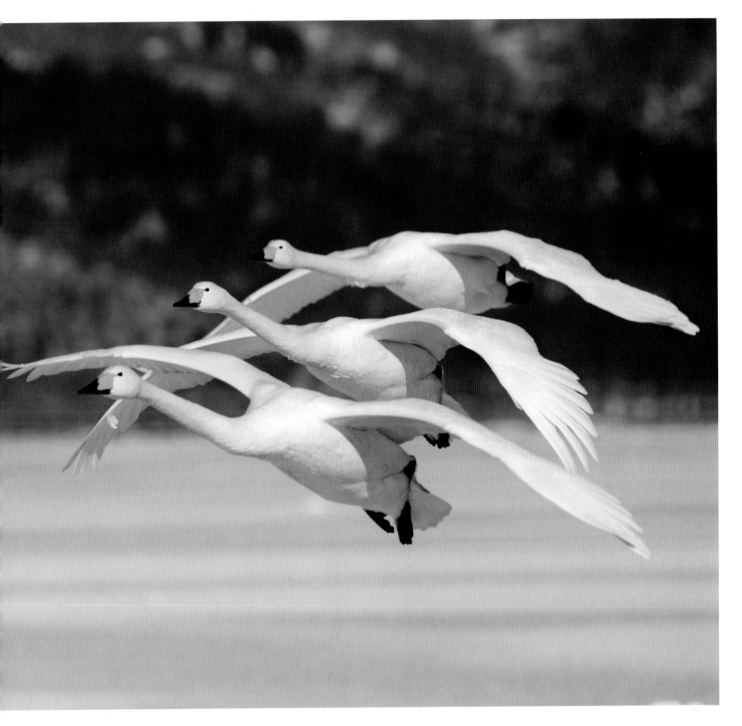

Understanding ISO

TG We often think of a camera's exposure being controlled by only two settings: lens aperture and shutter speed. However, there is also a third variable, the ISO, which is a measure of relative sensitivity of the film or digital sensor.

With film, we had the option to select a particular type based in part on its ISO: a low ISO (such as 100) meant that the film had a low sensitivity to light, requiring slower shutter speeds than might otherwise be possible. The reward was a finer grain structure, resulting in images that had a smoother appearance. Higher speed films (such as with an ISO of 800 or more) could be used in more varied lighting situations but also resulted in grainy images, which you might or might not like.

With digital photography things are somewhat similar, but with important differences. First of all, you can't actually change the light sensitivity of the image sensor in a digital camera. Instead, raising the ISO increases sensitivity to light through amplification applied to the signal gathered by the sensor.

As you can probably appreciate from having heard what happens to music when it is amplified significantly, raising the ISO setting on the digital camera can result in noise in the final image. Noise is represented as random variations in tonal and color values in the image, at the pixel level. The higher the ISO setting, the more amplification is applied to the image data, and the more noise you are likely to see.

To achieve the best image quality, use the lowest ISO setting possible. However, especially under low light conditions, when you are trying to achieve significant depth of field, or when you need a particularly fast shutter speed, you may need to raise the ISO setting.

Using the lowest ISO setting possible will help ensure the minimum amount of noise, but it is important to also be familiar with the noise properties of your digital camera. Take your camera out for a "test drive," capturing images of a variety of different subjects under different lighting conditions and capturing each scene with a range of ISO settings. You can then evaluate those images on the computer, zooming in closely to check the results. By reviewing the capture settings for these test images, you'll get a strong sense of the range of ISO settings that produce acceptable results in your camera.

Because noise can be such a significant factor in the final image, it is as important to pay attention to your ISO setting as it is to adjust the aperture and shutter speed to achieve an ideal exposure.

Using Slow Shutter Speeds to Capture Unusual Events

AW In most situations, nature photographers tend to photograph what is in front of them, but on occasion it is rewarding and thrilling to transform a scene and create something entirely new.

On Stromboli, an active volcano on an island north of Sicily, I put the camera on bulb and simply waited for an eruption to occur. Every 15 to 20 minutes there was an explosion, and the magma coming out of the crater painted its image across the open shutter.

In the image of circular star trails in the Namib Desert on page 158, I needed a double exposure and considerable planning. For the first of two exposures, I wanted a black sky while retaining detail in the landscape, so I combined a polarizing filter and a 2-stop neutral density filter, under-exposing the shot by a full stop. Then, at nightfall, I set the second exposure to bulb and opened the shutter for eight hours. As Earth rotates in space, the apparent motion of the stars creates gorgeous circles of light.

▲ **ERUPTION ON STROMBOLI, AEOLIAN ISLANDS, ITALY**
70–200mm lens, f/2.8 for 30 seconds, Fujichrome Velvia 50

◄ **MILKY WAY, BAOBAB ALLEY, MADAGASCAR**
16–35mm lens, f/2.8 for 30 seconds, ISO 800

In the lower image on page 157, I contrasted the beautiful, graceful lines of the giant baobab trees in Madagascar against the Milky Way. Just a handful of years ago, using film, getting an image of stars without motion was nearly impossible because of the long exposure required. Now, the higher ISOs of digital cameras allow us to use faster shutter speeds, making it easier to capture stars the way we see them, as pinpoints in the sky. To keep the camera stable, I use a tripod, a remote shutter release, Aperture Priority, and I compose the shot before setting the mirror lock-up. It is essential that the camera be absolutely still.

MH All three of these images show creative solutions to the challenge of nighttime photography. In the eruption and star trails, long exposures allowed the moving light sources to paint themselves on the sensor in a way that we could never see, and the results are graphic and astonishing, especially the circular star trails. However, I find the image of the Milky Way to be especially magical. While the baobab silhouettes anchor me to Earth, I have the feeling of being camped out under the vast, starry dome of the night sky.

▶ **STAR TRAILS, NAMIB-NAUKLUFT NATIONAL PARK, NAMIBIA**
Both exposures: 17–35mm lens, Fujichrome Velvia 50; 1st exposure: f/2.8 for 1/60 sec.; 2nd exposure: f/2.8 for 8 hours

Depth of Field: Stopping Down to Improve Composition

AW The first of these organ pipe cactus images was taken with an aperture of f/2.8, which gave me a very shallow depth of field (far left). The second, taken at f/8, shows how the middle-ground cacti start to come into focus (left), while in the third (below), at f/22, the entire picture is sharp.

MH This is an example where sharpness of focus is mandatory, not only for reproduction, but in order to make the clearest statement. In an image like this, where the eye must follow elaborate details throughout the picture space, it is jarring to have major elements blurred. Our normal expectation is to see everything in crisp detail, as our eyes do.

ORGAN PIPE CACTUS, ARIZONA
▲ 55mm macro lens, f/2.8 for 1/125 sec., Fujichrome Velvia 50

▲ 55mm macro lens, f/8 for 1/8 sec., Fujichrome Velvia 50

◄ 55mm macro lens, f/22 for 1 second, Fujichrome Velvia 50

AW The strong patterns and clean lines of aspen tree trunks have entertained photographers since the days of Ansel Adams and Edward Weston. Looking at this scene, I wanted every trunk to be in sharp focus. Stopping the lens down to f/22 made sure I got what I wanted.

MH I can't imagine either of these images with out-of-focus elements. The trunks of aspen trees cry out for crispness, with the black-and-white pattern being the most important design element. In the Death Valley image, the crisp focus allows us to savor the different textures and lines, giving us the feeling that the desert is infinite.

▲ ASPENS, MOAB, UTAH
70–200mm lens with 1.4 teleconverter,
f/22 for .6 sec., ISO 100

▲ SAND DUNES, DEATH VALLEY
NATIONAL PARK, CALIFORNIA
80–200mm lens (at 80mm range), f/22 for
1 second, Fujichrome Velvia 50

Depth of Field: Opening Up to Improve Composition

AW When photographing flowers, many people use maximum depth of field to make sure all the elements of the flower are in focus. They fail to use their depth-of-field preview button and to scrutinize the image in the viewfinder to make sure that what they are ultimately shooting will not be distracting.

Here are two shots of Indian paintbrush in the Canadian Rockies. The first (below left) was taken at f/22, but using the depth-of-field preview button, I found that the background was too busy. I opened up to f/8, which had the effect of diffusing the background and allowing it to recede behind the flower (below right).

MH Now we have the opposite challenge, where we do not want everything in crisp focus. Using depth of field, Art has managed to selectively choose which elements in the picture are in focus and which are not. Generally, close-up subjects are improved by softer, blurred backgrounds that do not distract the eye. Another way to achieve this effect is by using a telephoto lens, since they have very shallow depths of field at nearly all apertures. This is one reason, for example, why short telephoto lenses are often used for portraits of people.

INDIAN PAINTBRUSH, BANFF NATIONAL PARK, ALBERTA, CANADA

▼ 55mm macro lens, f/22 for 1 second, Fujichrome Velvia 50

▶ 55mm macro lens, f/8 for 1/8 sec., Fujichrome Velvia 50

DIGITAL WORKSHOP
Avoiding Heat Buildup

TG When photographing at night, very long exposures are often your only viable option. Many digital cameras will only allow you to use shutter speeds of up to 30 seconds, but you can achieve longer exposures through the use of a cable release with a long exposure function. However, when using extremely long exposures, you need to be aware of the issue of heat buildup for the image sensor. This heat buildup can lead to increased noise in the final image, and can also result in the camera automatically powering off to protect sensitive components. This is less of a problem when ambient temperatures are low.

To reduce this increased noise, take advantage of your camera's built-in long exposure noise reduction, if available. With this feature turned on, the camera will first record the actual exposure. It will then capture another image with the same exposure time, but with the shutter closed so that no light is reaching the image sensor. This "dark frame" exposure will be used to determine the noise signature of the image sensor under the present conditions, so the noise can then be more accurately removed from the final capture.

Because of these issues, many photographers who have embraced digital photography are still using film for star trail and other low-light photography that involves significantly long exposures. However, by employing the features offered by your digital camera, and perhaps using software to reduce the appearance of noise after capture, you can take full advantage of the benefits of digital photography even for extremely long exposures.

Graduated Neutral Density (ND) Filters

AW One of the most difficult outdoor lighting situations is a landscape with both bright highlights and dark shadows. The Grand Tetons in early-morning light was one of those tricky situations. In the first image (below), I exposed for the shadows. As you can see, the old homestead is in the mountain's shadow, clearly two f-stops darker than the sunlit mountains above (or two exposure values). In the second shot (bottom), I exposed for the mountain peaks, which leaves the shadowed areas too dense. For the third image (below right), I used a graduated neutral density filter to darken the bright peaks and sky, bringing the exposure values more in line with one another. The graduated filter made an otherwise unattainable photograph possible.

GRAND TETONS, WYOMING

▶ 80–200mm lens (80mm range), f/22 for 1/8 sec., Fujichrome 100

▶ 80–200mm lens (80mm range), f/22 for 1/30 sec., Fujichrome 100

While the eye can compensate automatically for different light levels and instantly see detail in both bright and shaded areas, the camera's sensor cannot. By balancing the extremes of contrast in the Tetons scene, Art ended up with the best possible image. In the first, the mountains look washed out. In the second, the foreground is too dark. The final version looks natural, the way we would actually see it.

▼ 80–200mm lens (80mm range), f/22 for 1/8 sec., with graduated neutral density filter, Fujichrome 100

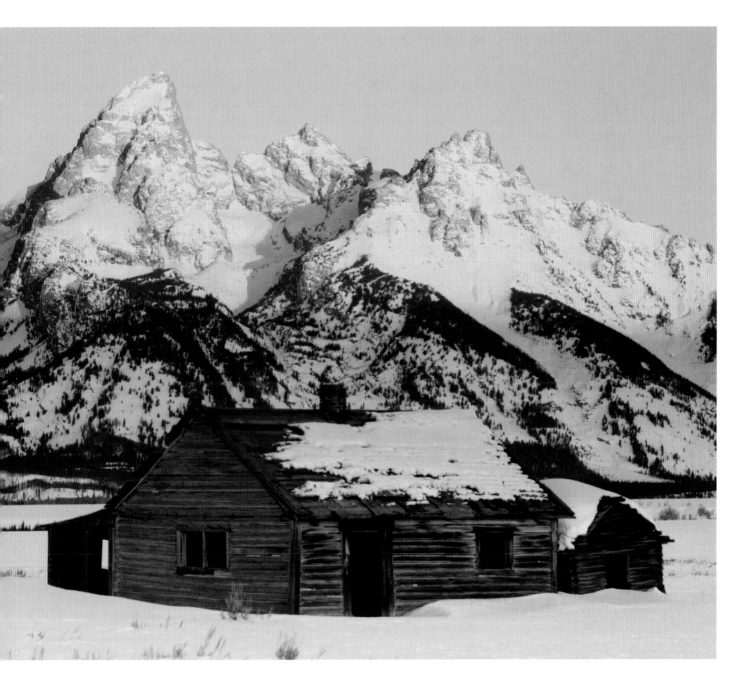

High Dynamic Range (HDR) Imaging

TG The *dynamic range* of an image is the ratio between measurable brightness and darkness. The problem is that camera sensors cannot capture the entire range between pure white and black in a single exposure. However, just because the image sensor in your digital camera isn't able to record the full dynamic range of a scene doesn't mean you need to compromise the level of detail in the final photo. Instead, try high dynamic range (HDR) imaging, in which you capture multiple images with different exposures, then assemble that information into a single final image in post-processing.

The first step in creating an HDR image is to capture two or more images; the exact number required depends on the dynamic range of the scene. Because you will be blending multiple images of the same subject, make sure the camera is mounted on a tripod to ensure the exact same framing for each capture.

Set the camera to manual exposure and adjust the aperture based on your desired depth of field for the final image; your aperture will remain constant throughout. The shutter speed should be based on an exposure that is as bright as possible without any loss of highlight detail (except specular highlights such as reflections from water, metal, or other shiny objects).

Make your first exposure, then adjust the shutter speed to darken the next exposure by one stop. Continue in this fashion, adjusting the exposure by one stop and capturing a frame, repeating until you have achieved the darkest exposure that still retains full shadow detail. The result will be a series of images, starting with an image exposed for the brightest area of the scene, and ending with an image exposed for the darkest area of the scene.

Eventually you will need to assemble these individual captures into a single image using software such as Photoshop. There are two general approaches, depending on the number of captures. If you only captured two or three images, you could assemble them into a single document in Photoshop and use layer masks to blend the best areas of each exposure into the final result. If you've captured more than two or three exposures (which is most likely when faced with high-contrast conditions), you'll want to use an automated approach to assembling the final result.

In addition to using Photoshop to assemble the final HDR image, there are also other software tools that produce excellent results. Two of the best are Photomatix from HDRsoft (www.hdrsoft.com) and HDR Efex Pro from Nik Software (www.niksoftware.com). Creating an HDR image certainly involves a bit more effort than a "standard" digital photo. However, the payoff is a unique (or creative) interpretation of a scene that would never have been possible with a single photographic capture.

The capabilities of digital cameras are improving all the time, expanding the dynamic range we are able to capture in a single frame. Some image sensors already use special designs to go beyond the inherent limitation of the photodiodes used to capture light. At the same time, cameras are now available with built-in HDR capability, blending multiple exposures automatically. All of these developments enhance the creative possibilities available to the photographer.

THE SUBWAY, ZION NATIONAL PARK, UTAH
When there is strong contrast in a scene, a single photograph cannot capture all of the detail from darkest shadows to brightest highlights. You can, however, capture a series of images at different exposures, such as the ones shown here, and then blend them together into a single HDR frame.

▲ 17–40mm lens, f/11 for .8 sec., ISO 100

▲ 17–40mm lens, f/11 for 2.5 seconds, ISO 100

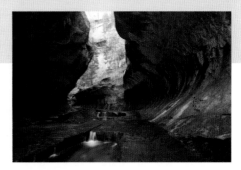

▲ 17–40mm lens, f/11 for 5 seconds, ISO 100

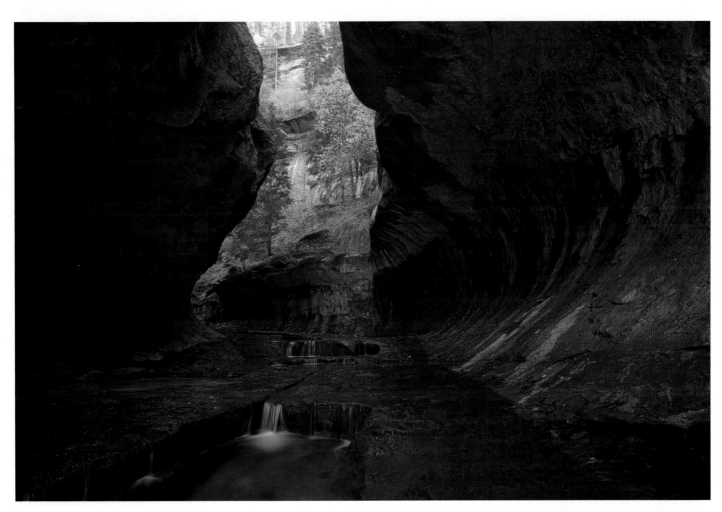

▲ The HDR composite, created with Photoshop's HDR Pro feature.

Polarizing Filters

AW Polarizing filters, I would have to say, are the filters I use more than any other, and I have one on every lens. I often shock my students when they see that I actually leave polarizing filters on my lenses and only take them off when I deem them unnecessary. Whether I'm shooting a dark green rain forest, the surface of a pond, or mountains in bright sunshine, polarizing filters are among my most valuable tools in the field. They can improve almost any image where water or sky are major elements, and by rotating the filter, you can see, and adjust, precisely for the results you want.

In these images, I was photographing ibex on a steep slope above Interlaken, Switzerland, but the harsh light rendered the image almost unusable (below). With the polarizing filter, I was able to reduce the reflections of the sky and remove the shine from the grass, resulting in more saturated hues (below right).

This same effect holds true for the lily pads comparison (on page 170). In the first shot (top) there is little color, but the polarizer brought out the color of the leaves, contrasting beautifully with the darkness of the deep water (bottom).

IBEX, INTERLAKEN, SWITZERLAND

▼ 70–200mm lens, f/18 for 1/15 sec., Fujichrome Velvia 50

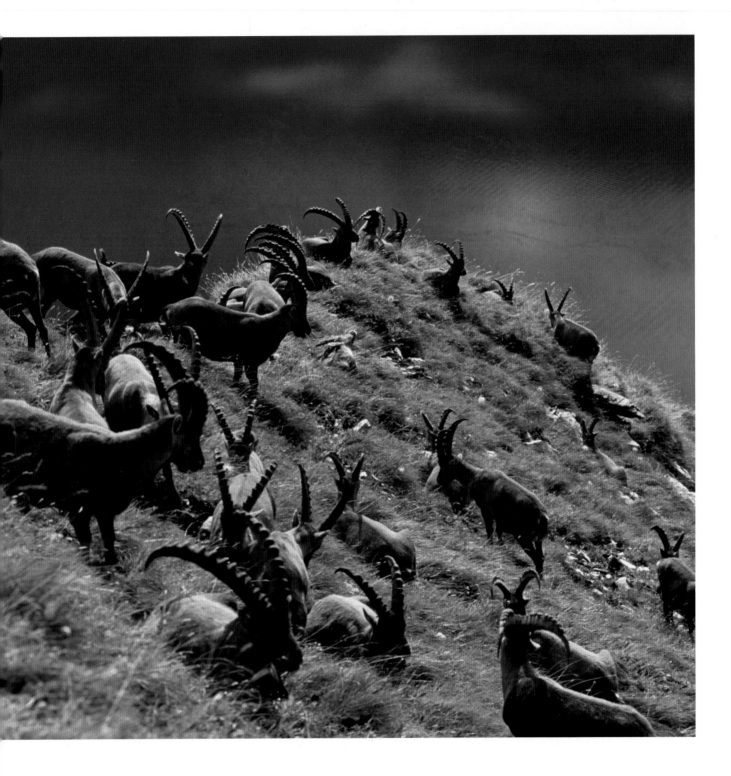

▼ 70–200mm lens, f/16 for 1/8 sec. with polarizing filter, Fujichrome Velvia 50

MH Generally, light waves radiate in all directions. But when they are reflected from a shiny surface, such as water in the case of Art's lily pad images, or the shiny wet grass in the Ibex images, they are reflected directionally, causing glare. This is sometimes referred to as a "specular" reflection because light is reflected back, the effect of which is to diminish apparent color (left). A polarizing filter can, when rotated, remove those specular highlights and thus allow the true color to emerge (below).

LILY PADS, OKAVANGO DELTA, BOTSWANA
◄ 70–200mm lens, f/25 for 1/4 sec., Fujichrome Provia 100

▲ 70–200mm lens, f/25 for 1/6 sec. with polarizing filter, Fujichrome Provia 100

Using Filters in Digital Photography

TG It is often suggested that, with the advent of digital cameras and software tools, there is no need to place a filter in front of your lens. For example, photographers have long used warming filters for color correction in shady conditions. Now, the same effect can be easily achieved by altering the white balance setting on the camera or later on the computer. It is even possible to improve upon the graduated split neutral density filter through the use of multiple exposures blended together with software such as Photoshop.

However, there are several filters that can still be very useful in digital photography. One of these is the polarizing filter. While computer software can approximate some of its effects, such as a darkened sky and more saturated colors, it can't replace the polarizing filter's ability to reduce glare and reflections.

Another useful filter is the simple (or variable) neutral density filter, which allows you to use a slower shutter speed when you want longer exposures, such as with images of moving water. The key is to consider which filters are unnecessary based on settings available in the camera and which filters remain valuable even with the most advanced digital cameras.

Adding Controlled Lighting: Flash and Fill-Flash

AW Sometimes it is necessary or desirable to use flash in the field, even during daylight hours. Normally, I use an external (hot shoe) flash unit for better lighting control. The first image shown here is of a northern pygmy owl peeking out of its nest hole in a ponderosa pine in eastern Washington. The hole was in the shade, so there was limited light, creating a fairly shallow depth of field and a bluish cast (below left). Since the animal was stationary within the tree, I was able to use flash to warm up the colors to a more natural hue (below right). Had he been moving around, flash would also have enabled me to stop the action of his movement, maintaining crisp focus.

MH In the comparison of the two pygmy owl images, the color is definitely more pleasing in the second image. Also, the increased depth of field makes it a more publishable shot because of its crisper focus. Some people find the multiple catchlights in the eye

an unnatural distraction, but with digital these can now be easily removed in post-processing, much like red-eye.

AW I often use flash when I am doing nighttime photography and I want a shot of an animal that simply would not be out during the day. In the image shown opposite (above), a giant anteater has emerged from the forest and is crossing open ground in the Brazilian Pantanal. Flash, along with an additional spotlight from my film crew, enabled me to get a shot that would have been otherwise impossible.

At times, the angle of the sun can prevent you from shooting without harsh shadows, as was the situation with the lemur, shown opposite, below. Half of its face was in shade, while the background was bright. I didn't want him to end up a silhouette, so by using the flash to fill in the unwanted shadow area, I could render more even lighting to the overall scene.

I feel that flash is often overused these days, and in workshops I advise my students to try to use available light first, since a single light source looks much more natural. Too often people just put on a flash and shoot, regardless of the direction of the sun, and the results look artificial, which is the exact opposite of what I try to obtain with my work.

NORTHERN PYGMY OWL IN PONDEROSA PINE, EASTERN WASHINGTON

▲ 80–200mm lens (80mm range), f/5.6 for 1/15 sec., Fujichrome Velvia 50

▲ 80–200mm lens (80mm range), f/11 for 1/60 sec. with flash, Fujichrome Velvia 50

The use of fill-flash in daylight has expanded the range of opportunities for nature photographers, enabling them to shoot under harsh lighting conditions, as Art did with the lemur, or to give a catchlight to the eye, render truer color, or otherwise balance uneven lighting conditions. It is now possible to shoot subjects at dusk, using the rich sky color as background while lighting the foreground subject with flash. When used subtly, this type of lighting can have an eerie quality, giving the final image a sense of mystery and drama.

▲ GIANT ANTEATER, PANTANAL, BRAZIL
70–200mm lens, f/4 for 1/15 sec., ISO 400

◄ SIFAKA LEMUR, MADAGASCAR
200–400mm lens (400mm range), f/11 for 1/60 sec. with fill-flash, Fujichrome Velvia 50

AW The first shot of these young long-eared owls is taken with available light at 1/60 sec. at f/5.6, making for a shallow depth of field (below). The owl farthest away is out of focus, so I decided to use flash to increase the depth of field, and a longer exposure to allow natural daylight to register a sense of place. In the second exposure (opposite, above), f/16 at 1/15 sec., the flash illuminated the owls while the shutter remained open long enough for the background trees and foliage to have a presence. In the third image (opposite, below), I used f/16 for 1/60 sec. to create the illusion of a nighttime shot, more in keeping with a person's expectation of seeing owls at night.

MH This comparison is interesting in that it shows you how the color of your subject can be affected by the light source. In the first image, because of the surrounding forest, the reflected light gives the birds a greenish cast. In the second and third shots, the use of flash restores the natural color of the owlets.

I personally prefer the middle image because it best captures the slightly spooky mood one associates with owls. It also gives better context to the birds than the all-dark, night-like background. In all fairness, though, all three images are publishable.

LONG-EARED OWLETS, EASTERN WASHINGTON

▶ 50mm lens, f/5.6 for 1/60 sec., Kodachrome 64

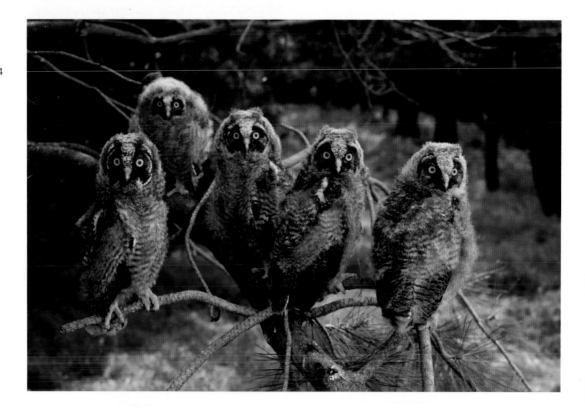

◄ 50mm lens, f/16 for 1/15 sec. with flash, Kodachrome 64

▼ 50mm lens, f/16 for 1/60 sec. with flash, Kodachrome 64

8 In the Field with Art Wolfe

◀ ART WOLFE PHOTO-
GRAPHING AFRICAN
ELEPHANTS, OKAVANGO
DELTA, BOTSWANA
Photo © Gavriel Jecan

When I first decided that I wanted to try to make a living from photography in the late 1970s, my biggest challenge was deciding what to photograph and how to market the results. Because I live in a beautiful part of the country, the obvious solution seemed to take pretty pictures of landscapes and get them onto the walls of the outdoor recreation stores in Seattle.

I spent a small fortune that first year making prints, and for the next year, I concentrated on marketing my prints through one store only, Recreational Equipment Inc., better known now as REI. A friend was writing a book on Indian baskets of the Pacific Northwest, so I offered to do the photography. Then the Army Corps of Engineers, who knew of my work from REI, called me to bid on a project that meant spending six months photographing every living creature in a valley that was to be dammed. I told them I'd do it for ten thousand dollars, and the next thing I knew, I had work for six months.

My next goal was to get published in magazines. I realized this meant coming up with story/photo packages, so I had to come up with an idea. I decided on something close to home—the Olympic Mountains. Over a succession of weekends during the summer, I trekked through the Olympics photographing animals of the high meadows, wildflowers, and panoramic landscapes. I was able to sell a story on the high, open ridges of the northeastern Olympics to *Pacific Search* magazine. The importance of being published in a regional magazine should not be discounted. It is usually easier to break in on a local level, where the competition isn't as stiff.

From there, I decided to broaden my horizons, still within mountain habitats, and cover the Rockies. Then I tackled the Oregon coast and the desert Southwest. All along, I kept looking for story possibilities and trying to get variety for each subject. If it was an animal, I planned for different seasons and habitats. Depth of coverage was my goal whenever possible, and still is.

Now that my photography career has spanned more than thirty years, I have witnessed extraordinary changes to the industry, in technology, business practices, and in the sheer numbers of people taking photographs, whether with simple point-and-shoots or elaborate systems costing tens of thousands of dollars. While the latter hardly ensures quality photographs, I have found that it is more the drive and willingness to get up and out the door that vastly increases photographic success.

Note: This is the first of three chapters sharing each of our individual areas of expertise. Here, Art offers experiences from the field. In Chapter 9, Martha explains the art of telling a story visually. And in Chapter 10, Tim shares his top technical tips for digital photographers.

▲ ART WOLFE, OLYMPIC
NATIONAL PARK,
WASHINGTON
Photo © Jay Goodrich

What's in My Camera Bag

I am often asked about the equipment I use, specifically cameras. I like to travel as light as possible. When I go on an extended trip, I generally pack two camera bodies, one to use, and one as a backup in case the first breaks down. In recent years, I've shot with the highest resolution pro digital camera offered by Canon: a 1DS, 1DS Mk 3, and now an EOS-1D X, an 18.1-megapixel brick of technology. The pro body is almost impervious to rain, snow, and dust, which is why I prefer it to other models like the cheaper 5D Mk 2, with its HD video and low noise capabilities.

I also limit myself to a few lenses most of the time, all of them Canon. More than half of my images are shot with either the 16–35 F2.8 Mk 2 or the 70–200 F4 lens, which is just as sharp as the much heavier and more expensive F2.8 version. If I need a more powerful telephoto, I reach for the 400mm DO; if I know I'll be shooting a lot of wildlife, the 500mm F4 comes along. I also take 1.4x and 2x teleconverters, graduated neutral density filters, and polarizing filters. For stability, I carry a sturdy carbon fiber tripod and ball head. Of course, with digital, I travel with a laptop and two extra hard-drives for backing up my images on location. That's it for 90 percent of my work.

Animals: Human Interest

When it comes to photographing animals, anthropomorphic images, where the animal takes on what we perceive as human characteristics, will always connect better with viewers than a straight natural history shot. The picture shown here of a baby giraffe appearing to kiss its mother, for example, shows a moment everyone can identify with. Rarely do you see photographs of giraffes where much emotion can be attributed. The poignancy of the mother/child relationship is also evident in the shot of an emperor penguin arched over her chick (see page 181) in a very graceful and tender way. I zoomed in to capture just the essentials; showing all of the birds was unnecessary.

▲ **ART WOLFE AND MADAGASCAR GIANT CHAMELEON, TOAMASINA PROVINCE, MADAGASCAR**
Photo © John Greengo

▲ **RETICULATED GIRAFFE AND CALF, OKAVANGO DELTA, BOTSWANA**
400mm lens with 1.4 teleconverter, f/8 for 1/250 sec., ISO 200

Humor is another popular angle. Whenever I've been able to capture an image of an animal doing something that seems funny to the viewer, they have always been much more successful than just straightforward portraits. The photo of a mountain viscacha, a three-pound relative of the chinchilla, adds comic relief to an otherwise routine grooming session. You can't help but smile at its big dog stretch and lopsided yawn. In the shot of the grizzly, the bear was moving across an open slope and suddenly it sat down, raised its leg, and started to scratch—hardly the posture of a fierce predator, nor typical of what we might expect. At the time, it seemed funny to me—like Yogi Bear taking a relaxing scratch—and it has proven to be one of my more popular images.

▶ GRIZZLY BEAR,
DENALI NATIONAL PARK,
ALASKA

200–400mm lens (400mm range), f/4.5 for 1/125 sec., Kodachrome 64

▶ MOUNTAIN VISCACHA,
BOLIVIA

70–200mm lens, f/8 for 1/250 sec., ISO 100

▶ EMPEROR
PENGUIN AND CHICK,
ANTARCTICA

70–200mm lens, f/8 for 1/60 sec., Fujichrome Velvia 50

Animals: Getting Close

When I photograph wildlife, I love to use all the different angles available. From tight portraits to shots that convey a sense of place, to intimate abstracts—all these are ways of capturing a variety of animals. Over the years I have realized that if I maintain a very calm mental condition and move slowly and low to the ground, I can often get very close to my subjects. This way, I present a less intimidating profile than if I were walking, no matter how slowly, toward the subject.

Of course, there is an element of danger and of being so close that I will upset the animal, possibly encouraging it to do something unpredictable. I generally know when an animal is getting stressed by reading its behavior. If it remains calm, as I remain calm, that's when I get my best results. Animals have very acute senses and can pick up human stress and anxiety. If you're stressed about the situation or anxious that your camera's not working, it can be picked up by the animal. So, the lower the profile I can take and the more slowly I move, giving the animal time to adjust to my new positioning, the more success I have.

It should be emphasized that approaching wildlife in this fashion takes patience, time, and experience. I have learned, over many years, how to avoid putting myself or my subjects at risk by carefully observing the animals' reaction to my presence. Photographers should always avoid interfering with animals' resting, feeding, and nursing behavior. It is never acceptable to harass wildlife in pursuit of an image.

Getting close to snow monkeys, as macaques are commonly called, is easy as they have been protected in Japan for years and are habituated to humans. Their comfort resulted in many wonderful opportunities for observing their behavior and inter-actions as they bathed and played in the nearby thermal hot springs.

Other animals are completely unafraid because they have little or no human contact, such as the eider, and do not see humans as predators. In the image below, I placed her face directly in the center, allowing the pattern of her feathering, meant for camouflage, to radiate out and fill the frame.

▼ COMMON EIDER, ARCTIC NATIONAL WILDLIFE REFUGE, ALASKA

70–200mm lens with 2x teleconverter, f/25 for 1/640 sec., ISO 400

In the gecko image shown below, it's the strong eye contact that makes the image successful. The decision of where to focus was critical, so I used a shallow depth of field that allowed me to really focus on the eyes and create a soft, undistracting background.

One way to get closer to wildlife is to get them used to your presence. This takes patience and time. To capture these shots of a fox family in Chile (opposite), I set up three sticks with a bag on top near their den site. This assemblage was meant to simulate my camera equipment. After three days I went back and replaced the decoy with the camera and tripod; the foxes were completely unfazed by the change in equipment. To photograph them, I used an automatic center-weighted setting to accommodate changing light levels and a remote shutter release so I could stay seventy-five yards away. This is what you see in the first image.

Finally, I found that the foxes cared so little about my presence that I was able to take a very low profile and approach them slowly. Then I was able to get the wonderful behavioral shots of their interactions.

▶ **GECKO, NAMIB-NAUKLUFT NATIONAL PARK, NAMIBIA**
70–200mm lens, f/16 for 1/5 sec., Fujichrome Velvia 50

**ARGENTINE GRAY FOXES, TORRES
DEL PAINE NATIONAL PARK, CHILE**
▲ 17–35mm lens, f/16 for 1/30 sec.,
Fujichrome Velvia 50

▲ 70–200mm lens, f/5.6 for 1/125 sec.,
Fujichrome Velvia 50

▲ 70–200mm lens, f/5.6 for 1/125 sec.,
Fujichrome Velvia 50

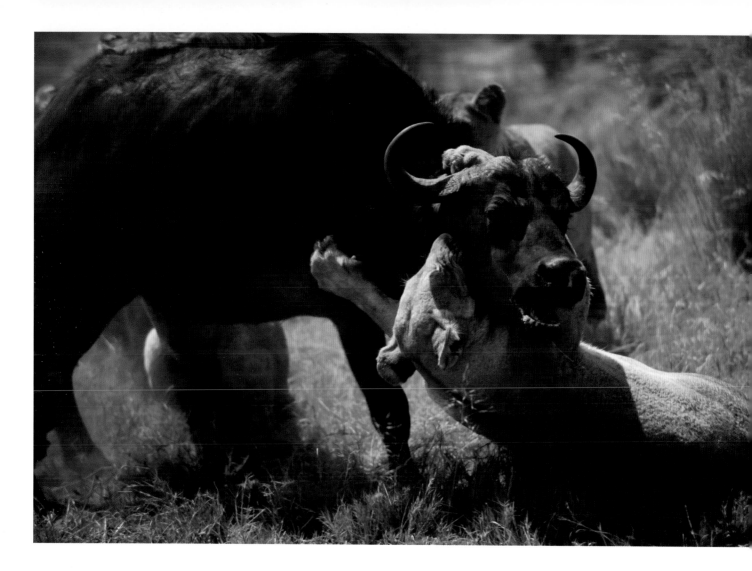

▲ AFRICAN LIONS
BRINGING DOWN CAPE
BUFFALO, OKAVANGO
DELTA, BOTSWANA

600mm lens with 1.4
teleconverter, f/5.6 for
1/500 sec., Fujichrome
Provia 100

Capturing the
Decisive Moment

Henri Cartier-Bresson coined the expression
"the decisive moment" to characterize the instant
of peak action, or most revealing behavior, that
we hope to capture with the click of the shutter.
Today's cameras have the capacity to shoot con-
tinuously, which makes it much easier to capture
those fleeting moments, especially in fast-moving
wildlife photography. Autofocus lenses also
increase the likelihood of success with a moving
subject. But even with all the automatic assists,
you still need to be alert to the potential, and
ready with your exposure and framing. The eye
and the mind are still the most important creative
tools we have.

In the image above, lions have approached
a large herd of Cape buffalo in Botswana's
Okavango Delta. This drama plays out daily and
is extraordinary to watch. The lions are clearly

outnumbered by the powerful buffalo, but they
know the herd behavior and are able to separate
the weakest animal from the rest and take it down.
Sometimes the herd will double back and chase
off the marauders, but more often than not, the
lions will have a successful hunt.

From a photographic point of view, you don't
want to be so close to the action that you thwart
the kill; these takedowns and kills, though difficult
to watch at times, are absolutely necessary to the
lions. On this day, there were three mothers with
four small cubs nearby and nourishment from the
buffalo herd was essential.

Anticipating the moment an animal decides to
move is the key to graphic wildlife photography.
In the first of this series of images of fish eagles
along the Chobe River, I was on a boat that kept
drifting closer and closer to where the eagles were
perched. I kept watching their behavior, knowing
that eventually we would be at the base of the
snag they were perched on, not high above the
surface of the river. I determined the necessary

shutter speed, ISO, and exposure to stop the motion of the bird should one take flight. All that was left was to maintain the eagle within the frame as it took to the air and flew by.

The second shot, where the bird is lifting off the branch, is somewhat awkward. It's the third shot that is my clear favorite; it's the decisive moment—that click when everything worked. Both the bird in flight and the one behind are tack sharp and fit within the relatively small frame.

In this situation, determining the shutter speed was critical. If I want to freeze action, I make sure my shutter speed is at least 1/500 sec., if not higher. When I want to capture a sense of movement and emotion, on the other hand, I use a higher f-stop and a correspondingly slower shutter speed. But most times when I am shooting a bird in flight, I'll go for the fastest shutter speed possible to get definition in every feather in its wings.

AFRICAN FISH EAGLES, CHOBE NATIONAL PARK, BOTSWANA
All images: 500mm F4 lens, f/8 for 1/2500 sec., ISO 400

Making the Most of Atmospheric Conditions

There is magic for me in photographing the unpredictable and varied lighting conditions I encounter in the field. I love shooting at the edges of a storm and in the margins of the day. If it's raining, snowing, windy—all those conditions often translate into images that go beyond standard landscapes.

Fog, for example, can be a photographer's best friend. In the image of Huangshan in eastern China (one of my favorite places on Earth), shards of rock rise out of the swirling mists while a secondary pinnacle of rock is host to twisted pine trees, shaped by relentless winds. The fog shrouds unnecessary detail and reduces the picture elements to shapes and overlapping layers, as the background recedes into the mist and almost disappears. The whole scene showcases a very hard substance in a soft way, rendering the image into something that looks more like a watercolor painting than a photographic landscape.

In the image of redwoods, a foggy atmosphere filtered the light and created what are often referred to as "God-beams," rays of light that conjure up visions of heavenly angels. I positioned myself so the trunk of the tree in the foreground obscured the brightness of the sun and allowed the rays to be properly exposed. Had I included the sun in the image, it would have been too bright, overwhelming the rays. The combination of the mist rising from the nearby Pacific Ocean, the descending sun, and these magnificent trunks all

▶ **PINE TREES IN MIST, HUANGSHAN, CHINA**
50mm lens, f/11 for 1/15 sec., Kodachrome 64

▶ **SUN RAYS IN REDWOOD NATIONAL PARK, CALIFORNIA**
80–200mm lens, f/22 for 1/8 sec., Fujichrome Velvia 50

came together in a very graphic way. The vertical columns of the trees are a nice counter to the diagonal slicing of the sun's rays, and warm afternoon light accentuates the image perfectly.

I also used a long shutter speed in the image of visitors passing through a bamboo forest in Kyoto's famous Temple District. Each fall, when the maples turn red, tens of thousands of Japanese make a pilgrimage to the ancient temples and their exquisite gardens. I think the pastel colors and blurred motion of the umbrellas counter the bold shapes of the bamboo, creating something unexpected. An off-center composition keeps the image from being static while the diagonals lead us through the picture space to the bright focal point.

▲ BAMBOO PATH, KYOTO, JAPAN
70–200mm lens, f/5.6 for 4 seconds, ISO 100

Violent, dramatic skies over expansive land-scapes offer another great opportunity. Here, a threatening sky over the Mongolian steppe indicated a giant thunderstorm heading our way. Shafts of light came down through a break in the clouds, illuminating a small farm and the verdant pastures surrounding it. This scene was absolutely magical to me. We are much more used to seeing landscapes where the sky is brighter than the land, but in this case, the distant rains were darker and more brooding. This translates into more drama, which leads to a more memorable image.

◀ APPROACHING
STORM OVER FARMS,
MONGOLIA
70–200mm F4 lens, f/5 for
1/250 sec., ISO 100

Working the Image

People sometimes imagine that great photographs are composed in a flash of inspiration, arriving in the world fully formed. While that can happen, most of the time we fumble toward a great shot, refining the composition with each exposure. This was certainly the case with my image *The Night Fishermen.* I will lead you through the process of steps it took to get there.

For centuries, fishermen on the Li River of Southern China have partnered with cormorants to catch fish. Each fisherman has a complement of a half dozen or so trained birds. The light of a lantern attracts the fish, and the cormorants catch the fish and return to the boat, fish in beak. The birds can't swallow the fish because the fishermen fix bands around their necks, but they eventually get their share.

While the fishermen are working, they see enough tourists to know that a few minutes posing can yield as much money as a night's work. After a few moments exchanging hand signals, we came to an agreement. In the first image (opposite, top left), I grabbed a shot of two fishermen approaching the shore. Unfortunately, nothing works here. A bright background throws the men into silhouette, some of the birds sit with their heads buried under their wings, and the composition is deadly static. I decided to try adding a second light to tame the contrast and provide a better sense of separation for the fishermen.

For the second shot (opposite, top right), I tried a simple flash but it overpowered the background. Even with gels to match color temperature and knocking down the power by a stop or so, I could tell I wouldn't get the result I wanted unless I could choreograph everything, which was out of the question given the circumstances. I needed better conditions, not better technique.

By the time I was ready for the third shot (opposite, bottom left), a darkening evening sky balanced the light somewhat. A 23mm focal length gave me the depth I wanted and, combined with an f/8 aperture, enough depth of field. Although blurred moving birds ruined most of the shots, they also blocked direct light from the lanterns. I was making progress.

By the fourth shot (opposite, bottom right), the light was getting good, but the composition was still too tight. I needed space for the image to breathe. Also, I was getting so close that the cormorants were becoming agitated.

**NIGHT FISHERMEN, LI
RIVER, GUANGXI, CHINA**

▲ 16–35mm lens (for 24mm), f/10 for 1/5
sec., ISO 400

▲ 16–35mm lens (for 22mm), f/10 for 1/5
sec., ISO 400

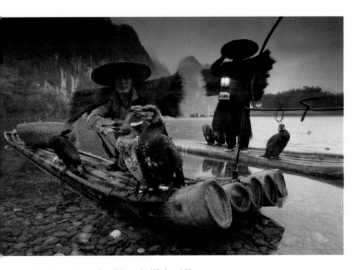

▲ 16–35mm lens (for 23mm), f/8 for 1/3
sec., ISO 400

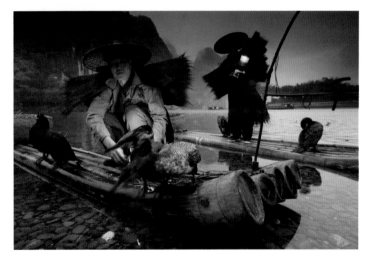

▲ 16–35mm lens (for 23mm), f/8 for 1/5
sec., ISO 400

The fifth image (below left), is a vertical. Everything is working here. The light was coming alive. I still preferred the horizontal composition, but I often license images for magazine covers or ads, which usually require vertical compositions. Never turn your back on a sale, I always say.

Finally, with the final shot (below right), it all came together. The cormorants stood stock still, heads up and blocking the lantern light like champions. The fishermen, now bored out of their skulls, were occupied with their tasks, transforming a posed image into a genuine candid shot. The light was in perfect balance: background, foreground, and warm lantern fill. The fisherman received their tips, I had my shot, the cormorants swallowed some morsels, and everyone was happy.

NIGHT FISHERMEN, LI RIVER, GUANGXI, CHINA

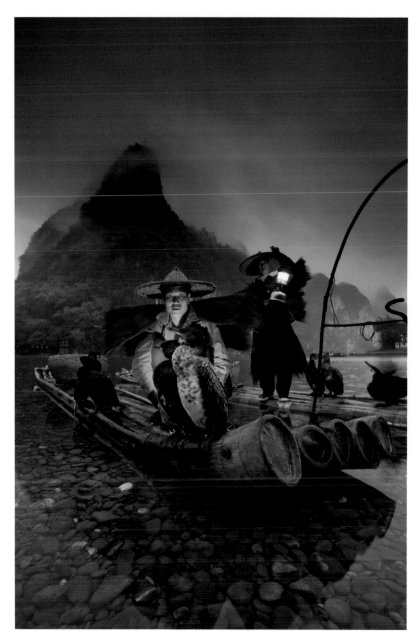

▲ 16–35mm lens (for 17mm), f/8 for 1/3 sec., ISO 400

▶ 16–35mm lens (for 16mm), f/8 for 1/3 sec., ISO 400

Tripod or No Tripod?

You may have heard photographers, including myself, say that using a good tripod is one of the easiest ways to take your photography to the next level. While this is more the rule than the exception, there are some situations where it is more practical to get the shots you want without one.

For example, here is a shot I took on the Antarctic Peninsula. There was a rookery of chinstrap penguins on a hill above me, and the birds were on constant parade coming and going from the rookery to the ocean and back again. In this case, using a tripod would have been a nightmare.

By hunkering down in the rocks with my camera off the tripod, I was able to offer a different point of view and maneuver ever so closely until they were walking toward me. A wide-angle lens with a polarizing filter softened the harsh light and made the best of a less-than-ideal situation. I bumped up my ISO to 400, which was more than enough to allow me to stabilize the camera as well as maintain deep depth of field. I wanted to be shooting around f/16 so the background of Antarctica—the icebergs and distant mountains—would be sharp, and part of the story. For me, this whole photographic composition was about giving the chinstrap penguins a sense of place.

▼ **CHINSTRAP PENGUINS, ANTARCTIC PENINSULA**
16–35mm F2.8 lens, f/11 for 1/320 sec., ISO 400

DIGITAL WORKSHOP
Adding Location Information to Your Photos

TG Often the specific location in which you captured a photo is important in some way. You may want to be able to return to the same spot another time, identify the location and subject later in a photo album, or tag your photo in an online album.

You're probably already familiar with the ability to store metadata as part of your digital photos. Your camera already stores information such as the aperture, shutter speed, and other settings into the metadata so you can refer back to it later. Among the many fields available for adding metadata to your photos, there is an option to include GPS coordinate information. This information is stored as latitude and longitude coordinates, which makes it easy to locate where a photograph was taken on a map.

The first step is to include GPS coordinate information in your photos. For certain cameras you can purchase a device that plugs into the camera and enables GPS coordinate information to be added to the photos when you take them. Another option is to use a separate GPS device (or even an application on a smartphone) to record your movements when you are photographing. Make sure both the GPS device and your camera are set to the same time, then simply record a GPS track log with your device while taking pictures. Later, you can associate that track log with your photos so location information can be added to the images in a relatively automated way later.

And of course, using various software applications, you can also simply add location information to your images after the fact, typically done with a map that allows you to navigate around and then identify where each image was captured.

Adobe Photoshop Lightroom 4 includes a new Map module, which makes it easy to add and review location information. If you are using a device that interfaces with your camera (or a camera that includes a built-in GPS receiver), then images will include GPS coordinate information automatically, which will appear as pushpins on the map. If you recorded a track log while capturing your images, you can load that track log and then associate images with the log, so they, too, will appear on the map. For images that don't contain location information, you can simply drag them onto the map to have GPS coordinates added to their metadata. To refine location information for any image, just drag the pushpin around on the map.

9 An Editor's View

◄ TIGER, BANDHAVGARH
NATIONAL PARK, INDIA
70–200mm lens, f/2.8 for
1/1000 sec., ISO 500

As picture editor at *Audubon*, my most important concern was finding original and striking images for our readers to enjoy. The magazine's mission was to inspire our members to actively care about the conservation issues we presented, and one way to do that was with powerful photographs. A still photo has just that—great power—and the capacity to move us and linger in our memories.

Photographing wildlife and nature requires time, patience, and a fair measure of luck. Most print and online publications simply do not have the budgets to send photographers into the field for weeks or even months at a time to shoot a story. Yet rarely can you expect top-quality wildlife coverage within a more limited time frame. For that reason, it's particularly rare for editors to assign wildlife subjects, and instead they depend on photographers to bring those kinds of stories to them. These stories are often from highly motivated individuals who are willing to devote long periods of time to capturing unusual subjects, often very close to home.

One of the great pleasures of being an editor is being surprised by unexpected images. I remember being bowled over by a photo essay submitted by one of our regular contributors who had taken a new look at one of nature photography's oldest clichés: the dew-covered spiderweb. He hadn't needed to travel to an exotic destination. He merely put on a macro lens and extension tubes and went looking for pictures in his own backyard. The resulting images were like strands of precious gems—iridescent, stunning, and elegantly graphic. In another instance, a photographer had ingeniously devised a floating blind to allow eye-level portraits of migrating waterfowl. The result was a completely new perspective on a very familiar subject. Both of these were examples of story packages that came in unsolicited, but that we instantly recognized as visual treats that would delight our readers.

With the digital revolution in photography, many things have changed, such as the ease and speed of submitting images to a publication for review. But one thing has not changed: editors are still looking for terrific, useful pictures. And for photographers hoping to get published, my best advice is the same as it has always been: make sure your submission is appropriate for any publication you approach, and edit your material ruthlessly.

One unexpected benefit of digital capture is that it has forced photographers to learn to edit, since most take many more images than they did in the days of film and processing. Editing is an important skill; a poorly edited photo submission will jeopardize your relationship with that editor by casting doubt on your picture judgment and leaving a poor first impression.

Just as editors need photographers, many photographers can benefit from working with editors. Editors depend on photographers to provide innovative material we'll want to publish. At the same time, editors can help photographers evaluate their work and pick out the truly special images. Often I would choose something a photographer would later confess to having only submitted at the last moment, hesitant as to whether or not it would be acceptable.

I suspect every photographer has pictures he or she is particularly attached to, either because they were extremely hard to get or because they record a memorable experience in the field. But difficulty of capture does not always translate to being the best image; an editor can provide the detachment and perspective that comes from looking at lots of images, while at the same time keeping the needs of a potential story firmly in mind.

When approaching an editor, remember that the freshness of your work may count more than the subject matter. Few editors will want to wade through even the most exhaustive coverage of Yellowstone wildlife, a subject thousands of photographers have already covered well, unless they see a new approach. Invariably, they want to see something striking, pictures that will stop them in their tracks. If you can get coverage of something unusual, or something familiar captured in an unexpected way, your chances of being published are vastly improved.

For most publications, a good picture story is one that communicates to readers without needing much text. This makes it an instant winner, as most magazines, both print and online, like to have visual variety and story packages they can plug in anywhere. Yet visual storytelling is very different than taking a single stand-alone picture, no matter how stunning. Shooting a picture story is an art in itself, one that many photographers never master. If you can, you will likely see your work in print—and editors will love you.

▲ I pulled this series of thirty-two images on tigers from Art's files, to demonstrate what goes into creating a picture-story package.

Telling a Story Visually

More and more magazines are looking for complete picture-story packages; it's often easier to buy a complete package than to research material from different sources. Telling a story in pictures is much like telling one with words. All good reporters learn to answer the questions Who?, Where?, What?, When?, and Why? A picture story should visually answer the same questions.

To demonstrate what goes into creating a picture story, I pulled a series of thirty-two images on a single subject—tigers—from Art's files. I pulled images that I liked, or that I thought made a point, knowing that most published stories end up using half that number or less. The "approved" indicates my final edit of eighteen for the story.

The first step was to choose a subject and theme for the story. Our subject is tigers. Only around 3,000 tigers still exist in the world, from an estimated 100,000 a century ago. Nearly half the remaining tigers, about 1,400 animals, live in India.

Since all of the images were taken from the same area—tiger reserves in Madhya Pradesh and Rajasthan—but consisted of many different individuals, the story could not be about one tiger in particular. It would therefore have to be more general—about tigers, tigers in India, or some aspect of tigers' lives. I ended up choosing the theme "Tigers versus Tourism," inspired by a recent controversial proposal in India to ban tourism from the core areas of tiger reserves. It's a significant issue; tourism brings in $100 billion of revenue each year, spent by some 17 million foreign visitors.

Opening Spread: Who?

In telling a story, one must have an opening, whether with words or images. The idea is to pique the reader's interest. For our opening spread, I wanted to introduce our subject—the tiger—and then connect him to the tourism angle, in this case with an image of tourists jamming the road. Their juxtaposition makes you wonder, "What is going on here?"

I could also have used the lying down tiger blown up to cover the entire spread. It would be lovely and elegant, and we could drop our title out of the dark space in the upper left. But I felt that adding the tourism shot at the opening was important to set the stage.

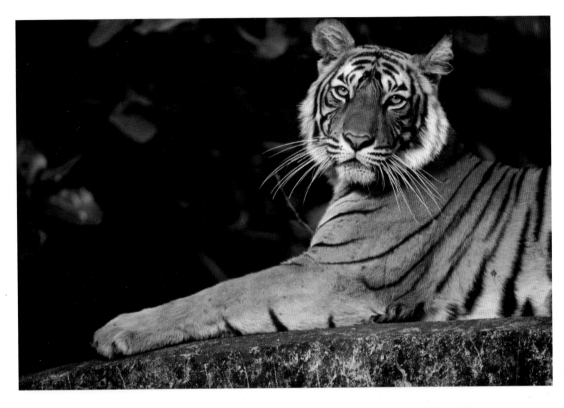

◀ **TIGER ON WALL, BANDHAVGARH NATIONAL PARK, INDIA**

◀ **TIGER SIGHTING, BANDHAVGARH NATIONAL PARK, INDIA**

Second Spread: Where?

This next spread establishes the *where?*: India. This is one of the last places in the world where tigers can be seen in the wild. I could have chosen to flesh out the landscape with shots of other wildlife: the owl, the chital (a favorite prey of tigers), and the langurs, whose alarm calls warn deer when tigers are on the prowl. I also wanted a landscape with trees, since illegal deforestation is a key threat to tiger populations. Our subject—the tiger—has now been given some necessary context, and good captions can tie the spread together.

▼ BLACK-FACED LANGURS, BANDHAVGARH NATIONAL PARK, INDIA

▼ TIGER IN GRASS, BANDHAVGARH NATIONAL PARK, INDIA

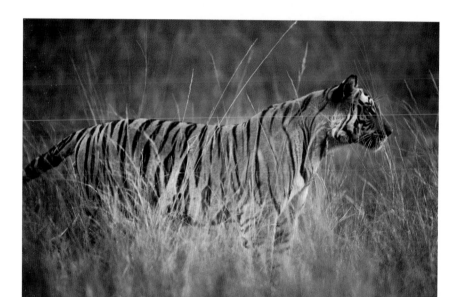

▶ AXIS DEER OR CHITAL, BANDHAVGARH NATIONAL PARK, INDIA

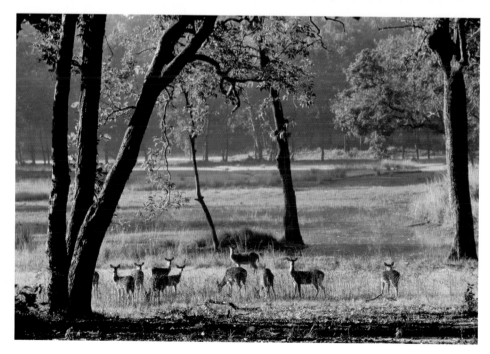

Third Spread: What?

This spread introduces the tourism part of the story. For starters, while open jeeps are used in all the reserves, riding on elephants is often the best way for tourists to see tigers as the elephants can go places jeeps can't and, being unafraid of tigers, can get you in close.

The action shot of the elephant's back suggests what being a tourist might feel like: the slightly blurred motion adds a nice sense of being there. I also liked the close-up of the mahout's foot resting on the elephant's ear, showing how he drives and steers his charge and the intimate nature of their relationship. These kinds of unexpected detail shots add a lot to a story and are the mark of an experienced editorial photographer.

I also included the shot of the Indian boy on his first tiger safari, to show that Indians themselves see tigers as worth preserving for future generations. His wool hat reflects the fact that tourism generally takes place during India's winter, the dry season from October to May, avoiding the monsoon season when many of these roads would be impassable. With the right caption, this also answers the question of *when?* for our story.

▲ RIDING WITH A MAHOUT, BANDHAVGARH NATIONAL PARK, INDIA

▲ MAHOUT'S FEET, BANDHAVGARH NATIONAL PARK, INDIA

▲ BOY ON TIGER SAFARI, BANDHAVGARH NATIONAL PARK, INDIA

◀ ART WOLFE ON LOCATION, BANDHAVGARH NATIONAL PARK, INDIA

Photo © John Greengo

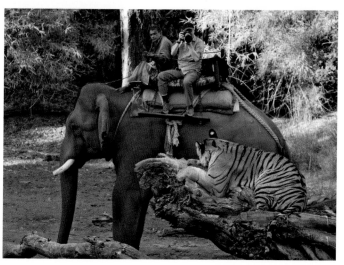

Fourth Spread: Why?

I chose three separate tiger shots for this spread to showcase their extraordinary beauty in a variety of settings. It is important that the picture choices are diverse enough to create visual interest and have the potential to add something to the overall story.

Tigers are often used to promote Indian tourism around the world, yet according to the government agency in charge of tiger preserves, all of these tourists are "loving tigers to death." They point to what has been called a "tiger circus" in some of the more popular reserves and claim this crush of visitors has caused the deaths of some tigers, which were hit by vehicles.

The first image is a close-up portrait of a handsome young tiger. He has reached the age when he will have to leave his mother and find his own territory, a time when tigers are most vulnerable to poaching. The eye contact in this shot separates it from the other images in the spread and provides a wonderful sense of personality.

The second image of a tiger drinking shows the entire animal in spectacular fashion, and illustrates that water is important to tigers' survival. As top carnivores, tigers have a strictly protein diet that requires lots of water.

The final shot of a mother and cub is more typical of the encounter one might expect to see as a tourist. I liked how the green contrasted with all of the dusty dry landscapes shown so far, and how the photograph captures the social lives of these big cats.

▼ **TIGER PORTRAIT, BANDHAVGARH NATIONAL PARK, INDIA**

▼ **TIGER DRINKING, BANDHAVGARH NATIONAL PARK, INDIA**

▲ **TIGER AND CUB, BANDHAVGARH NATIONAL PARK, INDIA**

Closing Spread

Every photo story needs a closing, just as it needs an opening. I used the central image of an elephant safari as a romantic notion, suggesting the long tradition of wildlife tourism in India. I chose the shot of the tiger lying in the water because it shows the powerful head and shoulders of this cat. Looking into the spread, he appears to be contemplating something—perhaps his uncertain future. Some estimates give tigers only another five years in the wild. I added the pugmark as both a design element and a symbol of what we hope is the tiger's enduring presence in the landscape.

With a few pictures and the right captions, we have pulled together a possible story package to market to magazines and websites. We have a subject, it does something interesting, and we have some colorful details to flesh out the story. When studying the selection, notice the variety of perspectives—close-ups, telephoto, and wide-angle views. This gives the story a visual dynamism. Pictures taken from one single perspective aren't as lively when viewed as a group.

I may not have selected some of your favorite images here, nor some of mine. I loved the shot of the two tigers playing because images of behavior are harder to find. But picture choices are often dictated by the story thread and sometimes fine single images have to be left out. You could create your own photo story using other combinations.

▼ ELEPHANT SAFARI, BANDHAVGARH NATIONAL PARK, INDIA

◄ TIGER IN WATER, BANDHAVGARH NATIONAL PARK, INDIA

▲ TIGER TRACK, BANDHAVGARH NATIONAL PARK, INDIA

Photography's New World

▲ **MARTHA HILL AT WORK**
Photo © Kevin Schafer

The digital revolution has not only changed the way pictures are taken but also how the photography business itself is conducted. Gone are the days when editors were deluged with packaged submissions from photographers hoping to be published. Today, digital capture has dramatically simplified the submissions process, much to everyone's relief; images can now be transferred electronically, with original slides no longer at risk of being lost or damaged.

At the same time, digital photography has ushered in a whole set of new challenges. In the days of film, a picture was essentially complete when the shutter closed. Today, however, the actual capture is often just the beginning of the process, which typically involves post-processing on the computer. This may include simple adjustments of color and contrast to bring the image in line with what the photographer remembers, or it can mean much more: pumping up saturation to intensify the color of a sunset, removing distracting elements, even adding or moving objects within the frame to "improve" the composition.

The image an editor sees may be quite different from what the photographer initially recorded. Yet most publications, and their editors, still pride themselves on the accuracy and reliability of the images they publish. So what level of alteration is acceptable, or honest? Where is the dividing line between accuracy and exaggeration—or even falsehood?

It is now commonplace for editors, either at a magazine or judging a competition, to insist on receiving the RAW version of an image to compare with the processed image submitted. Sometimes this is to ensure the best possible reproduction, but it can also allow the editor—who is ultimately responsible for accuracy—to make an informed decision if there is any doubt about an image's authenticity.

Many argue that dodging and burning in the darkroom, or the use of filters in the field, are techniques that have always been used to improve a photograph. To some, "enhancements" performed on the computer are an acceptable part of the creative process. The fact is, we may have opened a Pandora's box. Which forms of manipulation are acceptable and which are not? Where is the limit, and who should be the judge? The answers to

these questions vary for each individual, a fact that makes it nearly impossible to agree on meaningful standards within the field.

There may be nothing inherently wrong with tweaking the color a bit to improve a drab image, or deleting a distracting element, like a blade of grass in front of a lion's nose. Ultimately, the issue is one of context. Nobody expects the photographs used in commercial advertising to be truthful, for example. These images are often manipulated, sometimes outrageously, to help sell a concept or product. In this context, no amount of digital manipulation can be considered too much. But the situation is clearly quite different in a science or news magazine, where the pictures are assumed to be accurate and honest.

Nature is phenomenal in and of itself. Why turn it into make-believe? And if there are no limits to how much pictures can be "improved," who will believe anything they see anymore? Already we find ourselves asking, "I wonder how they did that (in the computer)?" rather than "Wow, wasn't he lucky to have seen that!"

For the nature photographer, the single most useful advance of digital capture has been the ability to instantly review your work. This, more than anything, enables photographers to see what doesn't work and make changes while still in the field. It encourages us to experiment and take visual chances.

Bill Garrett, former editor at *National Geographic,* is said to have told his photographers "f/8 and be there," suggesting that simply being there was the most important thing. (The mention of f/8 is thought to mean that no matter what your settings, you could still get something publishable.) Today's mantra, on the other hand, seems to be, "I'll fix it in Photoshop!"

That said, it is nearly always better to shoot the best possible image you can while on location, rather than count on correcting it in post-processing. First of all, many corrections made after the fact can damage the quality of the final image, such as by adding increased noise and posterization (when a continuous tone is broken into bands of colors).

More than anything else, getting the picture right the first time can simply make you a better photographer. After all, composition is about

seeing and training your eye to create a memorable image out of the chaos around us. That training is what will ultimately make your work stand out.

Finally, a few words about our own behavior as photographers in the field. At *Audubon*, we took seriously the issue of harassment of wildlife by overzealous photographers eager for close-up portrait shots. Sadly, this behavior still exists, putting the lives of photographers at risk as well as the lives of the animals they provoke. It is difficult to justify any situation in which a picture is worth harming your subject.

Our negative impact can be as subtle as leaving behind human-scented detritus near a bird's nest that attracts a predator. Or it might be as blatant as cutting down a tree to access a nesting warbler, something the legendary Eliot Porter did early in his career—and later regretted. Ultimately, Porter's philosophy became one of no intrusion whatsoever; if he didn't like the composition of leaves or branches in a landscape, he found another angle or a new location.

Today, there are few, if any, universally agreed upon rules governing ethical behavior, either in the field or on the computer. Some membership organizations, like the North American Nature Photography Association (NANPA), have tried to establish guidelines for ethical practices, but ultimately every photographer must judge his or her own actions. In the Hippocratic oath, doctors are guided by the phrase: "First, do no harm." That would be as good a place for us to start as any.

10 Tim's Top Tips for Digital Photographers

◄ ART WOLFE ON
LOCATION IN ICELAND
Photo © Gavriel Jecan

Countless books could be written with useful information for the digital nature photographer. Throughout this book we've tried to share as much information that we consider important as possible, most of it regarding composition and creativity. However, we thought it fitting to end with some top technical tips regarding both digital capture and post-processing.

Shoot RAW vs. JPEG

Whenever possible, shoot in RAW rather than JPEG mode. To be sure, RAW captures will take up considerably more space on your memory cards, and you will also have to convert RAW captures to actual pixel values, such as TIFFs or JPEGs, before working on them (though with some workflows, such as when using Adobe Photoshop Lightroom, you would hardly notice this "extra" step).

The advantages of RAW, however, are significant. To begin with, by shooting RAW you avoid the issue of JPEG compression. Even with the highest quality setting for JPEG images used by most cameras, there can be visible artifacts that degrade the overall photo. Also, RAW mode allows you to refine the white balance after capture with no penalty in terms of image quality. It also gives you more wiggle room when it comes to exposure by allowing you to easily adjust the overall brightness and contrast after capture. Finally, RAW

▶ **SURF, CANNON BEACH, OREGON**
24–105mm F4L IS USM lens, f/18 for 1/6 sec., ISO 50

capture enables you to convert your images to 16-bit per channel mode, which ensures the best quality final result (see page 216).

It is worth noting, by the way, that when shooting in RAW, the only camera settings that affect the final capture are aperture (affecting depth of field), shutter speed (affecting how motion is rendered), and ISO (affecting noise levels). With certain cameras, there are also settings that apply noise reduction to the RAW data or help ensure detail is retained in the highlights. All other settings, such as those affecting white balance, contrast, saturation, and so on, will not affect the RAW capture (though they *will* alter the JPEG preview, which is what you see on the camera's LCD display).

▲ A zoomed-in view of a TIFF.

▲ In this zoomed-in view of a JPEG, you can see the artifacting.

Expose to the Right

**CACTUS, BAJA
CALIFORNIA, MEXICO**

In the darker exposure
shown above, we lose
detail and get increased
noise in the darker areas.
A proper exposure
(opposite) allows for finer
detail in both light and
dark areas.

▲ 70–200mm F4L IS USM
+2.0x lens, f/22 for 1/20
sec., ISO 400

In digital photography, the ideal exposure, from a
detail and quality standpoint, may be different from
the ideal exposure for film. Instead of exposing
for the shadows, as you would with film, with
digital the ideal exposure is as bright as possible
without losing highlight detail. Again, by "ideal
exposure" we're talking about detail and quality,
not the final overall tonality of the photo. This is
often referred to as *exposing to the right* because
an image captured in this way will have a his-
togram display that is shifted toward the right,
reflecting the shift toward brighter values.

Because of the nature of digital image sensors
and the way they record information, the majority
of information is contained in the brightest tonal
values. That means in bright areas of an image,
you're able to see finer detail and smoother
gradations of tone and color. By contrast, in the
darker areas of the image you will find less detail,
and the gradations between tone and color will
not be as smooth.

In addition to the level of detail, noise is also a
more significant issue in the shadow areas of an
image. Noise is, in effect, the opposite of informa-
tion. It presents itself as random variations of tonal
and color values at the pixel level.

By keeping an exposure relatively bright, you
maximize the amount of information in the photo
and minimize the amount of noise. Naturally, if
the image is brighter than you would like it to be
from an aesthetic standpoint, you'll have a little
more work to do in the computer after capture.
However, it is usually a price worth paying to
ensure the greatest image quality possible. Just
be sure not to expose so brightly that highlight
details start to get blown out.

▲ 70–200mm F4L IS USM +2.0x lens, f/22 for 1/10 sec., ISO 400

Use the Lowest ISO Possible

For photographers who got their start with film cameras, there seems to be a tendency to think of exposure as only involving two factors: lens aperture and shutter speed. That is, in part, because the ISO (or ASA), which defined the sensitivity of film, was fixed for a given type of film. You chose your film based on the ISO rating, and then adjusted exposure through aperture and shutter speed.

With digital photography we are now able to adjust the ISO setting from shot to shot, which provides much greater flexibility. It also means that we can more directly think about exposure as being based on three settings: lens aperture, shutter speed, and ISO setting.

A common misconception is that changing the ISO setting for a digital camera adjusts the sensitivity of the image sensor. The reality is that a higher ISO setting doesn't change the sensitivity of the image sensor but rather adjusts the degree of amplification applied to the signal being recorded, enabling a faster shutter speed or a smaller lens aperture opening. Because amplification is used, the result is an increased risk of noise (random variations of tonal and color values) in the final photographic image.

Today's digital cameras employ a wide variety of technological tools to help minimize the amount of noise in your images. And software tools can

RICE TERRACES, YUANYANG, YUNNAN, CHINA

▼ 16–35mm F2.8L II USM lens, f/14 for 0.3 sec., ISO 100

be used after the capture to reduce the appearance of noise. However, none of these solutions is a good replacement for avoiding noise in the first place. The best way to avoid noise is to use the lowest ISO setting possible for a given capture.

In some situations, however, you may be forced to raise the ISO setting in order to achieve an adequately fast shutter speed or an acceptable depth of field. I encourage you to think carefully about these exposure settings, and only increase the ISO setting when it is actually needed, and then only by the minimum amount needed to achieve a good photographic result. By doing so, you'll be ensuring your photos will have the least amount of noise possible for a given photographic situation.

It is also a very good idea to spend some time testing your camera by capturing a variety of different images at different ISO settings. This will enable you to get a much better sense of how high you can comfortably raise the ISO setting for your camera before noise starts to become problematic. For example, with many cameras, you won't find objectionable noise all the way up to 400 ISO. Other cameras may get great results at even higher settings, and some cameras need to be kept at even lower settings for good results. Whatever camera you use, it is critical that your image is correctly exposed, since noise is dramatically increased with underexposure.

◀ When the ISO is pushed to 800 or more, severe graininess or noise occurs, rendering an image unusable. Here is a zoomed-in view of what noise would look like.

Work in 16-Bit Depth

The *bit-depth* of an image determines the total number of possible colors available, which in turn impacts the potential color gamut, as well as the smoothness of gradations between different color and tonal values. Whenever possible, work in the 16-bit per channel mode, especially when working on black-and-white conversions.

A single bit, which is the basis of digital information, can have one of two values, generally referred to as "zero" and "one." In a digital photo, the color value of a pixel is defined by three values, one for each primary color (red, green, and blue). If an image is set to the 8-bit per channel mode, each of those three channel values can have up to 256 possible values. This is because there are two values for each bit, so the total number of possible

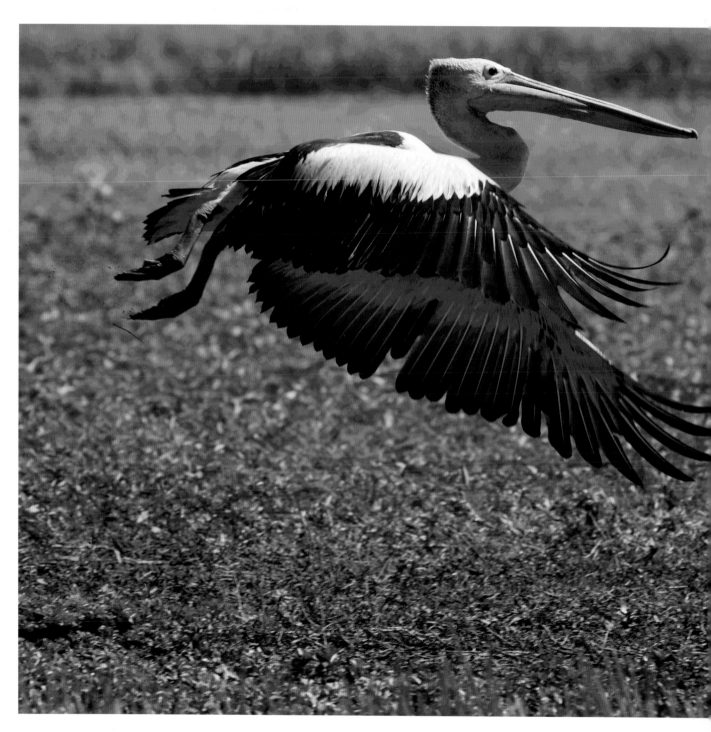

values is two multiplied by itself eight times, or 256. Since there are three individual channels comprising the full color information, we can determine the total number of possible colors by taking the 256 possible tonal values per channel and multiplying that number by itself three times (since there are three channels). This results in 16,777,216 total possible colors. That may seem like a large number of colors, and it is. In fact, it represents the approximate number of colors that can be detected by the human visual system.

However, as you apply adjustments to your images, some of the individual color and tonal values will be lost. If your adjustments are especially strong, you may sacrifice enough of those tonal and color values, which results in *posterization,* or the loss of smooth gradations of tonal or color values.

If you work in the 16-bit per channel mode, however, each channel can record a total of 65,536 possible tonal values. That translates into more than 281 trillion possible color values. That is, by any measure, a huge number. The result is that even with relatively strong adjustments to the image, you're not likely to see any posterization at all.

Working in the 16-bit per channel mode is especially important when applying adjustments to a black-and-white image, though it can also be helpful for color images. However, you must start with high-bit data in order to gain these advantages. Simply converting an 8-bit per channel image to the 16-bit per channel mode won't provide any real benefit in terms of image quality.

As an aside, most digital cameras don't actually capture 16-bit per channel data. The majority of cameras today capture at 14-bit per channel, with some cameras capturing at 12-bit per channel, and a handful capturing at a full 16-bits per channel. With any of these bit-depths, you would still convert to 16-bit per channel when processing your RAW capture, since the only real options are 8-bits per channel and 16-bits per channel. In other words, any bit-depth over 8-bits per channel must be stored as a 16-bit per channel image, but that doesn't necessarily mean you actually have full 16-bit per channel data. In terms of ensuring optimal image quality, more is always better when it comes to bit-depth, so it is a good practice to convert your RAW captures to a 16-bit per channel image.

◄ AN EXAMPLE OF POSTERIZATION (EXAGGERATED FOR EFFECT).
It's particularly noticeable in the top portion of the background.

**PILINGS, COLUMBIA
RIVER, WASHINGTON**

▲ Above: Art's original
color image.

▶ Opposite: His black-
and-white conversion.

Both images: 70–200mm
F4L IS USM lens, f/14 for
578 seconds, ISO 100

Take Control of Your Black-and-White Images

There are, as with so many things in digital pho-
tography, many ways to approach the process of
converting a color image to black and white. To
help ensure you achieve the best results, consider
taking an approach that gives you the most control
possible.

In Photoshop or Lightroom, for example, you
can adjust individual sliders for ranges of colors
to brighten or darken all reds, yellows, blues, or
other colors within the image. Another solution is
to use software specifically tailored for creating
black-and-white conversions, and that offers a
variety of creative effects. One excellent software
solution is Silver Efex Pro from NIK Software. One

of the great advantages of Silver Efex Pro is that
you can preview a series of thumbnail images with
sample effects. These include simple conversions
from color to black and white, simulations of filter
effects from the wet darkroom (such as a red filter
to increase contrast), addition of film grain or a
vignette effect, and many more options. Once
you've selected the preview that offers the best fit
for your image, you can continue fine-tuning the
result via various sliders and controls. You can
even apply adjustments to specific areas of an
image, such as if you want to dodge (lighten)
and burn (darken) specific areas.

Not every image calls for a black-and-white
interpretation, but when removing the color
element of a photograph seems like the best
option, retain as much control as possible to
produce a unique and interesting result.

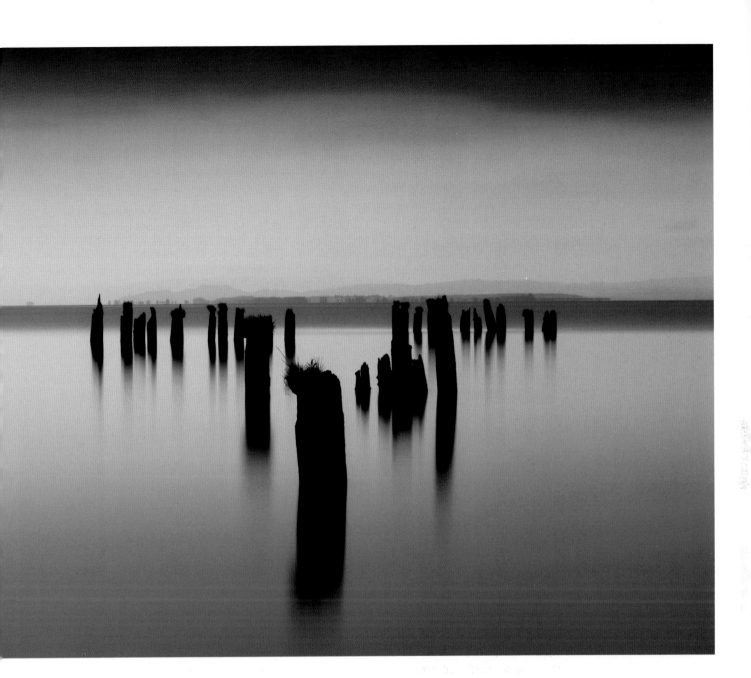

Edit in a Nondestructive Way

Nature photographers spend a lot of time and energy maximizing the quality of their images, ensuring sharpness, finessing the ideal exposure. This focus on quality should be extended to your post-processing work. Specifically, be sure to adjust your images in a way that preserves the original pixel values, ensuring maximum flexibility when returning to the image to apply further refinements.

If you are using Adobe Photoshop Lightroom, your workflow is automatically nondestructive. Lightroom keeps the adjustments you apply separate from your original image. The original is never altered, so the final effect is only truly converted to pixel values when an image is exported from Lightroom for printing, emailing, or creating a web gallery.

If you're using Adobe Photoshop, however, it is quite easy to alter the original pixel values, which can be problematic if you want to return to the original image to apply a variety of refinements. The key to being nondestructive in Photoshop is to use *adjustment layers.* This way, instead of applying your adjustments directly to the original, you are simply recording information about how you want to alter it. This allows you to return to the original image as many times as you like to fine-tune your adjustment, without a cumulative loss of image quality.

For other work, such as cleaning up blemishes, use separate image layers to keep the corrections separate from the original image. For example, when cleaning up a dust spot in the sky, copy sky pixels from the original image onto a separate layer, placing the pixels so as to cover up the blemish.

There are a variety of books, video training titles, and other resources available to help you learn to make the most of a nondestructive workflow, which in turn will help you make the most of your digital photos.

▼ **ADOBE PHOTOSHOP SCREENSHOT SHOWING LAYERS**

Back Up, Back Up, Back Up

One of the most important habits for digital photographers is to consistently back up your images. Digital imaging provides the great advantage of creating backup copies that are an exact duplicate of the original, which was never truly possible with film. The drawback is that there is a greater risk of losing a large number of images at once. Backing up your images consistently can help you avoid that risk.

At all times, maintain at least two copies of your digital photos. It is even a good idea to have a third copy of at least your favorite images, if not all of them. Each backup should be stored on a separate storage device (such as a hard drive). That means a separate *physical* device, not just a different volume on the same physical hard drive, for example. In addition, it is best to store one copy of your photos at a separate physical location, such as having one copy at home and one copy at the studio or office.

There are many ways to back up your images. You can use software that automatically backs them up at set intervals, or you can manually back up images on a regular basis. You can even use online backup services to store your most important photos, though due to bandwidth and storage limitations, these options aren't realistic for backing up most photographers' full catalog of images.

Whatever solution you use, the key is to be consistent and careful about your process. How many images are you comfortable losing in the event of a hard drive crash? If your answer is "none," you should be backing up your images as soon as you've captured them, and always ensure you have a backup (or two) of your entire catalog.

There may not be anything more painful than losing important images. Why not set up a consistent backup process to avoid having this happening to you?

◄ SCREENSHOT OF APPLE CHRONOSYNC BACKUP SYSTEM

Resources

There are a wide variety of websites, organizations, books, and other resources available to nature photographers, all of which can help you improve your photography, your business, and your involvement in the greater photographic community. Here are some of the resources we recommend.

Organizations

American Society of Media Photographers: www.asmp.org
American Society of Picture Professionals: www.aspp.com
International League of Conservation Photographers: www.ilcp.com
North American Nature Photography Association: www.nanpa.org
Photographic Society of America: www.psa-photo.org

Websites

Art Wolfe's blog: http://blog.artwolfe.com/
Arthur Morris (Birds As Art): www.birdsasart-blog.com/
Ask Tim Grey eNewsletter: www.timgrey.com/asktimgrey/
David Leland Hyde (landscape photography): http://landscapephotographyblogger.com/
Jim M. Goldstein (technology and landscape photography blog): www.jmg-galleries.com/blog/
John Paul Caponigro (black-and-white landscapes): www.johnpaulcaponigro.com/blog/
The Luminous Landscape: www.luminous-landscape.com
Outdoor Photographer magazine: www.outdoorphotographer.com/
TWiT Photo netcasts: http://twit.tv/show/twit-photo/52

Books

Arbabi, Sean. *The Complete Guide to Nature Photography*. Amphoto Books, 2011.
Eismann, Katrin, Sean Duggin, and Tim Grey. *Real World Digital Photography* (3rd edition). Peachpit Press, 2010.
Evening, Martin. *Adobe Photoshop CS5 for Photographers*. Focal Press, 2010.
———. *The Adobe Photoshop Lightroom 3 Book.* Adobe Press, 2010.
Fraser, Bruce, Chris Murphy, and Fred Bunting. *Real World Color Management* (2nd edition). Peachpit Press, 2004.
Grey, Tim. *Color Confidence* (2nd edition). Sybex, 2006.
Lepp, George. *Wildlife Photography: Stories from the Field*. Lark, 2010.
Long, Ben. *Complete Digital Photography. Course Technology*. PTR, 2011.
McNally, Joe. *The LIFE Guide to Digital Photography*. LIFE Books, 2010.
Patterson, Freeman. *Photography and the Art of Seeing*. Firefly Books, 2011.
———. *Photography for the Joy of It.* Key Porter Books, 2007.
Shaw, John. *John Shaw's Nature Photography Field Guide*. Amphoto Books, 2001.
———. *Photoshop Techniques* (ebook). johnshawphoto.com, 2010.
Sheppard, Rob. *KODAK Guide to Digital Photography*. Lark Books, 2008.
Tharp, Brenda. *Creative Nature & Outdoor Photography* (revised edition). Amphoto Books, 2010.

Index

A

Adams, Ansel, 161
Adobe Bridge, 114
Adobe Photoshop, 78, 80, 114, 207
 Content-Aware option, 27
 HDR image, 166, 171
 location information, 197
 Spot Healing Brush, 27
Adobe Photoshop Lightroom, 78, 80, 210
 adjustment layers, 220
 composite panorama, 114
 4 map module, 197
Adobe RGB color space, 67
aerial perspective, 94–95
angle of camera, 61–63
angle of light, 126, 133
Aperture Priority, 144, 158
aperture settings, 144, 147, 152, 156, 214
 HDR image, 166
 RAW image, 211
Apple Chronosync Backup System, 221
Arnheim, Rudolf, 35
asymmetrical compositions, 13, 35, 38–39
atmospheric conditions, 78, 97, 188–91
Audubon (magazine), 10, 19, 26, 68, 152, 207
 best-selling cover, 72
 cover format, 29, 34
 editorial photo selection, 199–207
Auto Curves, 78
autofocus lenses, 186

B

backing up images, 221
backlighting, 134–35
balance, 13–14, 17, 25, 33, 36, 104
bit-depth, 216–17
black-and-white photography, 66, 76, 78
 color image conversion to, 80, 216, 217, 218

blurriness, 152, 155, 162
bright exposure, 212
Brush tool, 78

C

cable release, 163
Canon cameras and lenses, 178
Cartier-Bresson, Henri, 186
centerline, 90–91
center of interest, 29, 35, 36, 38–39, 92
 symmetry vs. asymmetry, 13, 35
circles, 35, 104
close-up photos, 182, 184
 telephoto lens, 54
 wide-angle lens, 57
cloudy day, 123–25
clutter elimination, 22, 24–25
color, 17, 65–81
 bit-depth, 216–17
 composite panorama, 114
 digital photo value, 216
 digital post-processing, 206
 emotional responses to, 65–66
 filter use, 181
 flash use, 147, 172, 174
 image conversion to black and white, 80, 216, 217, 218
 light and, 65, 73, 117, 118, 120, 124, 174
 polarizing filter, 170
 power of absence of, 78
 specular reflection, 170
 symbolism of, 66, 73
 temperature adjustment, 120–21
 uniformity of, 76
complementary colors, 70
composite panoramas, 110–16
composition, 10, 17, 29–43, 189
 camera angle changes, 61–63
 center of, 29, 35, 36, 38–39, 92
 component integration of, 29
 contrast and, 19, 63
 cropping and, 29
 depth of field and, 160–62
 distractions in, 26, 27, 54

elements of, 13–14, 29, 33, 197
 focal point of, 35, 38
 golden mean and, 38–39
 live view display use for, 43
 perspective and, 45–63
 scale and, 48–51
 simplicity of, 22, 24, 54
 steps in, 19
contrast, 19, 108, 118, 124, 133, 211
creative options, 147–74
cropping, 29, 32, 38, 52
Cunningham, Imogen, 21

D

"dark frame" exposure, 163
daylight, 118
 flash use and, 147, 172, 173–74
depth, 15, 85–86, 87
 horizon placement and, 88–91, 92
 line to create, 98
depth of field, 147, 160–62, 166, 211, 215
 opening up, 162, 172, 174
 stopping down, 160–61
design, elements of, 83–115
detail, highlighting of, 144
diagonal lines, 98, 100, 104
digital photography, 199
 compact cameras, 52
 new challenges of, 206–7
 top tips for, 209–21
 wildlife tools, 147
digital SLR camera (DSLR), 43, 45, 52, 147
distracting elements, 26, 27, 54
dynamic range, 166

E

editing, 199–207, 220
18 percent gray, 140
enhancement, photographic, 206–7
ethical practices, 207
exposing to the right, 144, 145, 212
exposure, 156, 186, 187

digital ideal, 212
evaluation of, 144
flash use and, 174
HDR imaging, 166, 171
ISO setting, 214–15
night photography, 163
RAW advantage, 210
external (hot shoe) flash, 172
Eye and Brain (Gregory), 84

F

Feininger, Andreas, 10, 19
field of view. See sensors
50mm lens, 20–21, 24, 47, 58
 "normal" perspective of, 45
fill-flash, 147, 172
film cameras, 45, 156, 163, 214
filters, 147, 164–65, 168–71, 178, 206
flash, uses of, 147, 172–74
focal length, 45, 52, 58, 60
focal point, 35, 38
focus, 152, 160, 172
 selective, 19, 147
fog, 96–97, 140, 188
14-bit per channel, 217
framing, 32–34, 186
 live view display and, 43
 reframing and, 20–21
 scale and, 48, 51
 telephoto lenses and, 54
Friend, David, 29
frontlighting, 128–30

G

Garrett, Bill, 207
glare, 147, 170, 171
golden mean, 38–39
Goodrich, Jay, 78
GPS coordinate information, 197
graduated neutral density (ND) filters, 147, 164–65, 171, 178
gray card, 140
Gregory, R. L., 84

H

harmonious colors, 72
harmony, compositional, 14
heat buildup avoidance, 163

high-contrast lighting, 140, 144, 147
high dynamic range (HDR) imaging, 147, 166–67, 171
horizon, placement of, 87, 88–95, 98
horizontal format, 30–31, 194
horizontal lines, 84, 86, 87, 91

I

in-camera color space, 67
indirect light, 137
ISO, 156, 158, 187, 211
 lowest possible setting, 214–15

J

James, Henry, 19
JPEG, 67, 120
 RAW advantage over, 210–11

L

lenses, 20–22, 24, 48, 147, 156
 autofocus, 186
 close-up photos, 54, 57
 fieldwork preferences, 178
 filter use, 168–70, 171
 magnification, 45, 47, 52
 spatial compression, 58
 spatial expansion, 60
 specialty, 52
 subject size, 45
Leonardo da Vinci, 85
light, 17, 117–45, 156, 193–94
 digital exposure and, 212
 direction of, 126–38
 filter types and, 147, 164–65, 168–71
 flash use and, 147, 172–74
 quality vs. quantity of, 117, 118
 reflection of, 136–37, 170, 171, 174
 shutter speed and, 147
 time of day and, 122
 See also color
Lightroom. See Adobe Photoshop Lightroom
line, 17, 83, 84–103, 104
live view display, 43, 211
location tagging, 197
long exposure, 163, 171
low-contrast lighting, 140
low-light photography, 163

M

macro lens, 55mm, 20–21, 24
manual exposure mode, 114, 166
memory cards, 210
Mencken, H. L., 29
metadata storage, 197

monochrome, 76
mood, 118
moving subject, 150, 152, 154–55, 186–87, 211

N

National Geographic (magazine), 207
ND (neutral density) filters, 147, 164–65, 171, 178
Newton, Sir Isaac, 65, 117
night photography, 147, 163, 172–73
Nik Software, 166
 Silver Efex Pro, 78, 80, 81
noise reduction, 163, 211, 212, 214–15
North American Nature Photography Association, 207

O

off-center placement, 34, 38–39, 189
 of horizon, 92–93
O'Keeffe, Georgia, 21
overcast light, 123–25

P

Pacific Search (magazine), 177
panoramas. See composite panoramas
pastel colors, 73
pattern, 83, 104–6, 133, 135, 138, 161
perspective, 45–63, 85, 86, 97
 angle of light and, 126
 contrast of light and, 140
 photographer's personal voice and, 10, 45
Photomatrix, 166
Photomerge, 114, 115
Photoshop. See Adobe Photoshop
picture story, 200–205
pixel values, 220
polarizing filters, 147, 168–71
Porter, Eliot, 207
post-processing, 27, 172, 220
primary colors, 68, 73
Principles of Composition in Photography (Feininger), 19
proportion, 38–39

R

RAW image file, 67, 80, 206, 217
 advantage over JPEG, 210–11
 Automatic White Balance setting, 120
receding lines/shapes, 96–97

reflected light, 136–37, 170, 171, 174
REI (Recreational Equipment Inc.), 177
remote shutter release, 158, 168, 170
"rule of thirds," 38

S

Saturation Slider, 78
scale, 48–51
sensors, 80, 166, 212
 heat buildup, 163
 ISO setting, 156
 sizes, 52, 53
shadows, 17, 108, 126, 133, 166, 172
shapes, 83, 96–97, 104, 135
Shutter Priority (Time Value), 144
shutter speed, 147, 148–58, 187, 189, 214, 215
 digital advantages, 155
 HDR imaging, 166
 longer exposure and, 163
 RAW and, 211
 use of slow, 157–58, 171
sidelighting, 108, 132–33
Silver Efex Pro, 78, 80, 81
16-bit per channel mode, 211, 216–17
spatial relationships, 38, 85–86, 132, 133
 compression of, 58
 expansion of, 57, 60
 See also depth; line
spotlighting, 138
sRGB color space, 67
subject, 19–27, 192–94
 framing of, 32–33
 importance in relation to surroundings of, 48, 50, 57
 lens choice and, 20–23, 45, 47, 54, 57
 live view display use and, 43
 mood and, 118
 placement of, 33–34
 shutter speed and, 150
 size alteration of, 45
 visual weight of, 33, 35
 See also composition; moving subject
sunlight, 123–24
 direction of, 128–30
 reflected light and, 137
 shadows and, 172
 shooting directly into, 143
sunrise/sunset, 138, 143
symmetry
 asymmetry vs., 13, 35, 38
 horizontal axis and, 90, 91

T

teleconverters, 178
telephoto lens, 45, 47, 52, 58
 close-up photos with, 54
 shallow depth of field of, 162
texture, 17, 76, 83, 84, 104, 108, 133
TIFFs, 210
tripod, 158, 166, 178
 when not to use, 196

U

underexposure, 144

V

vanishing point, 85
vertical format, 30–31, 194
 horizon photograph, 93
vertical line, 84, 86, 90, 91

W

warming filters, 171
Weston, Edward, 21, 161
Whistler, James McNeill, 10
white balance adjustment, 114, 120–21, 171, 210, 211
white light, 65, 117, 120
wide-angle lenses, 22, 52, 62
 close-up photos with, 57
 usefulness of, 47, 50, 60
wildlife photography, 177–97
 decisive moment, 186–87
 digital advantages, 206–7
 digital technical tips, 209–21
 editor's viewpoint, 199–207
 ethical behavior, 207
 post-processing work, 220
 tagging locale, 197
 vantage point of, 22